LAW

LAWYERS ASSOCIATED
WORLDWIDE™

25th Annual General Meeting

Denver, Colorado

September 17-20, 2014

Hosted By

BERENBAUM
WEINSHIENK PC

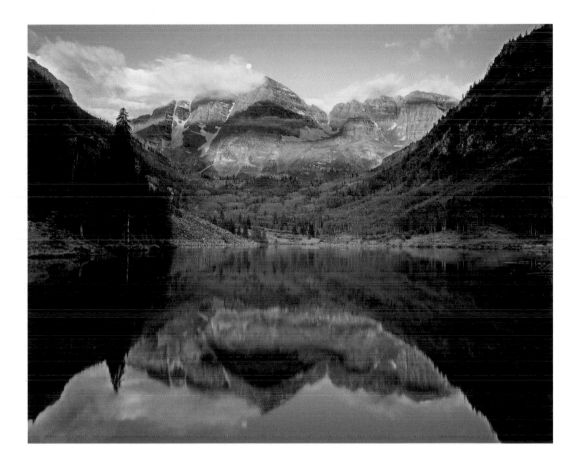

GREETINGS *from*
COLORADO

LEGENDS, LANDMARKS & LORE OF
The Centennial State

J.C. LEACOCK

Voyageur Press

Library of Congress Cataloging-in-Publication Data

Leacock, J.C.
Greetings from Colorado : legends, landmarks & lore of the Centennial State / J.C. Leacock.
 p. cm.
Includes index.

ISBN 978-0-7603-3729-5 (plc)
1. Historic sites—Colorado. 2. Colorado—History, Local. 3. Historic sites—Colorado—Pictorial works. 4. Colorado—History, Local—Pictorial works. 5. Legends—Colorado. 6. Folklore—Colorado. 7. Colorado—Social life and customs. I. Title.

F777.L433 2011
978.8—dc22
 2011000234

Edited by Amy Rost
Design Manager: LeAnn Kuhlmann
Series designed by Simon Larkin
Cover designed by Matthew Simmons
Layout by Cindy Samargia Laun

Printed in China

10 9 8 7 6 5 4 3 2

Frontispiece: Moonrise over Maroon Bells.
Title page: Aspen-lined road near Crested Butte.
Back cover (top): Kids on skis, Steamboat Springs, 1916.
 Denver Public Library, Western History Collection, photo: L.C. McClure
Back cover (bottom): The Crystal Mill.
Spine: The Maroon Bells.

A 120 GREETINGS FROM
HIDEAWAY PARK, COLORADO

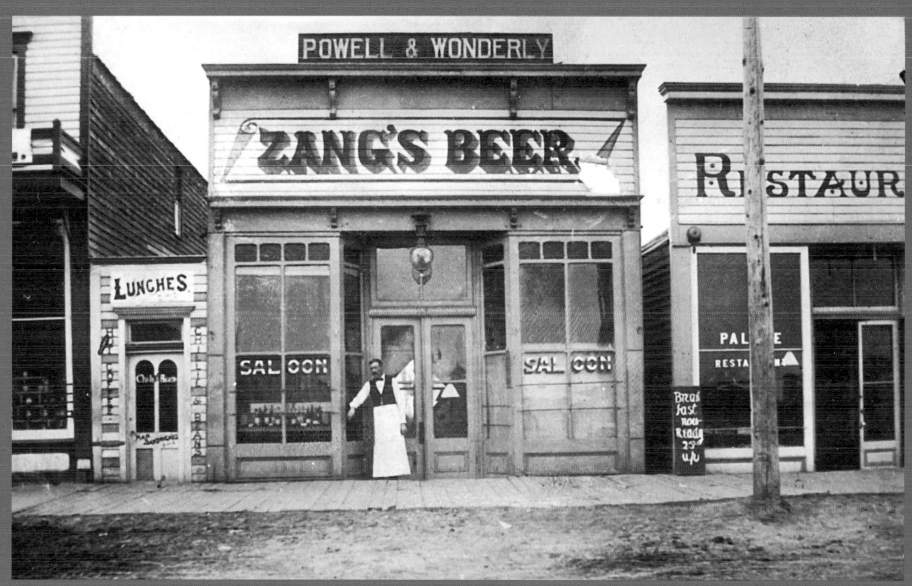

Saloonkeeper in front of Zang's Beer, La Junta, 1883. *Denver Public Library, Western History Collection*

Contents

Colorado Springs and Pikes Peak postcard.

Introduction

F or most people, Colorado is synonymous with mountains. They don't realize how diverse the landscape of this beautiful state actually is. Not only does Colorado have some of the nation's most stunning rivers and valleys, but it also encompasses a large swath of prairie, red-rock canyons, buttes, and mesas. And within that mix of terrain lies the state's cultural history, from its early Native American inhabitants to the trappers and mountain men to the miners and the many who followed to make Colorado what it is today. In essence, the history of Colorado encompasses the narrative of the Great American West, in all its diversity.

Native Americans have inhabited this region for thousands of years. The first Europeans to arrive were the Spaniards, who named the region *Colorado* after the red-colored river they'd named *Rio Colorado*. Spanish descendants were among the first Europeans to settle southern Colorado, but the real boom was to happen later, in 1859, after gold was discovered along the banks of the South Platte River. In a series of gold and silver booms that lasted until the turn of the nineteenth century, the framework was built for what was to become the "Centennial State" (named for its inception on the centennial of the United States in 1876).

The mining industry rollercoastered with the 1890 Sherman Silver Purchase Act and its repeal three years later. Though most of the gold and silver veins in the mountains played out over time, a new resource has injected the old mining towns with new life. This "white gold"—snow, in all its abundance—has provided the state with new notoriety as a destination for hordes of skiing enthusiasts.

Today, Colorado still thrives on its diversity. The hub of the western Rocky Mountains, with vibrant Denver as its capital, Colorado has something for everyone: stunning scenery and outdoor activities, as well as rich cultural and historical resources. From the 14,000-foot mountains to the red-rock spires, from the sweeping vastness of the plains to the thriving cities of the Front Range, from dramatic sand dunes to the charm of old mining towns–turned–ski meccas, Colorado offers a complete experience for resident and visitor alike.

Opposite: Barn at the base of Horn Peak, Sangre de Cristo Mountains, near Westcliffe.

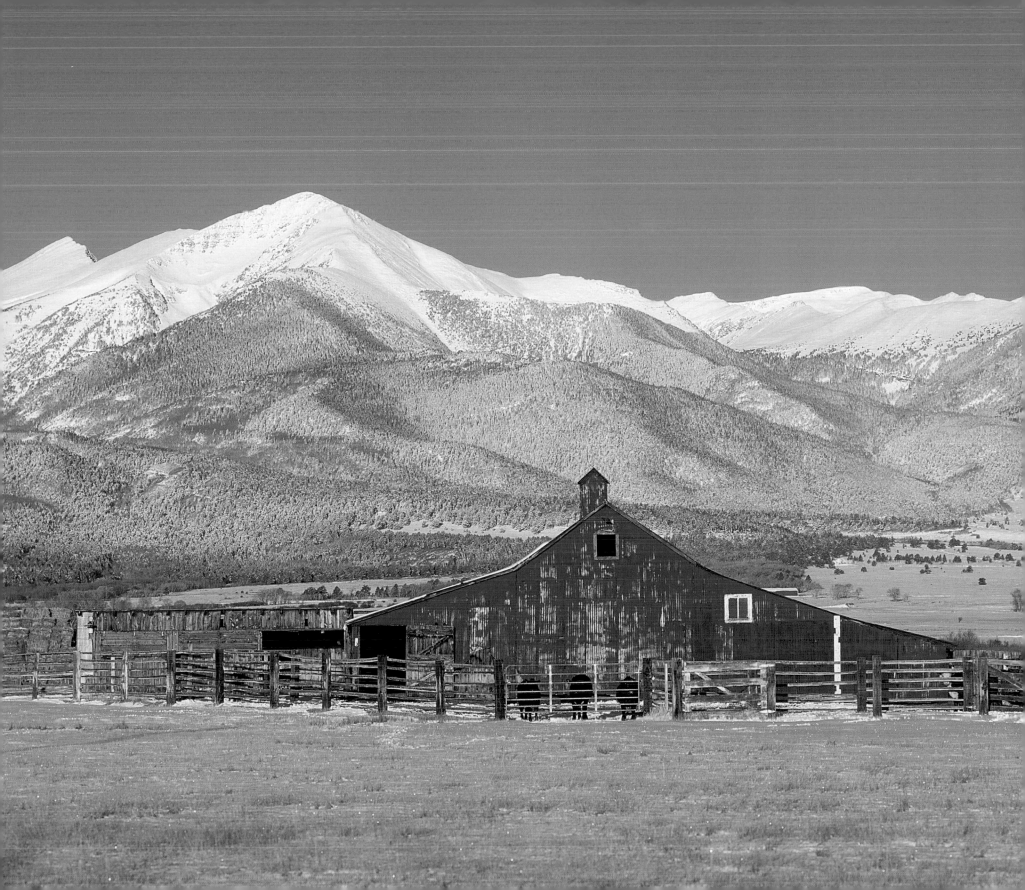

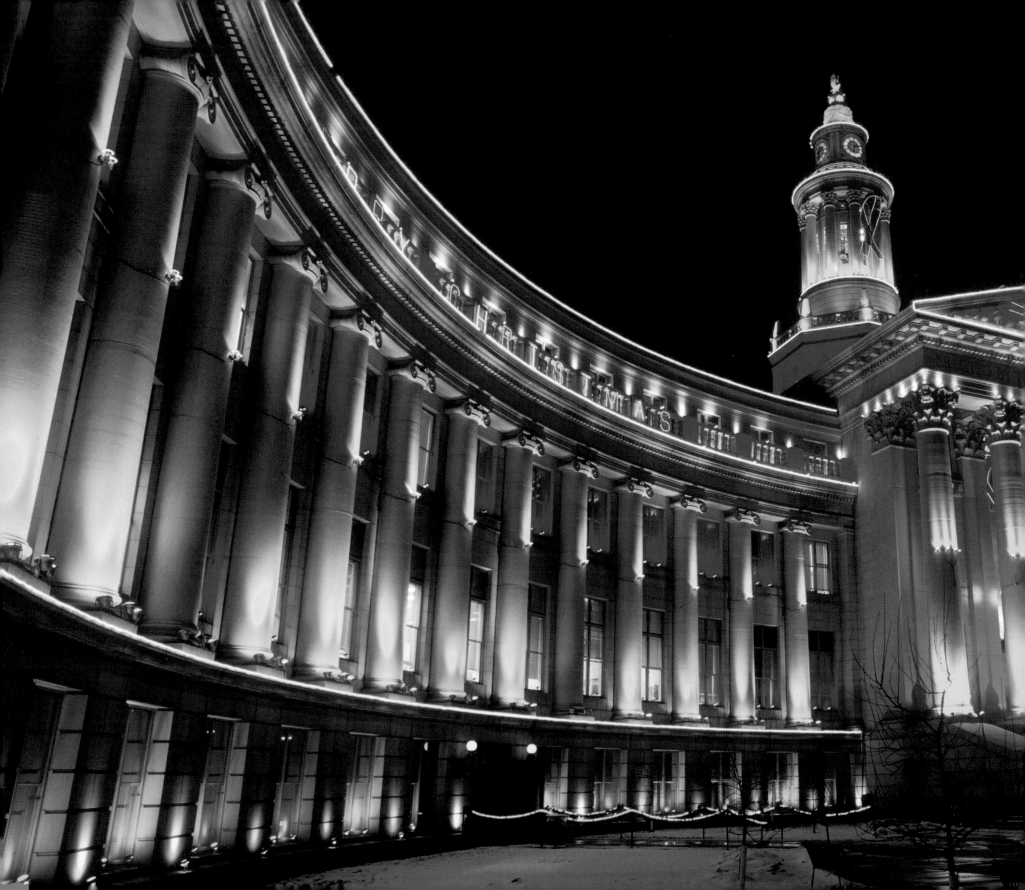

Denver and the Front Range

The Front Range of Colorado, so named because it is the first mountain range encountered by travelers coming from the Eastern Plains, is Colorado's most populous region and the heart of the state's economic and cultural activity. At the base of this range sits Colorado's largest urban areas, including its capital, Denver, and the cities of Boulder and Fort Collins. It is perhaps fitting that this same area is where it all began, with the 1858 discovery of gold along the South Platte River, in the heart of what is today Denver. From the cultural attractions, museums, and nightlife of Denver's downtown to casinos in historic Blackhawk and Central City to the fine universities in Boulder and Fort Collins, Colorado's Front Range has something for all residents and visitors.

Denver City and County Building lit with Christmas lights.

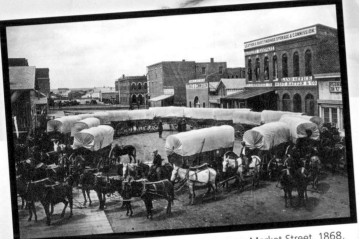

Wagon supply train from Leavenworth, Kansas, on Market Street, 1868.
Denver Public Library, Western History Collection, photo: W. G. Chamberlain

Denver

DENVER WAS FOUNDED by opportunist General William Larimer, who staked a gold claim at the confluence of Cherry Creek and the South Platte River in 1858, setting off the Pikes Peak gold rush. Additional gold discoveries farther into the Rocky Mountains rendered Denver unprofitable as a mining town, but its location made it a center of commerce and a supply point for both the miners in the mountains and the new farmers of the Eastern Plains.

After the railroads arrived in 1870, Denver's population soared from 4,700 to 106,000 in twenty short years. Its growth was also fueled by additional gold and silver discoveries in the Front Range, such as Gregory Gulch and Georgetown, as well as silver discoveries in Leadville in the 1870s. While the financial panic of 1893 and the silver crash had a significant impact on Denver, the city had built up enough industrial and agricultural diversity to stay on its feet.

After World War II, Denver saw another economic boom from oil and gas, and many firms located their regional headquarters in the city. This era saw the growth of much of Denver's downtown and many suburbs. Denver's economic foundation has evolved to encompass a variety of other industries, including high tech, telecommunications, aviation, skiing, and tourism.

(CONTINUED ON PAGE 14)

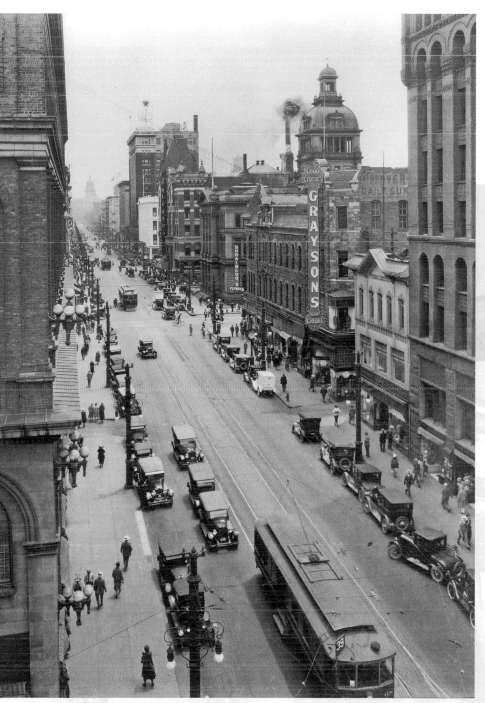

Sixteenth Street, circa 1925. *Denver Public Library, Western History Collection, photo: L. C. McClure*

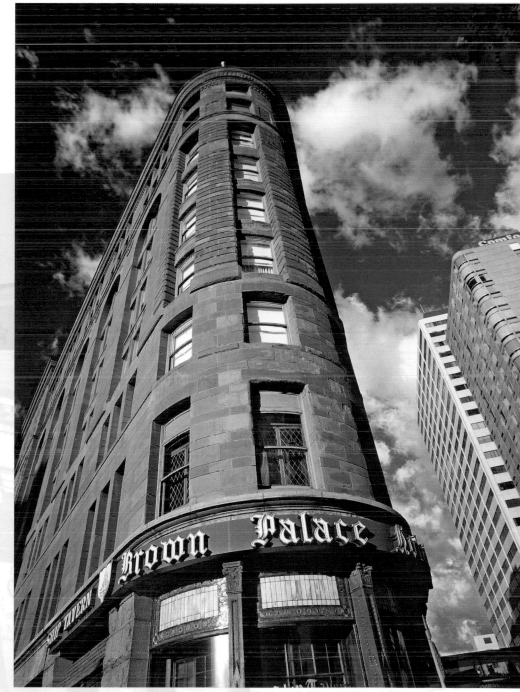

Brown Palace Hotel, Seventeenth Street.

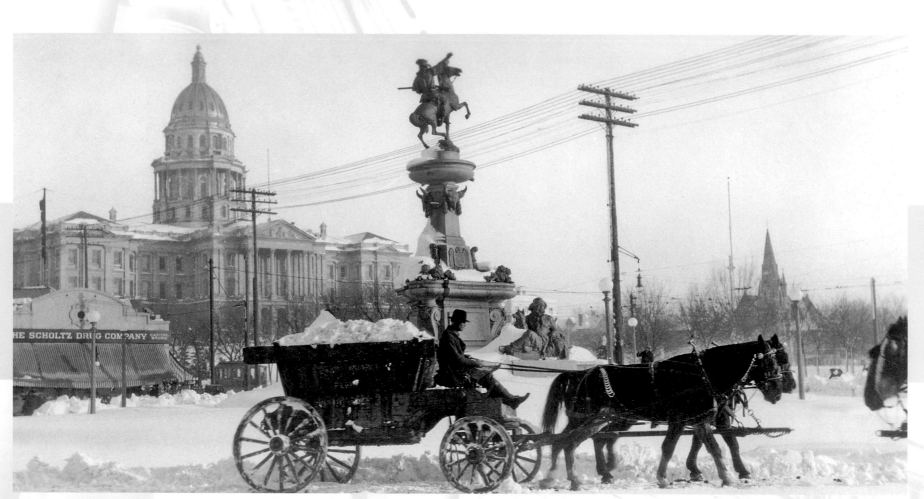

Snow removal by horse-drawn wagon, 1913. *Denver Public Library, Western History Collection, photo: George Beam*

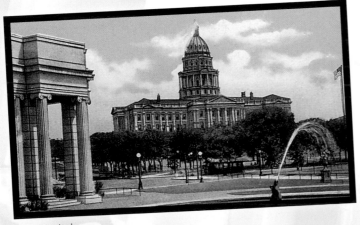

State capitol.

(CONTINUED FROM PAGE 12)

Today the Mile-High City is the urban, economic, and cultural hub of the Rocky Mountain region, with science, history, and art museums, a beautiful performing-arts complex, a revitalized lower downtown, and popular Sixteenth Street pedestrian mall. Coors Field and Invesco Field at Mile High Stadium, the city's baseball and football venues, respectively, are major landmarks and testaments to the enthusiasm Denverites have for their professional sports teams, which include the Denver Broncos (football), the Nuggets (basketball), the Colorado Rockies (baseball), and the Avalanche (hockey).

Denver International Airport, a symbol of Denver's modern optimism and success, opened in 1995, replacing Denver's former airport. Built on the plains east of the city, Jeppeson Terminal can be seen from miles away; its white fiberglass, tentlike roof emulates the snow-covered peaks of the distant Rockies. A steel-catenary cable system supports the translucent roof, which provides diffuse light throughout the building.

Opposite: Denver from City Park.

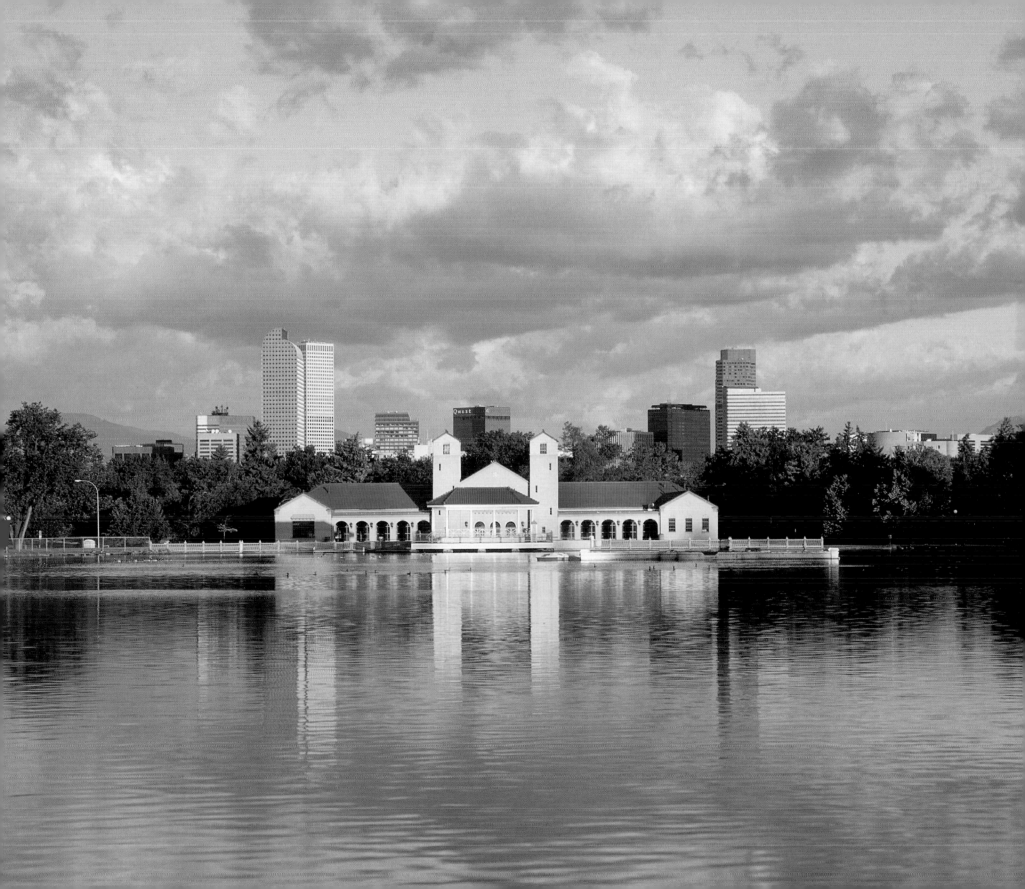

Boulder

Diners on Tenth Street.

NESTLED AT THE BASE of the Rocky Mountains, with the wedgelike peaks of the Flatirons creating a picturesque backdrop, Boulder is aptly named. Because of its proximity to both the mountains and to Denver, not to mention its mild weather, many people have realized that Boulder is an ideal place to put down roots.

Boulder, originally a supply town for miners, was, like Denver, a product of the 1859 Pikes Peak gold rush. The Boulder City Town Company was founded in 1859 and incorporated as Boulder City in 1871. Discoveries of gold, silver, and coal kept the town prosperous through the early 1900s. In 1876, the University of Colorado was founded in Boulder. That event, along with the establishment the Colorado Chautauqua, which was part of the nationwide adult cultural education movement known as Chautauqua, made the city an intellectual center. An additional source of revenue—and brains—arrived in the form of the National Institute of Standards and Technology (NIST), established in Boulder by the U.S. Department of Commerce in 1901. The National Center for Atmospheric Research (NCAR) and several offices and divisions of the National Oceanic and Atmospheric Administration (NOAA) are also located here.

Panorama of Boulder, 1890s. © *Carnegie Branch Library for Local History, Boulder Historical Society Collection*

The exterior of each building on the University of Colorado at Boulder campus is covered in locally quarried sandstone.

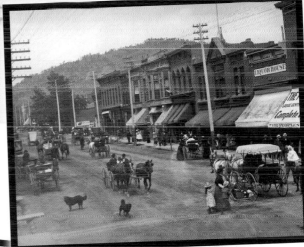

Today, Boulder is a vibrant community with a reputation for being über-athletic, upwardly mobile, and politically progressive. In addition, proactive policies aimed at maintaining Boulder's natural beauty have protected the city from overdevelopment.

In the heart of the city lies the idyllic historic district, dotted with beautifully landscaped gardens, sculptures, and unique local shops. Its main artery is Pearl Street Mall, one of Boulder's most historic and scenic avenues and a magnet for pedestrian shoppers and street performers. South of downtown is the Hill, the main hub of activity for the university crowd; adjacent to it are the stunning historic edifices of the University of Colorado.

Right top: Pearl Street, 1899. © Carnegie Branch Library for Local History, Boulder Historical Society Collection
Right bottom: Street performers on the Pearl Street Mall.

Boulder, Colorado
Photo Ed Tangen

Left: West Elk Coal Mine in Somerset.

Mining

Below: Miner panning for gold, Clear Creek, 1890. *Denver Public Library, Western History Collection, photo: L. C. McClure*

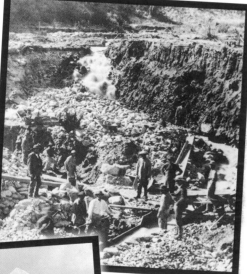

Above: Miners sluicing near Fairplay, circa 1870. *Denver Public Library, Western History Collection*

FEW TOWNS in modern Colorado have been untouched by the influence and effects of mining.

In 1849, a group of prospectors on their way to California spent the winter near the junction of the South Platte River and Cherry Creek, the site of present-day Denver. There they found some evidence of gold and, almost ten years later, returned to expand on their explorations. Men from this party, among others, began to make significant discoveries around the area in Gregory Gulch, near Central City and Black Hawk, and in Russell Gulch. News of the finds spread nationwide, and the Pikes Peak gold rush of 1859 was born, as was Colorado. In the 1870s, silver lust supplanted gold fever and fed the growth of places like Leadville, Aspen, and Telluride.

The mining booms brought a continuous flow of people and money to the territory. Towns sprang up anywhere gold or silver was found and attracted every type of business and profession. Doctors, lawyers, tailors, grocers, newspapermen, gamblers, gunmen, lawmen, ladies of the evening—they all came in droves. Roads were built, rail was laid, fortunes were made and broken. Every political or business decision, including the decision to push the Utes, the local Native American tribe, farther west, was ultimately made because of mining and the potential commerce resulting from it. The fortunes that were made from not only the mining, but also its supporting industries, from railroad empires to cattle ranches, influenced the growing state in innumerable ways.

Miners went to great lengths to wrest the precious metals from the earth. In the 1860s, they used placer techniques, which employed gravity-driven water processes such as panning and sluice boxes. These relatively primitive techniques gave way to the much more destructive hydraulic methods, in which miners used giant, high-pressure water hoses to wash away the soil, and dredging, in which manmade lakes were created and a device called a dredge was used to bring up dirt from the lake bottoms. Eventually, hard-rock mining became the norm; miners accessed ore by tunneling deep into the earth and carting the rock to the surface for stamping (a method of crushing rock to remove the ore) and smelting (where metal is melted out of the ore).

The Sherman Silver Purchase Act of 1890 increased the amount of silver the federal government was required to buy and led to unprecedented profits for the state. But when the act was repealed in 1893, Colorado and its mining industry were thrown into a tailspin. This downturn, along with the decline in the value of gold and the increasing cost of extracting the metals from played-out mines, ended the mining-boom days.

Opposite: Gold prospector in camp, 1920s. *American Stock Photography, Classicstock*

Although it has a smaller population, Black Hawk generates seven times more gambling revenue than Central City.

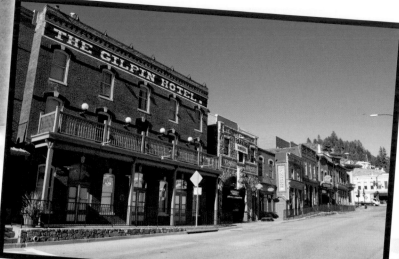

Gilpin Hotel, Black Hawk.

Below: Black Hawk, 1899. *Denver Public Library, Western History Collection, photo: Harry L. Lake*

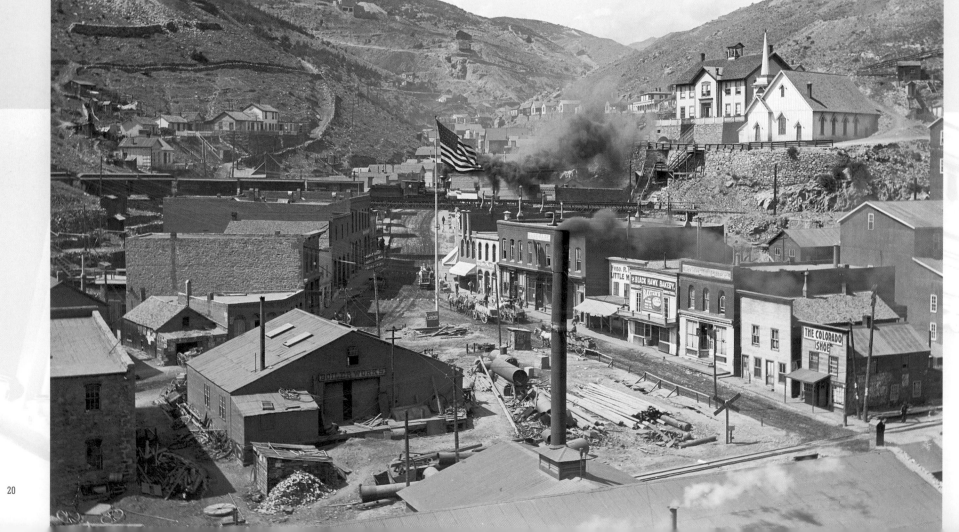

A PRODUCT OF the Pikes Peak gold rush, Central City once rivaled Denver for the title of most populous city in the Colorado territory. Prospector John H. Gregory first discovered gold in what became Gregory Gulch on May 6, 1859. Additional gold veins were soon found throughout the area, and within a span of two months, between 20,000 and 30,000 people covered the hillsides in every available form of shelter. Within a few short years, Central City was a thoroughly modern, built-up town, complete with an opera house. Black Hawk, its sister city less than a mile down the gulch, also thrived.

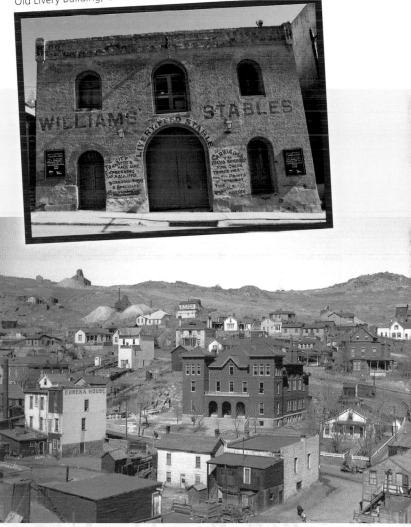

Old Livery Building, Central City.

Central City and Black Hawk

As the gold veins began to play out, the miners had to dig deeper and deeper, and soon the price of extracting and smelting the precious metal surpassed its value. From 1900 onward, the two towns declined. By the late 1980s, their populations had dwindled to a few hundred each, and their major source of revenue was tourism.

Then, in 1990, a state referendum was passed, allowing limited-stakes gambling in Central City, Black Hawk, and nearby Cripple Creek. Casino companies from far and wide descended on both Central City and Black Hawk and began building casinos at an astonishing pace. Despite both towns being part of an official national historic district, before long historic preservation began to take a back seat.

Because of its location along the main highway, the smaller town, Black Hawk, outpaced its sister city. To compete, Central City built the Central City Highway from Interstate 70 to make access easier for travelers coming from the west. But Black Hawk, with its location and less restrictive building codes, continues to dominate, recently opening the thirty-three-story Ameristar Casino Resort Spa.

Central City, 1900. *Denver Public Library, Western History Collection, photo: Harry L. Lake*

Golden

LOCATED AT THE BASE of the Front Range of the Rocky Mountains at the mouth of Clear Creek Canyon, Golden was the perfect jumping off point for miners heading to Black Hawk, Central City, Georgetown, and points beyond. Founded at the beginning of the Pikes Peak gold rush, the mining camp was originally called Golden City in honor of Thomas L. Golden. George Jackson, who suggested the name upon arriving in the fledgling mining camp, nearly died that very day but was saved by Golden when the two were caught in a flashflood. Jackson was a prominent figure in the genesis of the gold rush.

From the beginning, Golden was locked in a battle with its neighbor to the east, Denver, as the two vied for supremacy in the Colorado territory. Railroad politics would be the determining factor in this race, and in the end, Denver won when the first north-south train rolled into that city from Cheyenne, Wyoming, bypassing Golden. Golden would have one railroad success, however: the Colorado Central Railroad passed through the town, provided service into the mountains, and linked Golden to the Kansas Pacific north of Denver.

In 1873, two immigrants from Germany, Adolph Coors and Jacob Schueler, started the still-successful Coors Brewing Company. The Colorado School of Mines, a highly regarded college of engineering and applied sciences, also opened in 1873 in Golden.

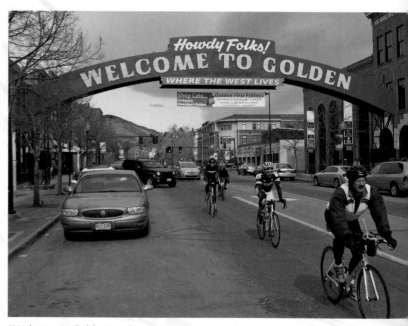

"Welcome to Golden" archway.

22

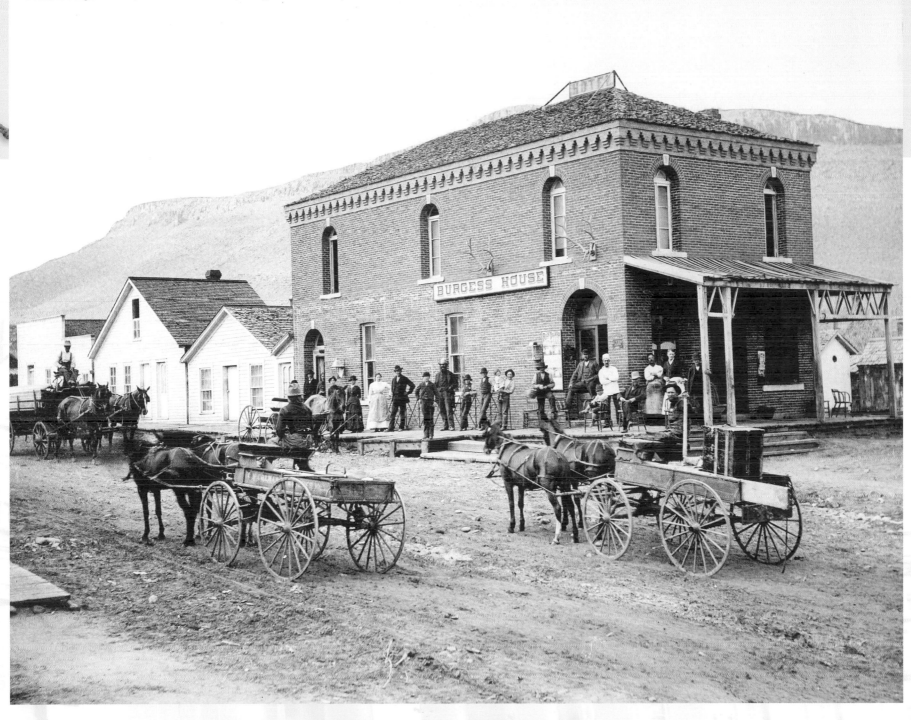

Colorado State University's nationally renowned veterinary school is the go-to facility for difficult-to-diagnose pet and livestock cases.

Fort Collins

Linden Street, 1904. *Fort Collins Museum/Local History Archive*

Fort Collins' growth in the nineteenth and twentieth centuries was not mining related but agriculture based; sugar-beet farming and processing, along with sheep and cattle ranching, formed the town's financial base.

College Avenue at night.

FORT COLLINS IS part of a busy area known as the Front Range corridor, the populous strip of cities along the base of the Front Range that comprises the bulk of Colorado's population, yet the town seems distant from the corridor's hustle and bustle.

Its laid-back attitude, mild climate, tree-lined streets with charming Victorian houses, proximity to mountain recreational opportunities, and a thriving historic center make Fort Collins an ideal place to live and work. Its Old Town has been magnificently preserved and converted into an outdoor pedestrian mall with coffee shops, brewpubs, and retail outlets. Weekend evenings bring out a vibrant mix of locals, from college kids to seniors, who enjoy a night on the town.

High-tech industries and Colorado State University (CSU) dominate the city's economy. The university's expansive campus and classic historic buildings are well worth a look. CSU is a leading research university, specializing in infectious diseases, atmospheric science, clean energy technologies, and environmental science.

Originally known as Camp Collins, Fort Collins was founded as a military outpost on the Cache La Poudre River, just south of the Wyoming line, in 1864. The fort was established during the Indian wars of the 1860s to protect the overland mail route. Pioneers traveling on that route quickly began to settle around the fort, and by 1868, it had become a full-fledged town and the county seat.

The Agricultural College of Colorado, founded in 1870, created a major source of revenue as well. During the twentieth century, as the school grew into Colorado State University, its increasing enrollment and physical expansion fueled Fort Collins' slow but steady growth and became a defining factor in the city's identity.

Right: The Oval and administration building, Colorado State University

Below: Colorado State University Oval. *Fort Collins Museum/Local History Archive*

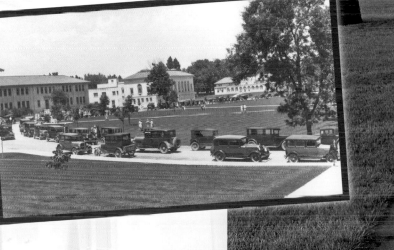

The National Western Stock Show

THE NATIONAL Western Stock Show—known to Denverites as just "the Stock Show"—is the largest livestock show in the world. Stock growers from all over the country converge at the Denver Union Stockyards every January to show off their prize cattle, horses, sheep, and other livestock and to participate in rodeos and a variety of livestock-oriented performance competitions.

The purpose of the first stock show, held in 1906, was "to preserve the western lifestyle by providing a showcase for the agricultural industry through emphasis on education, genetic development, innovative technology and offering the world's largest agricultural marketing opportunities." More than 15,000 stockmen arrived in streetcars, horse-drawn carriages, and special trains to attend.

National Western Stock Show, 1916. *Denver Public Library, Western History Collection*

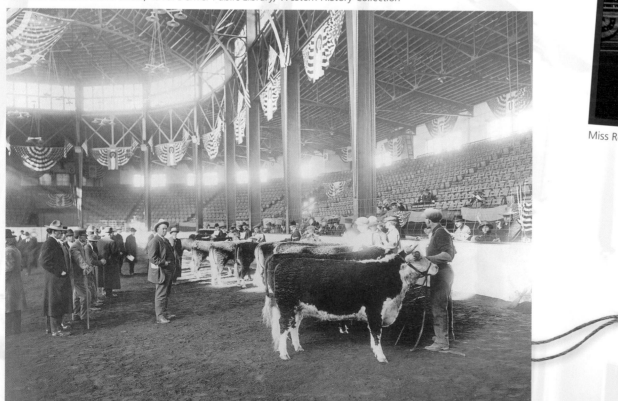

Miss Rodeo America 2010, Kelli Jackson.

Saddle bronc rider.

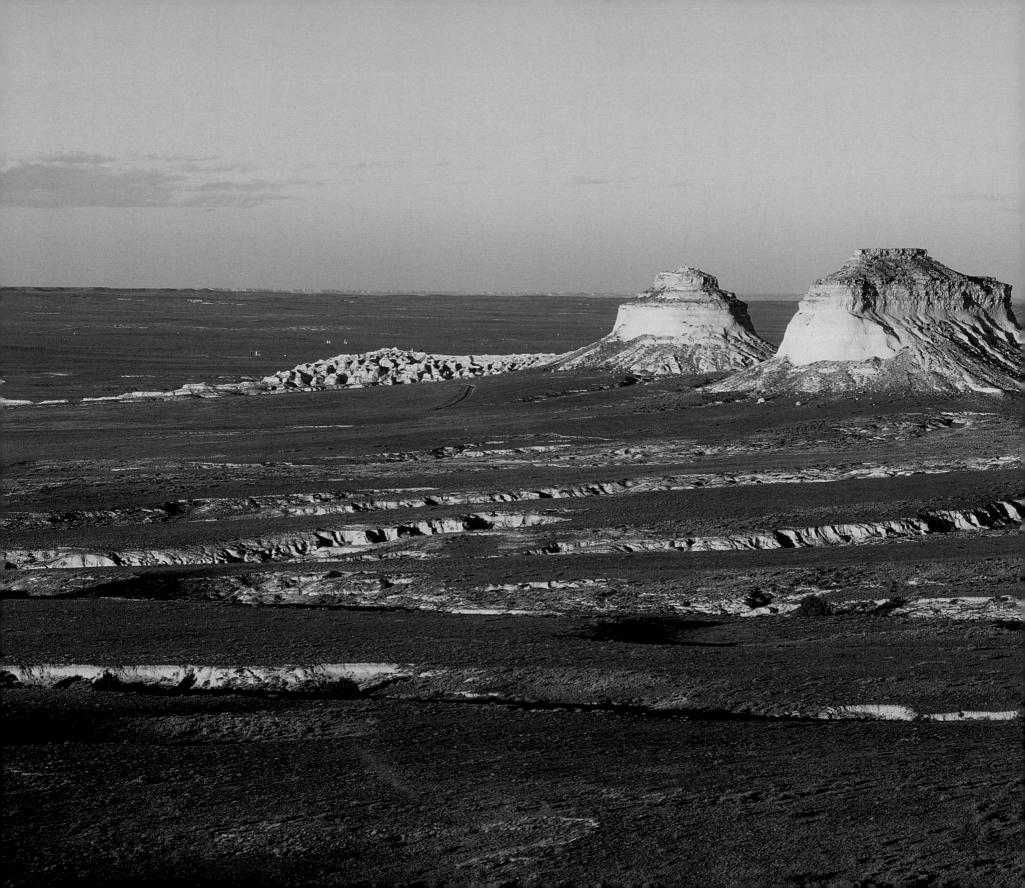

Eastern Plains

"O beautiful, for spacious skies / For amber waves of grain / For purple mountain majesties / Above the fruited plain!" So goes the poem by Katharine Lee Bates, which she wrote during a visit to Colorado in 1893 and which inspired the song "America the Beautiful." The fruited plains are Colorado's own Eastern Plains, the bounteous bread belt of the state, with thousands of acres of wheat, grassland, and other agricultural mainstays. The plains' abundant lakes are destinations for water-sport enthusiasts, and hunters can find all kinds of game here, big and small, including pronghorn antelope, pheasant, ducks, and geese. The Pony Express passed through the plains, and today visitors can experience western history in the various abandoned settlements, emigrant trails, and historic monuments scattered throughout this big-sky country.

Pawnee Buttes, northeastern plains.

FORT MORGAN, a hub of the Eastern Plains, finds its roots early in the history of the territory. The first settlement here was Junction Station, a small outpost at the crossroads of the Overland Trail stagecoach route and its Denver cutoff. The outpost, in the middle of Plains Indian territory, suffered numerous attacks in the early 1860s. It was a turbulent time for relations between whites and Indians on the plains. To protect this important sites from further attacks, the U.S. Army established Camp Junction in 1864.

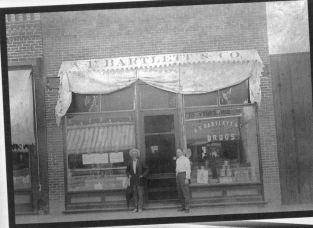

Arthur F. and Phineas Bartlett in front of drugstore.
Denver Public Library, Western History Collection

Fort Morgan

Main Street.

In 1865, a fort was built by Confederate prisoners released in exchange for the promise to fight Indians. It was named Fort Morgan after Colonel Christopher A. Morgan. After the railroad came to Denver in 1870 and the Indian troubles subsided, the fort became unnecessary and was dismantled.

In 1884, Abner S. Baker began an irrigation project. The once-sleepy town of Fort Morgan soon became a vibrant agricultural community, in large part due to the boom in sugar beets, which grew well in Colorado's climate.

Today Fort Morgan is a center of economic activity on the plains, surrounded by productive farmland and ranchland. The area has numerous lakes for hunting and fishing and is in close proximity to the Pawnee National Grasslands and the spectacular Pawnee Buttes. The town itself is a charming amalgam of old and new, with some classic architecture and the famous Rainbow Arch Bridge built in 1923. The Fort Morgan Museum is a good place to learn about the rich history of Fort Morgan and the Eastern Plains.

Dinky train at the Great Western Sugar Factory, 1910s. *Denver Public Library, Western History Collection*

Fort Morgan's Great Western Sugar Factory used a small, narrow-gauge "dinky train" to haul sugar beets around the factory yard.

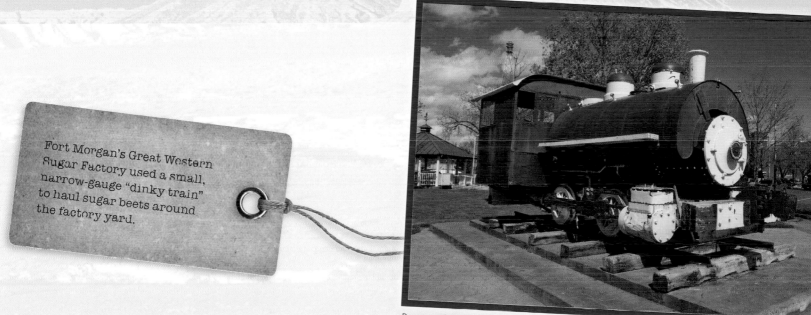

Preserved dinky train in City Park.

Native Americans

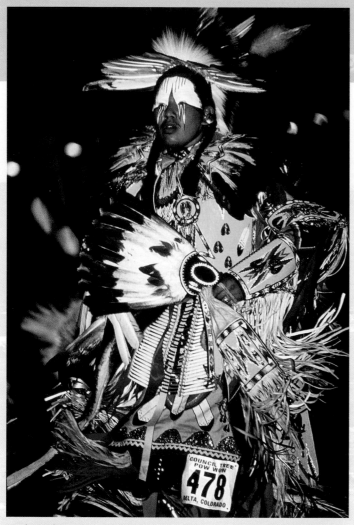

Merle Eaglespeaker, Council Tree Pow Wow and Cultural Festival, Delta, Colorado. *Photo © Kathleen Norris Cook*

Visitors who want to learn about Ute culture while in Colorado can visit the Ute Indian Museum in Montrose.

COLORADO'S ORIGINAL inhabitants reflect the state's diverse landscapes. To the southwest, in the Four Corners area, ancient Puebloan peoples, ancestors of the Zuni and Hopi tribes farther south, lived in cliff dwellings, the ruins of which can be seen today. After drought and pressure from other tribes forced out the Puebloan people, the early Navajo tribe occupied the area. Various bands of the Ute tribe inhabited significant portions of western Colorado, and Plains Indian tribes such as the Cheyenne, Arapahoe, and Shoshone occupied the Eastern Plains. The Ute and Plains Indian tribes bore the brunt of the incoming Spanish conquistadores and subsequent European-American invaders.

By 1859, the quest for gold was bringing the white settlers to Colorado in droves. The settlers crossed Indian lands, conflict was the inevitable result, and soon the federal government was pressured to take control of the situation. In 1861, the Treaty of Fort Wise forced the Cheyenne and Arapahoe tribes onto a relatively small reservation in southeastern Colorado. Not all tribal members complied, however, and ongoing conflict culminated in the tragic 1864 Sand Creek Massacre (see pages 40-41).

By 1867, the government had sufficiently subdued the Plains tribes, and the southern Cheyenne and Arapahoe were relocated to a reservation in Oklahoma. In 1868, the Utes were coerced into signing a treaty that reduced their territory to the western third of modern Colorado, mostly west of the Continental Divide. In 1874, the Utes were again pressured to cede their lands to white interests and sign the Treaty of Brunot, which gave the San Juan region to the U.S. government and further restricted the tribe's movements. The Meeker Massacre, precipitated by Indian agent Nathaniel Meeker (the idealistic founder of Greeley; see page 39) in 1879, gave the government a final excuse to move the Utes to Utah and southern Colorado.

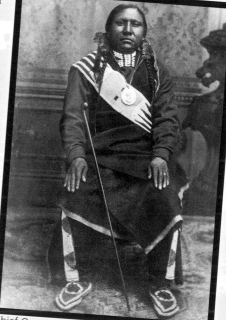

Chief Ouray of the Uncompahgre Utes, 1870s. *Denver Public Library, Western History Collection, photo: William Henry Jackson*

Today, the only Indian reservations in Colorado are the Southern Ute Reservation and the Ute Mountain Reservation. The Southern Ute Reservation runs the Sky Ute Casino in its capital, Ignacio, and also owns several gas and oil investment and production companies. The Utes celebrate their culture in numerous festivals throughout the year, including the Council Tree Pow Wow and Cultural Festival in Delta and the Bear Dance in Ignacio.

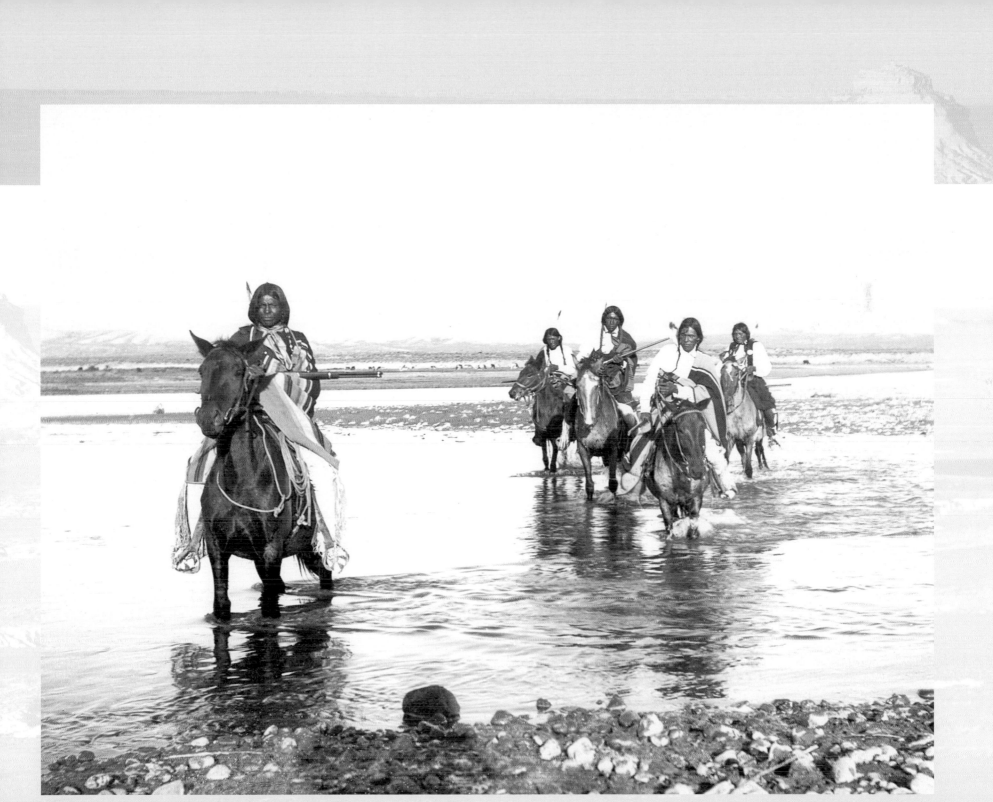

Ute Indians on horseback, crossing the Gunnison River, 1873. *Loyd Files Research Library*

Vineyards, found in Paonia and down to the Grand Valley, are a recent Colorado agricultural development. Colorado's warm days and cool nights make excellent conditions for growing wine grapes, and though winemaking is still a small industry, the state is acquiring a reputation for critically acclaimed wines.

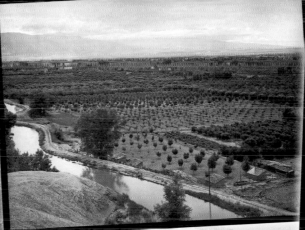

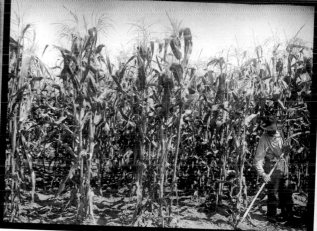

Agriculture

LIKE MANY western states, Colorado's agricultural history is largely defined by water access. Unlike many other western states, however, Colorado's boundaries hold numerous mountain ranges with rivers and streams that can tapped for irrigation. And in the relatively dry and arid mountain west, irrigation is the key.

Colorado's ditch irrigation system began with the construction of the San Luis People's Ditch in 1852 and the Union Colony canal/irrigation system in 1869, and it now runs throughout the state. The right to divert, store, and use water quickly became a complex and important legal issue, one based on the "first in use, first in right" prior-appropriation doctrine outlined in the state constitution.

For a state where high-altitude, mountainous terrain predominates, Colorado's agricultural regions are surprisingly diverse. The largest is the vast Eastern Plains, where agriculture drives the economy. Here the principal crops are wheat, corn, and sugar beets, and cattle production thrives in the less arable areas. To the west, in the desertlike Grand Valley, orchards with peaches, apples, and pears fill the landscape. Farther north, around Delta and Olathe and up to Paonia, corn gives way again to fruit orchards and organic farms.

Stone Cottage Vineyards, Paonia.

So important are the legalities of water access that Colorado has a specific judicial branch, called the Water Courts, dedicated solely to dealing with them.

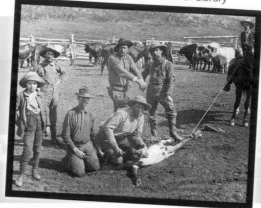

Ranching

COLORADO'S RANCHING HISTORY begins not long after the 1859 gold rush when ranchers saw potential markets in the growing population on the Front Range. With the arrival of the railroads, they also saw a means to transport cattle to the populous East Coast. By 1864–1865, drovers began moving large herds north from Texas, ushering in the heyday of the big cattle drives.

This was the time of the classic cowboy—the long-range cattle drover who was the hero of countless books and movies, the independent cowhand who braved weather, stampedes, Indians, and countless hours in the saddle alone on the wide-open prairie.

Eventually, the cattlemen began to settle on the Colorado prairie, and the cattle barons of the Eastern Plains carved out huge ranches with thousands of heads of livestock. Cattle brands were developed to keep track of the various outfits' cattle on the unfenced land, and huge roundups were done twice a year. Gradually, farming claimed its share of land, and irrigation ditches and fences of barbed wire subdivided the open range.

Large ranches still exist on the Eastern Plains, and ranching is also common in the rest of the state. Ranches and grazing lands can be found everywhere, from the valley bottoms to high mountain meadows, from the lush, rolling pastures near Steamboat Springs to the high, windswept valley of South Park.

Right: Modern cowboy checking cattle, Wet Mountain Valley.

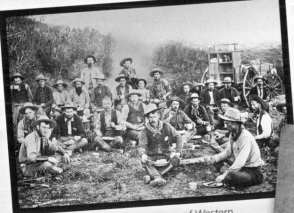

Cowboys at dinner, 1890s. *Museum of Western Colorado, Loyd Files Library*

Most people think of mountains when they think of Colorado, but the state's vast Eastern Plains make up almost half its landmass.

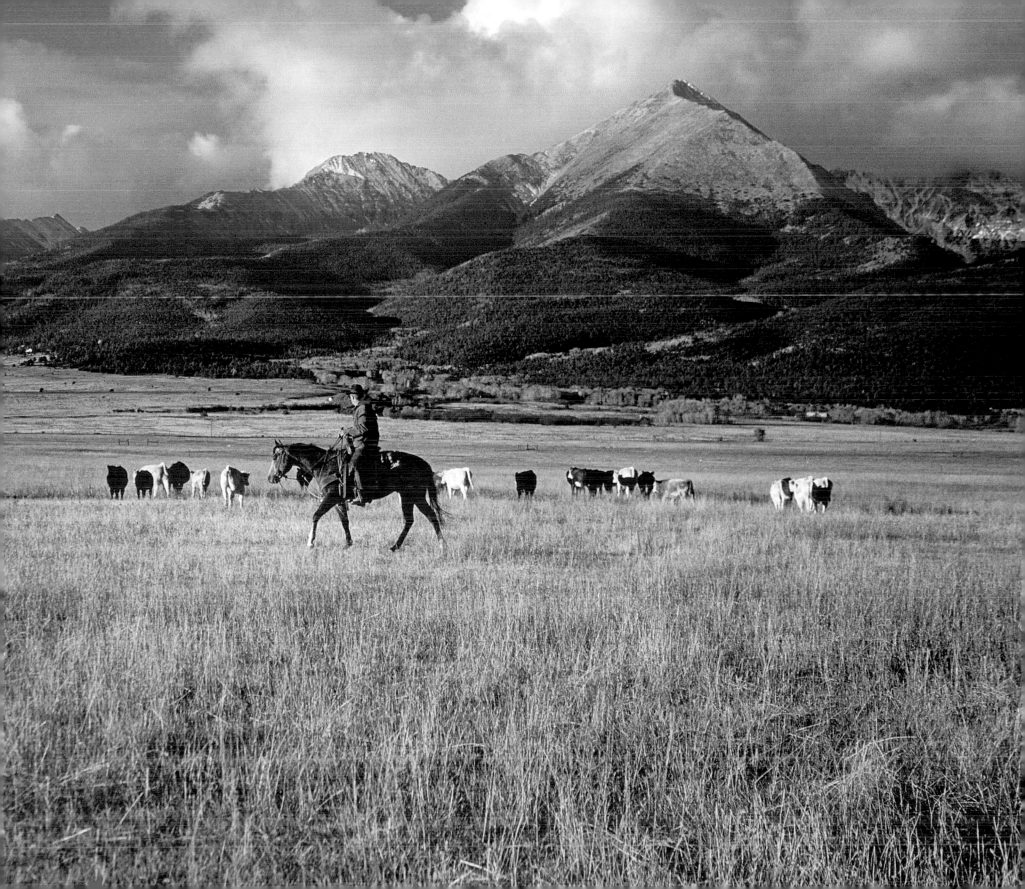

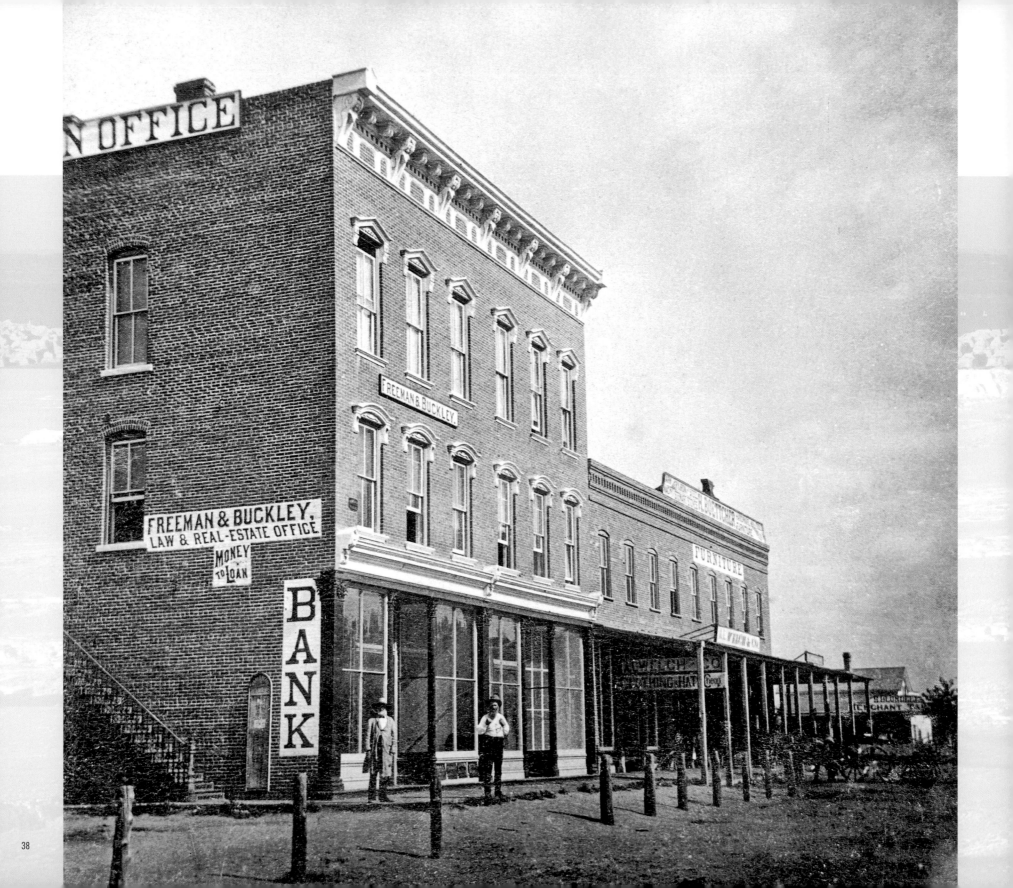

Greeley's Stampede Days Rodeo is the largest Fourth of July rodeo in the nation.

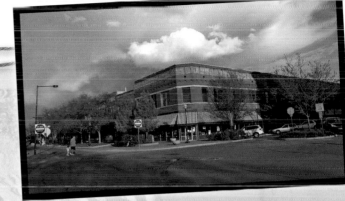

Downtown Greeley.

Greeley

UNIQUE AMONG Colorado towns, Greeley began as an experimental utopian community called Union Colony in 1869. Founder Nathan Meeker, a newspaper writer/editor from New York City, worked for Horace Greeley of the *New York Tribune*, which at the time was America's largest and most widely read newspaper. Greeley was heavily involved with homesteading issues and eager to convince people to resettle out west. He is famous for the phrase, "Go West, young man."

And at Horace Greeley's behest, go West is what Meeker did, originally to report for the newspaper about the new territories. Having lived in a utopian community in Ohio, he then presented Greeley with the idea of forming the same type of community in the Colorado territory. Greeley immediately jumped on the idea. Union Colony's utopian ideals were temperance, religion, agriculture, education and family values. The site for the colony was well chosen, located as it was between the Cache La Poudre and South Platte Rivers (perfect for irrigation purposes), and half way between Cheyenne and Denver along the tracks of the Denver Pacific Railroad. An important stagecoach station on the Overland Trail at Latham also brought visitors. The community quickly caught on, and by 1870, more than a thousand members were farming on its 12,000 acres.

Over the years Greeley has grown steadily and remained a primarily agricultural-based community with numerous grain, corn, and meat processing plants as well as other agribusiness-related industries located here.

Home of Nathan Meeker, Greeley founder.

Opposite: Downtown Greeley, circa 1880. *Denver Public Library, Western History Collection*

Sand Creek Massacre National Historic Site

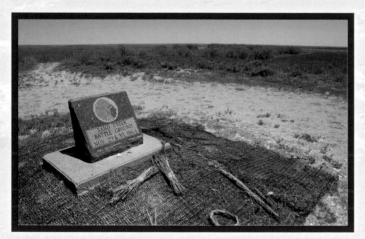
Site marker above Sand Creek.

The Sand Creek Massacre National Historic Site opened to the public in 2007.

IN JULY 1864, a force headed by Lieutenant George S. Eayre of the First Colorado Cavalry encountered a Cheyenne hunting camp at Ash Creek. Despite friendly gestures by tribal chiefs Lean Bear and Star, Eayre shot and killed them both.

The murders touched off a war of retaliation that led to the killing of a family of settlers, the Hungates, as well as livestock raids. In order to protect his people, Chief Black Kettle of the Southern Cheyenne, along with some Arapahoes lead by Chief Left Hand, moved his people to Fort Lyons at the request of territorial governor John Evans. Their resulting peace treaty was agreed to that September at Fort Weld, near Denver. Black Kettle and his fellow chiefs then moved their people back to Sand Creek, in southeastern Colorado, secure in the assumption that they would not be attacked.

Meanwhile, Evans was authorized by the federal government to establish the Third Colorado Cavalry, led by an ambitious—and, some would say, arrogant—Colonel John Chivington, to fend off raiding Indians. But rather than attacking the more troublesome Indians, Chivington chose to attack the peaceful encampment at Sand Creek. On November 29, 1864, with some 700 horsemen and artillery, he descended on the unwitting and unprepared band, killing and mutilating around 170 people, most of whom were women and children. The majority of warriors had been sent away to hunt, thinking that the camp was secure. Though some in the U.S. government approved of the raid, many, including the famous Kit Carson, called the act an abomination.

Today, the lonely site of the massacre is preserved by the U.S. National Park Service as a National Historic Site. Visitors can walk a trail to an overlook of the creek, where interpretive panels tell about the massacre.

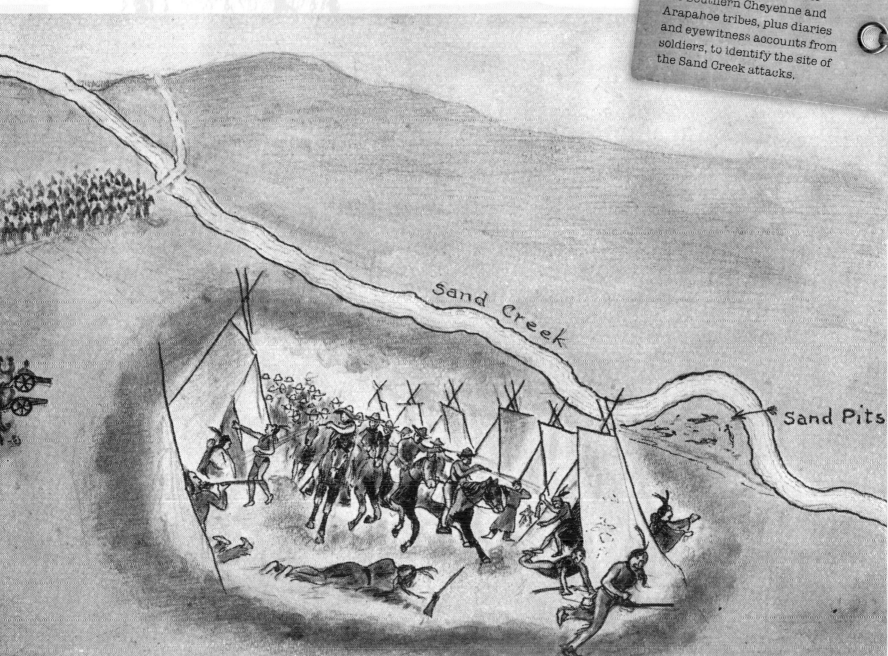

Sand Creek

Sand Pits

Drawing depicting the Sand Creek Massacre, 1860s. *Denver Public Library, Western History Collection*

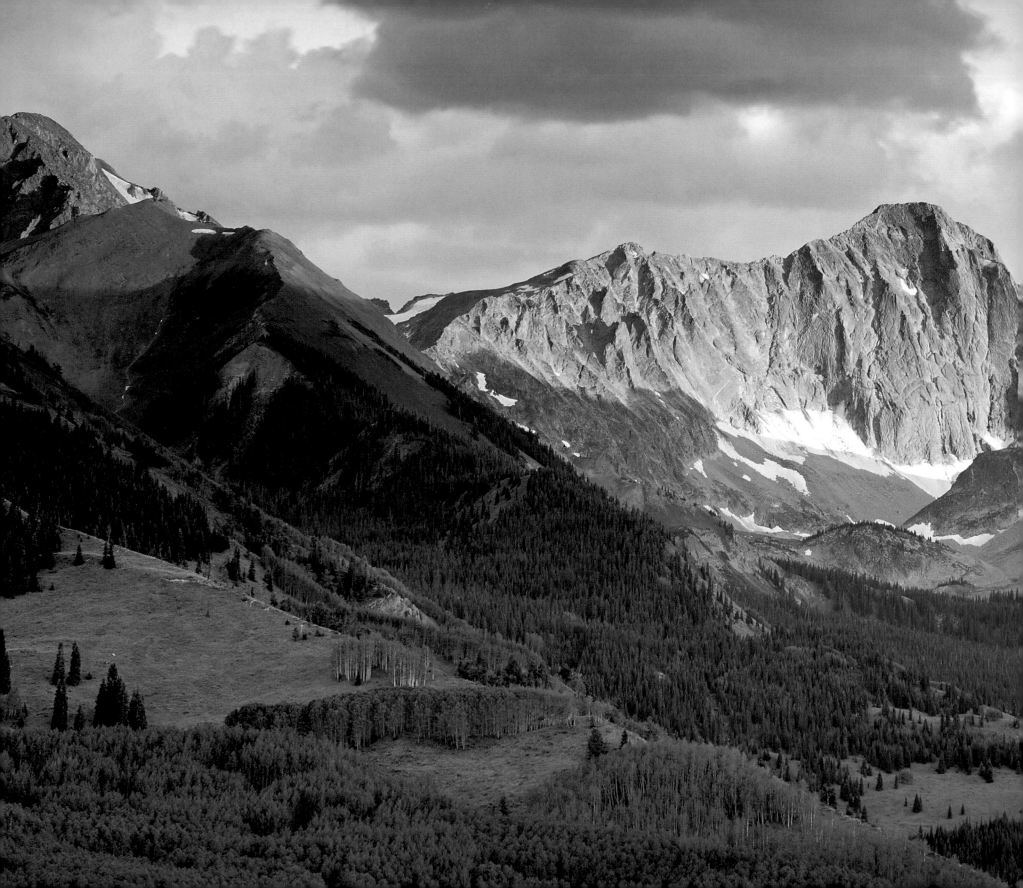

Central and Northern Mountains

The central and northern mountains are not just the heart of Colorado's ski country, but they are also the hub of year-round outdoor recreational activities. Premier skiing, mountain biking, hiking, fishing, hunting, climbing—it's all here in abundance, along with quaint former mining towns, such as Breckenridge, Aspen, Leadville, and Georgetown. Stunning scenery and fascinating history can be found everywhere, from the Georgetown Loop Railroad to the hot springs of Glenwood Springs and the grand jewel of Colorado's national parks, Rocky Mountain National Park. Much of the northern mountains can be accessed via the main east-west artery through Colorado, Interstate 70, and that easy access makes this region popular with weekend warriors from Denver and the Front Range. The area is a gold mine for visitors wanting to experience the beauty of Colorado's mountains in a short span of time.

Capitol Peak, Maroon Bells–Snowmass Wilderness.

Hunting

WITH THOUSANDS of acres of pristine wilderness, Colorado is an outdoor sportsman's paradise. Hunting in Colorado attracts enthusiasts from far and wide. The mountains are rich with trophy-quality elk, white-tailed deer, mule deer, and moose. Intrepid big-game hunters also seek bear, Rocky Mountain bighorn, mountain goat, and mountain lion on the rugged slopes.

Colorado's high plains abound with game as well. Numerous pronghorn inhabit the vast plains, as well as whitetails and muleys and even some elk. For small game, Colorado offers excellent hunting for grouse, prairie chicken, and turkey. The prairie's lakes and wetlands are host to a wealth of duck, geese, and other waterfowl.

Before the arrival of white settlers, Native Americans hunted the huge buffalo herds that roamed the plains. Game was sustenance. Hunting is a fundamental part of Colorado's heritage. The abundance of wilderness, parks, and national forests, particularly in the mountainous regions, has preserved a haven for wildlife, making Colorado one of the finest hunting destinations in the country.

Top hats made of felted beaver fur were once all the rage, allowing Colorado's mountain men in the early nineteenth century to make a living trapping beaver and selling pelts for as much as $5.99 per pound.

The big draw for hunters in Colorado is elk. The sheer number of elk in the mountains provides excellent odds of getting a bull of trophy proportions.

Hunter with bull elk, near Craig. *Photograph © Dennis Flaherty*

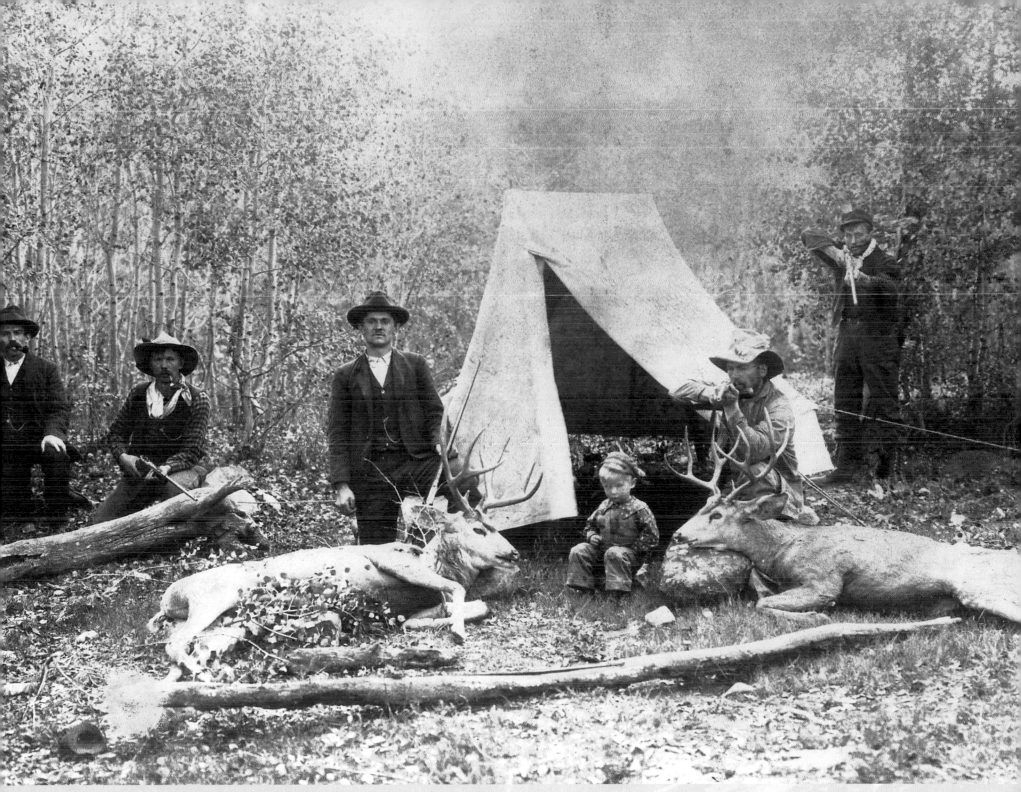

Hunting party with bucks near Crested Butte, 1890s. *Crested Butte Mountain Heritage Museum*

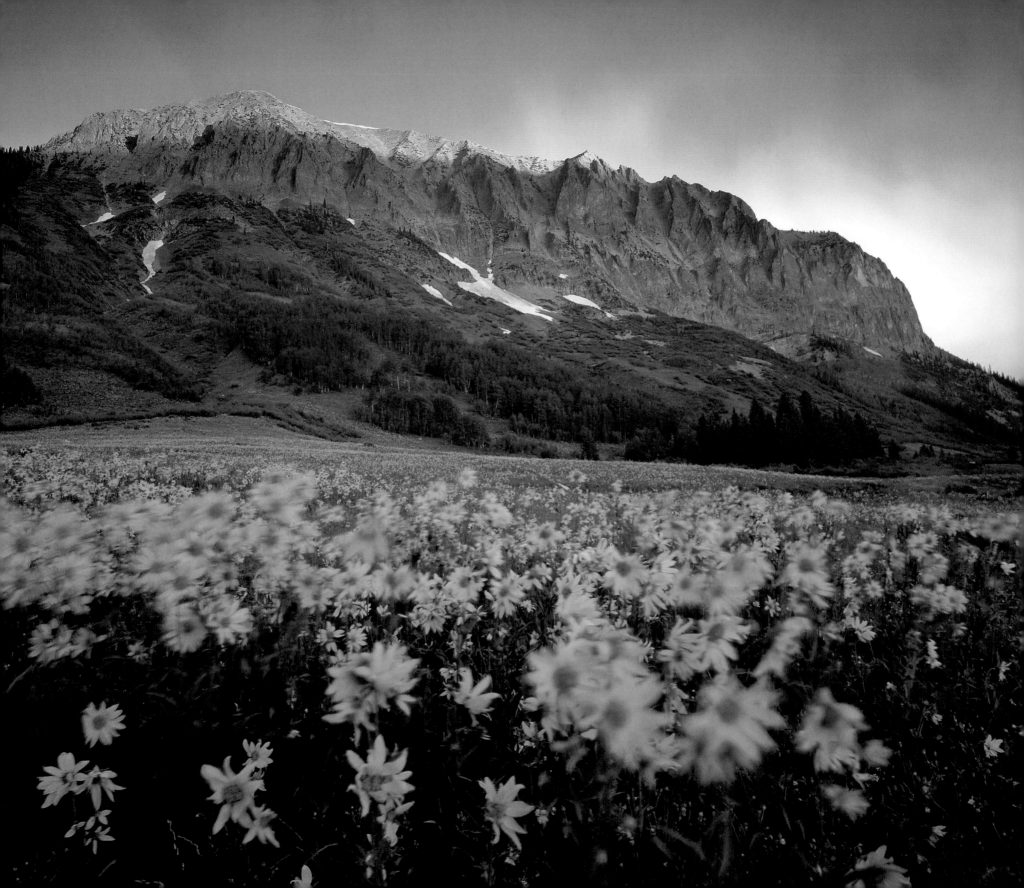

Mt. Toll from Blue Lake, Roosevelt National Forest.

The Rocky Mountains

THE ROCKY MOUNTAINS, which make up about 40 percent of Colorado's landmass, are a nature lover's paradise, offering stunning mountain vistas, crystal clear rivers and lakes, high valley meadows, summer wildflowers, golden fall aspen, and charming old mining towns. Whether you're in search of a Fourteener to climb, a fly-fishing stream, a scenic road, a ski run with fine powder, or river rapids for rafting, Colorado's Rocky Mountains have something for every outdoor enthusiast.

The Rockies were formed by uplift in the earth's crust about seventy million years ago, and since then the elements have sculpted them into dramatic peaks and valleys. Colorado's portion of the Rockies is the highest in the whole range. The highest mountain is Mt. Elbert, with an elevation of 14,440 feet. The Continental Divide, which is the dividing line between waters that flow to the Pacific Ocean and those that flow to the Atlantic Ocean, is part of the Colorado Rockies.

Native Americans probably started inhabiting the Rockies about 13,000 years ago. The first European explorer to arrive in the Colorado Rockies was Fernando Cortez in 1540, followed by French fur traders Pierre and Paul Mallet in 1739. In 1806, Zebulon Pike led an expedition to the southwest and discovered Pikes Peak and the Front Range.

Opposite: Gothic Mountain, Gunnison National Forest.

Natural deadfall near the Mountain of the Holy Cross, 1873. Denver Public Library, Western History Collection, photo: William Henry Jackson

Rocky Mountain National Park

Right: Hallett Peak from Sprague Lake.

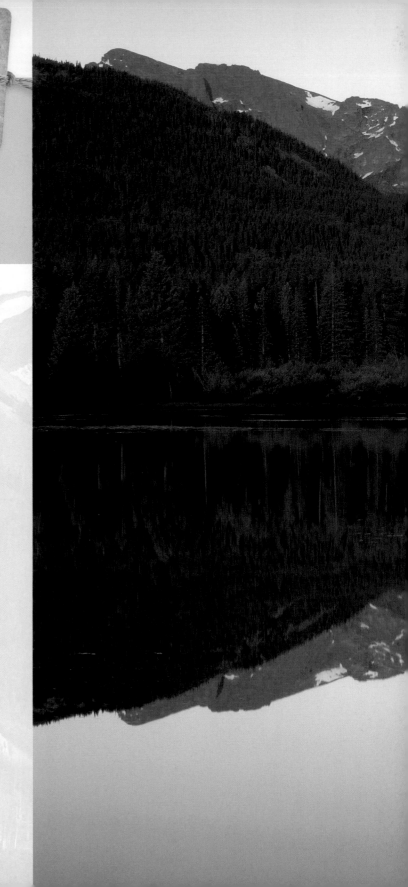

THE VALLEY that composes the main, eastern entry to Rocky Mountain National Park was originally ranched by Joel Estes as early as 1859. Although he abandoned raising cattle here due to the harsh winters, the valley and town that eventually occupied his space became known as Estes Park. Tourists interested in climbing the peaks in this area began arriving in the 1860s.

Known as the father of Rocky Mountain National Park, Enos Mills moved to Estes Park as an adolescent and explored the region and other mountainous parts of the West extensively as a young man. After meeting naturalist John Muir on a San Francisco beach in 1889, Mills decided to dedicate his life to promoting nature conservation through writing and lecturing. Aided by such diverse groups as the Sierra Club and the Daughters of the American Revolution, he succeeded in convincing the powers that be in Washington, D.C., to pass legislation creating Rocky Mountain National Park in 1915.

One of the more popular destinations within the park is Trail Ridge Road. Built between 1926 and 1932, the road's eight miles climb to over 11,000 feet, peaking at 12,183 feet and traversing above tree line. The views of the surrounding peaks, canyons, and tundra are spectacular.

Near the entrance of the park are Sprague Lake and Bear Lake, popular hiking destinations with great views of flat-topped Hallet Peak. Longs Peak is perhaps the centerpiece of the park and is visible from many vantage points, even from the Eastern Plains below. At 14,259 feet, it is extremely popular with climbers year round.

Many visitors come to the park for wildlife viewing. Elk, bighorn sheep, mule deer, moose, black bears, cougars, and coyotes, as well as many smaller furry critters and a variety of birds, make their homes within the park's boundaries.

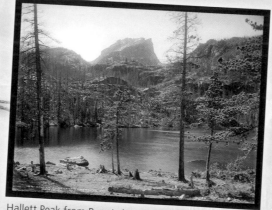

Hallett Peak from Bear Lake, 1908. *Denver Public Library, Western History Collection, photo: L. C. McClure*

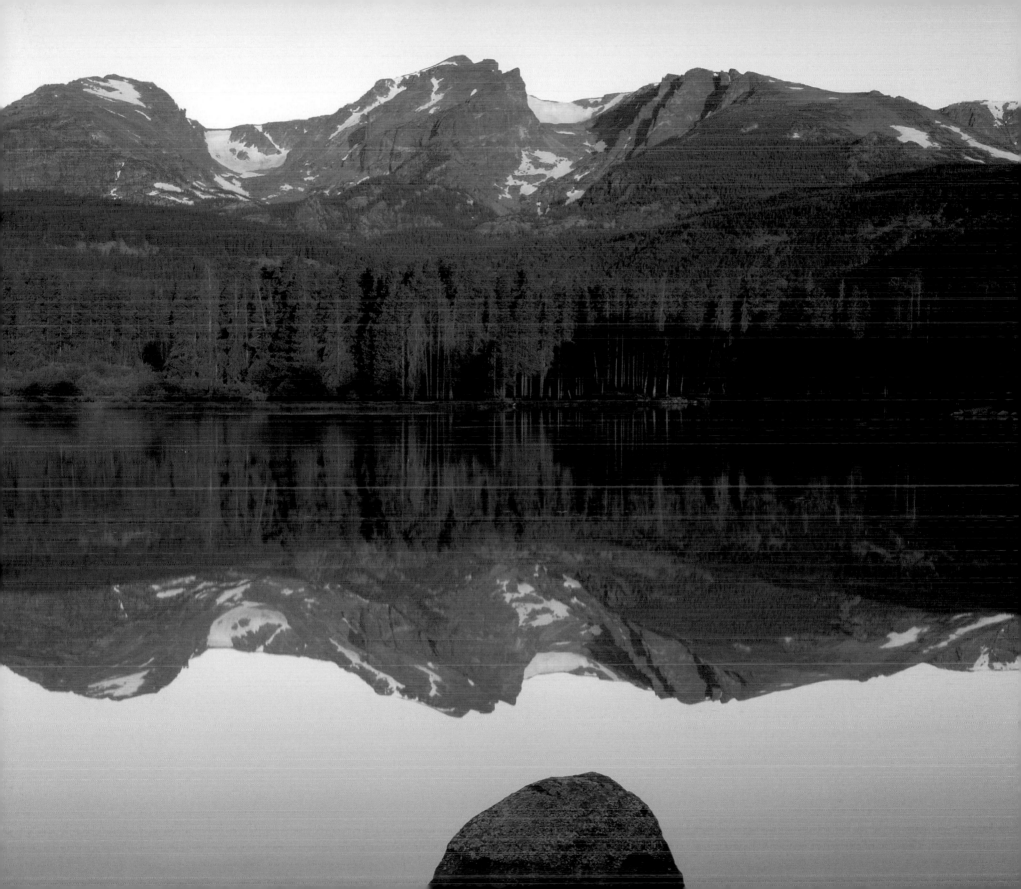

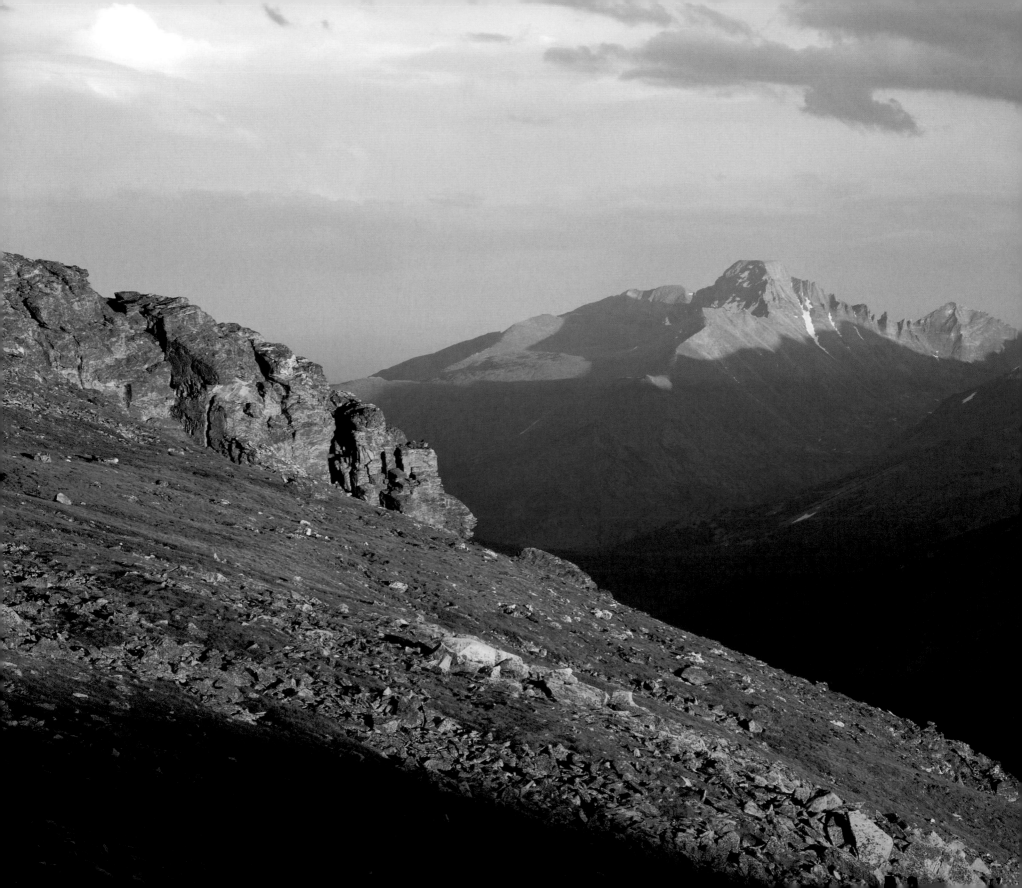

Left: Hikers in the boulder fields at the base of Longs Peak, 1880s. *Denver Public Library, Western History Collection, photo: William Henry Jackson*

Opposite: Longs Peak.

The precipitous east face of Longs Peak, known as the Diamond, is popular with rock climbers.

During the summer, hikers tackling Longs Peak are advised to leave before dawn, to avoid the dangerous lightning of afternoon thunderstorms.

Longs Peak

LONGS PEAK, at an altitude of 14,259 feet, is perhaps the most famous of all of Colorado's fifty-four Fourteeners, or peaks over 14,000 feet. A prominent feature in Colorado's Front Range, it can be seen from a great distance on the Eastern Plains, including from Denver and the city whose name echoes the peak, Longmont.

The peak is named after Major Stephen Long, who, when leading an expedition here in 1820, became the first white man to view the peak. It was first climbed by an expedition team lead by Major John Wesley Powell in 1868. The peak soon became popular with adventurers and mountain climbers, and in 1885, at the age of fifteen, Enos Mills, the father of Rocky Mountain National Park, climbed the peak for the first time—a climb that forever changed the young man's life (see page 48).

The easiest trails ascending Longs Peak include East Longs Peak Trail, Longs Peak Trail, Keyhole Route, and Shelf Trail. The hike from the Keyhole trailhead to the summit is seven and a half miles one way.

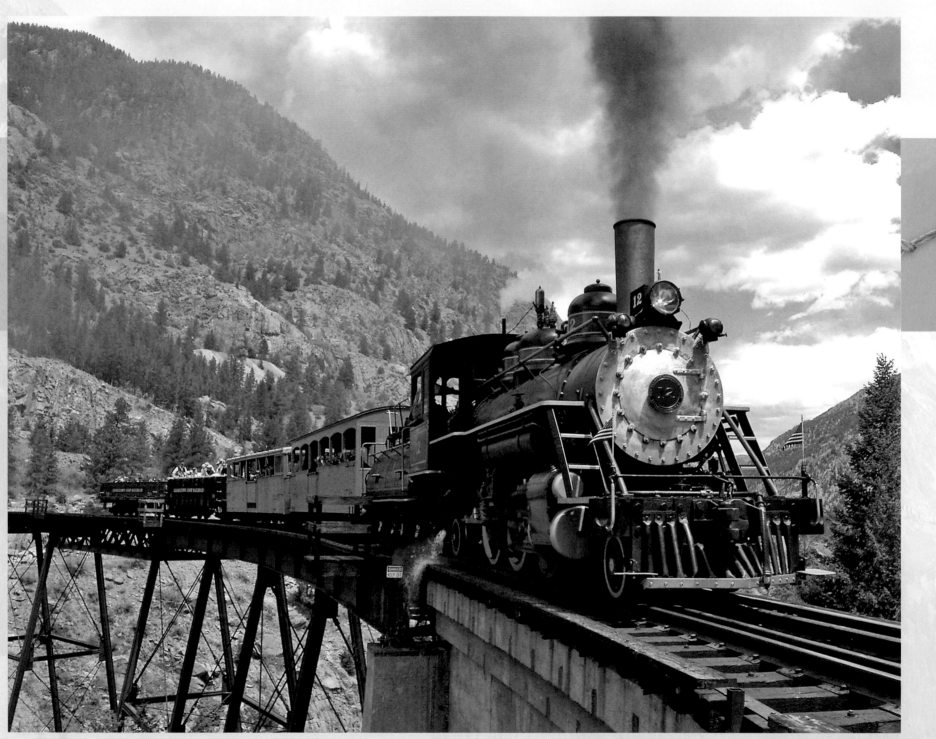

Georgetown Loop Railroad. *Photo © Gary Haines*

Sixth Street, Georgetown.

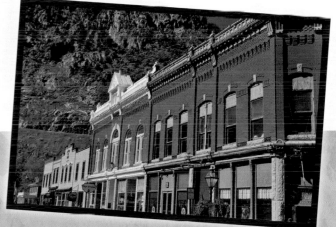

Along its route, the Georgetown Loop Railroad passes both over and under Devil's Gate High Bridge. Its route contains three hairpin curves, four bridges, and a 30-degree horseshoe curve.

Sixth Street, Georgetown.

Georgetown and the Georgetown Loop Railroad

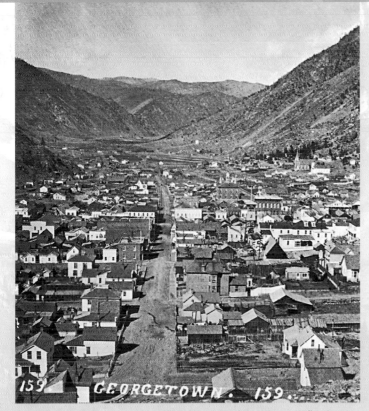

Georgetown, 1880s. *Denver Public Library, Western History Collection, photo: J. Collier*

THE HISTORIC MINING community of Georgetown sits in a narrow valley floor near the upper end of Clear Creek in the mountains west of Denver. Two prospectors from Kentucky, George and David Griffith, founded the town during the Pikes Peak gold rush. But it was the discovery of silver about eight miles away in 1864 that precipitated the real boom, and the town grew rapidly in the succeeding years, becoming a major center for commerce, mining supplies, and entertainment.

In the 1870s, the Colorado Central Railroad reached the town, further increasing Georgetown's prominence in the area. During the peak of the 1880s silver boom, Georgetown's population was as high as 10,000, and it rivaled Leadville for the title of mining capital of Colorado.

As it did for many mining towns, the end of the silver boom signaled Georgetown's demise as a commercial center, and the town languished for many years. But as tourism in the Rocky Mountains has increased, Georgetown's location along Interstate 70 has become a boon, bringing visitors to its historic sidewalks and gift shops. The town's charming and exquisite Victorian brick buildings have been well preserved and provide a fascinating glimpse of the architecture of the mining era.

Visitors also come to Georgetown to ride the historic narrow-gauge railway that has been preserved between here and Silver Plume, four and a half miles away. The Georgetown Loop Railroad curves its way up a steep, narrow mountain canyon, offering both spectacular views and a reminder of Georgetown's historic past.

Georgetown was named after George Griffith, the eldest of the two brothers who founded it.

FOR MANY people, the terms *skiing* and *Aspen* are synonymous. The sport came to the town when Friedl Pfeifer, a member of the U.S. Army's Tenth Mountain Division (see pages 74-75), partnered with industrialist Walter Paepcke and his wife, Elizabeth, to transform Aspen into Colorado's first major ski area in 1946. The area and its prominence as a skiing mecca grew with the addition of three more ski areas: Buttermilk (1958), Aspen Highlands (1958), and Snowmass (1969).

Aspen

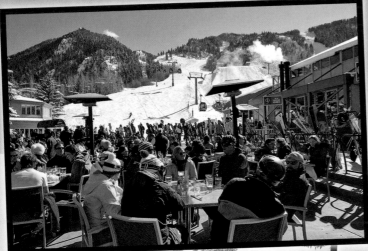

Skiers on the patio at the base area of Aspen Mountain.

Scooters in downtown Aspen.

Originally named Ute City for the Indians who had previously lived and hunted here, Aspen was founded in 1879 by a group of prospectors who discovered one of the biggest silver lodes the world had seen at that time. The town's fortunes grew quickly, and by 1893, it had surpassed even Leadville in silver production. The burgeoning town of 12,000 had banks, theaters, and an opera house, all built in the Victorian architecture of the day. The repeal of the Sherman Silver Act in 1893 and the subsequent plummet in silver prices devastated Aspen's economy. Although mining in the area continued, by 1930 Aspen's population was down to a paltry 705 before the town was reborn as a skiing and tourist destination.

Today, Aspen is known as a playground for the rich and famous, many of whom own second or third homes here. The town still manages to maintain its historic character, despite the facts that its nineteenth-century buildings now serve as homes for purveyors of upscale jewelry, furs, and handbags.

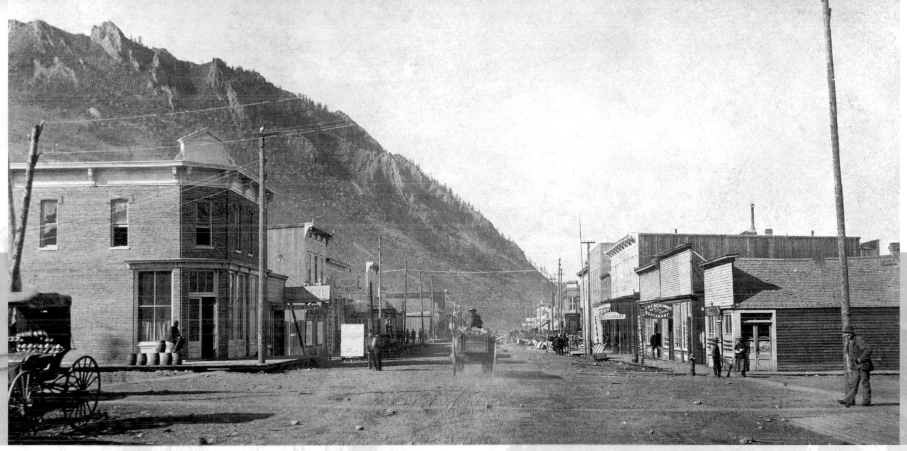

Above: Aspen, 1886. Denver Public Library, Western History Collection

Below: Hyman Avenue, 1888. Denver Public Library, Western History Collection

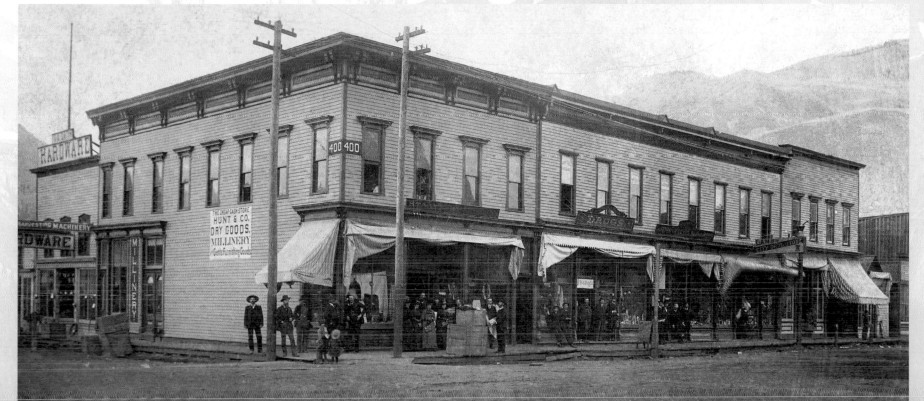

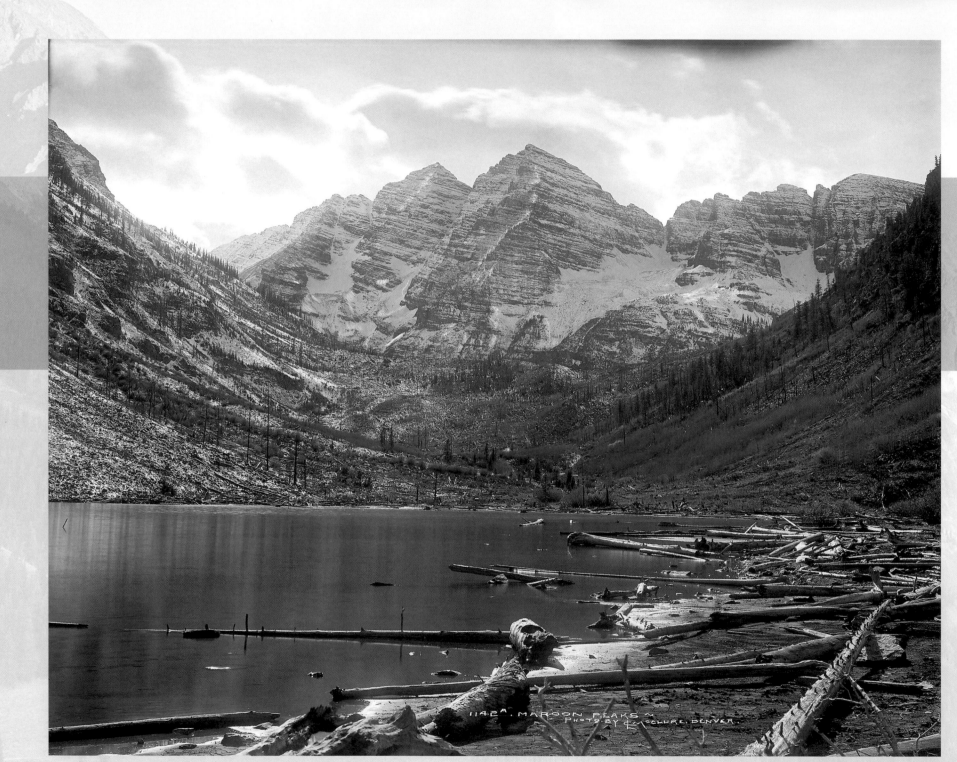

The Maroon Bells, 1890s. *Denver Public Library, Western History Collection, photo: L. C. McClure*

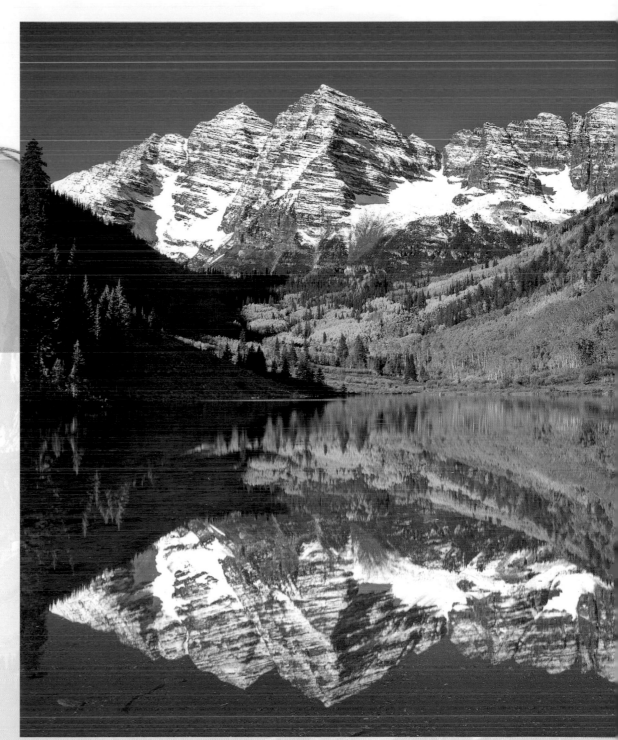

The first recorded ascent of Maroon Peak was by Percy Hagerman and Harold Clark in August 1908. The first ski descent of the peak was by Fritz Stammberger, a German skier and mountaineer, in June 1971.

The Maroon Bells

NAMED FOR their distinctive maroon color, the Maroon Bells are probably the most photographed mountain in Colorado. The mountain is actually made up of two peaks: Maroon Peak (14,156 feet) and North Maroon Peak (14,014 feet).

The Bells are located near the resort town of Aspen, and the road to the trailhead and viewpoint at Maroon Lake are so popular that traffic to them is regulated by the U.S. Forest Service in the summer months. A regular shuttle bus transports sightseers and hikers to and from the base of Maroon Creek Road and Maroon Lake. Because of the aspen trees at the base of the Maroon Bells, the view of it is especially beautiful in the fall. Combined with stunning Maroon Lake in the foreground, it is easy to see why it is such a popular spot for photographers.

Many climbers have been killed on the Maroon Bells, including eight people in 1965, which gave the mountain the moniker "The Deadly Bells."

The Maroon Bells reflecting in Maroon Lake.

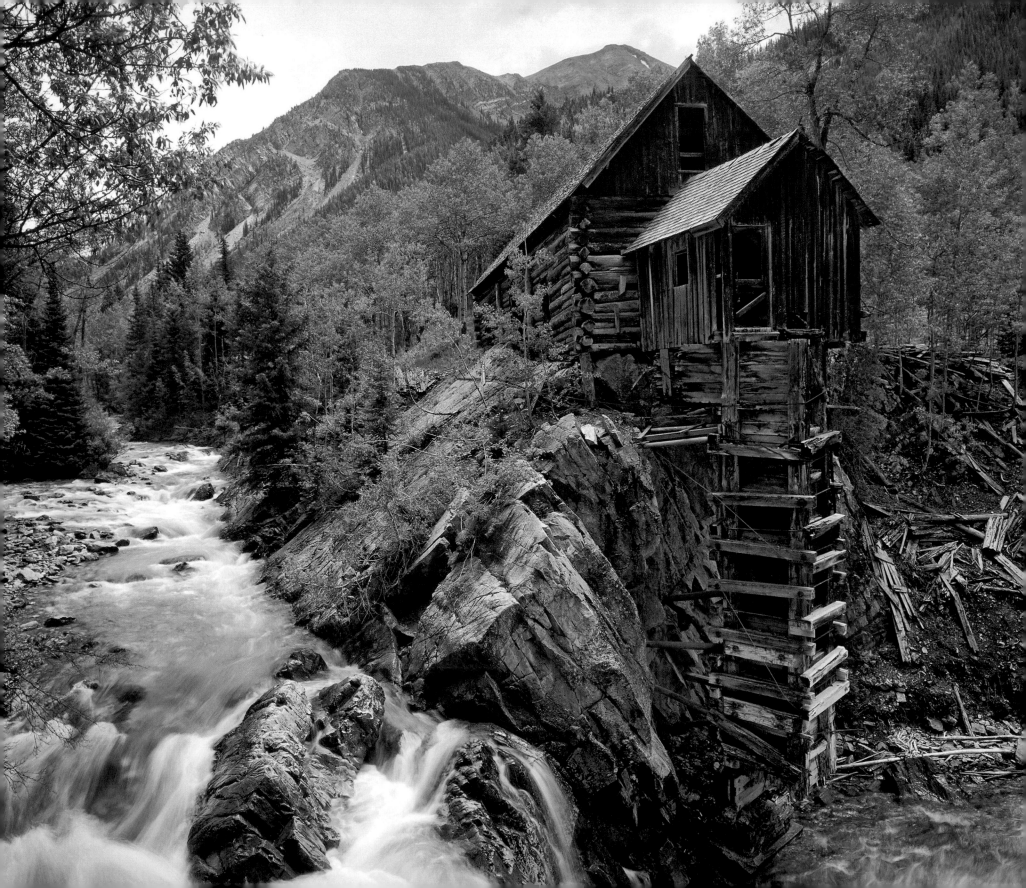

The Crystal Mill

A WELL-KNOWN SYMBOL of Colorado's mining days, the Crystal Mill is one of the most photographed historic sites in Colorado. It was built in 1893 and harnessed the hydraulic power of the river as the water fell over a manmade waterfall to power an air compressor. The huge compressor-powered drills bored holes in nearby mines, into which miners placed dynamite.

At the time, Crystal was a bustling silver mining town complete with hotels, a pool hall, and two newspapers. After the 1893 silver crash, the town's fortunes fell. Fewer than ten people lived there by 1915, and the mill was shut down in 1917.

Crystal is now essentially a ghost town, located on a popular four-wheel-drive road between the towns of Marble and Crested Butte, just six miles east of Marble.

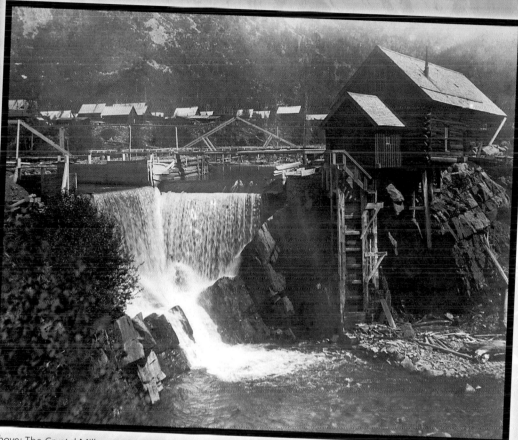

Above: The Crystal Mill powerhouse the year it was built, 1893. *Denver Public Library, Western History Collection*
Opposite: The Crystal Mill today.

The Crystal Mill was originally called the Sheep Mountain Power House.

The Crystal Mill has been preserved by Aspen and Gunnison historical societies.

Marble

THE TOWN of Marble was established by prospectors filtering over Schofield Pass from Crested Butte and Gothic. But the aptly named town became famous not for gold or silver, but for high-quality white marble. John Osgood brought a large block of marble quarried from here in 1882 to the 1893 World Columbian Exposition in Chicago, creating sufficient interest for the town to acquire a nationwide reputation.

In 1906, the Colorado Yule Marble Company leased the Crystal River Railroad from Carbondale to Placita and built a spur into Marble. The company also built a huge finishing mill, where the quarried marble was carved and processed to order on site. The mill measured 150 by 1,700 feet.

By 1915, Marble's population had grown to 1,500, and the town was home to numerous businesses. The advent of World War I devastated the market for marble. Additionally, most of the Italian stone workers who made up the majority of the mill's employees were conscripted into the Italian army and forced to return home. This ruinous blow brought the population of Marble to fifty souls. By 1943, the tracks were taken up and machinery sold for scrap.

Marble today is mostly a scenic little hideaway for second home (or cabin) owners and has about 125 permanent residents. The mill reopened in 1990. Acquired in 2004 by Polycor, a Canadian-based company, it has lately enjoyed an upsurge in business, exporting large quantities of marble worldwide.

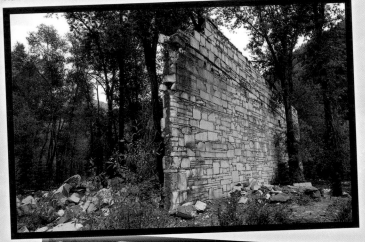
Ruins of the old mill at Marble.

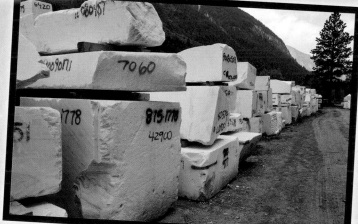
Blocks of new marble from Marble's reopened quarry.

The quarry at Marble provided marble for such famous projects as the Tomb of the Unknowns at Arlington National Cemetery and parts of the Lincoln Monument.

Colorado's state government was one of the Marble quarry's first customers, using the marble for the interior of the capitol building in Denver.

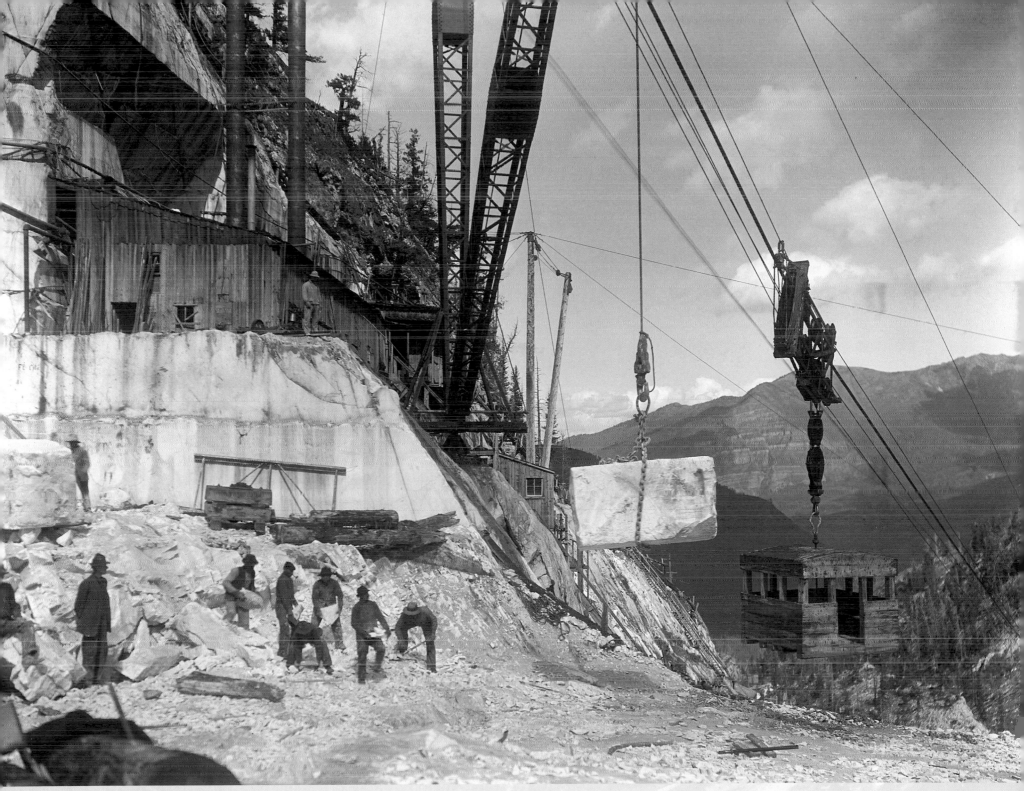

The Colorado Yule Quarry, Marble, 1910. *Denver Public Library, Western History Collection, photo: George Beam*

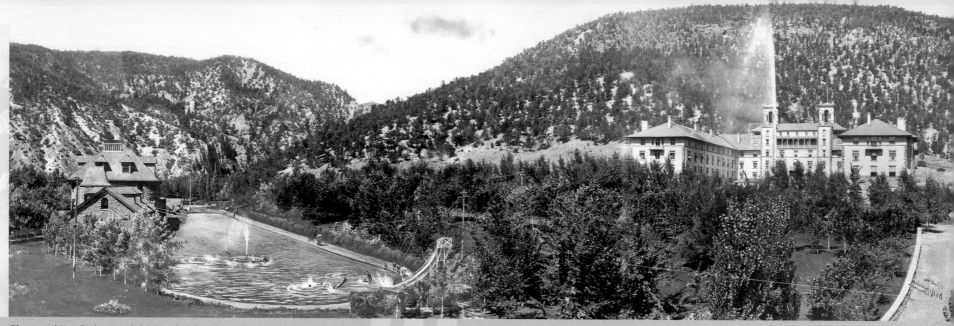

Glenwood Hot Springs and the Hotel Colorado, early 1900s. *Denver Public Library, Western History Collection*

Glenwood Springs

Town founder Isaac Cooper chose the name Glenwood Springs in deference to his wife's beloved hometown of Glenwood, Iowa.

In 1887, the Hotel Glenwood was home to Doc Holliday during his last days, when he was dying of tuberculosis.

IN 1860, a prospecting party led by Captain Richard Sopris came upon some hot springs east of Grand Junction in the valley of the Colorado River at the junction of the Roaring Fork River. They cut down some pines to build a raft and cross the Colorado there, then traveled down the Roaring Fork Valley to what is now known as Mt. Sopris and Carbondale.

Years later, in 1882, the hot springs site became known as Defiance but was later renamed Glenwood Springs. Seeing the potential for a hot springs resort, Aspen resident Isaac Cooper moved to the area and set about building the grandiose Hotel Glenwood. Later, in 1893, silver magnate Walter Devereux opened the even more palatial Hotel Colorado, which quickly became a popular summer retreat, earning the nickname of "The Little White House of the West" after visits by Presidents Theodore Roosevelt and William Howard Taft.

Today, Glenwood Springs is still a popular destination for visitors who come to enjoy the hot springs, vapor caves, river rafting, and the charm of the town's historic buildings and avenues. Located along Interstate 70, Glenwood Springs is close to both Aspen and Vail and just west of the stunning rock walls of Glenwood Canyon.

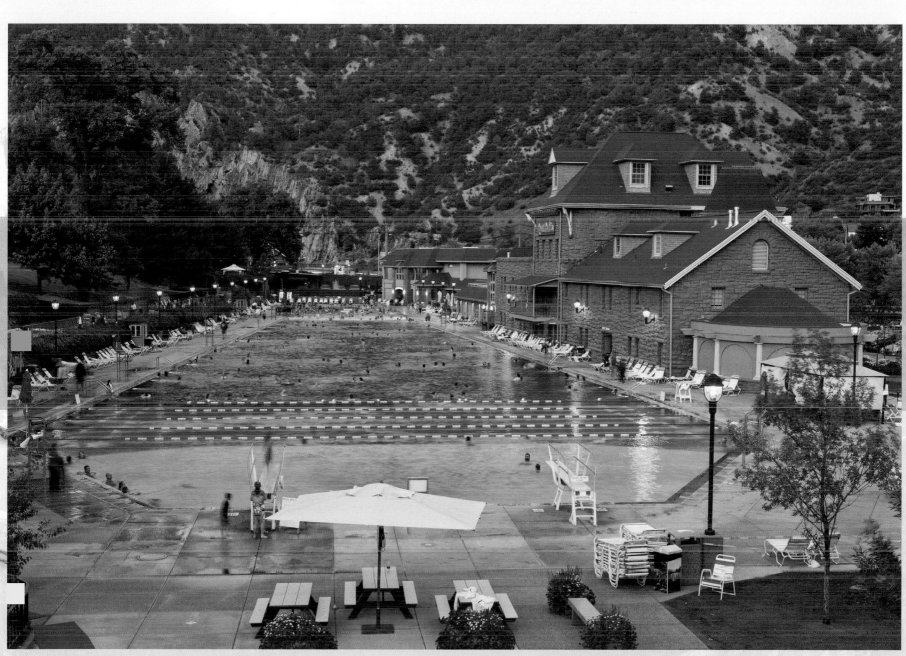

Glenwood Hot Springs.

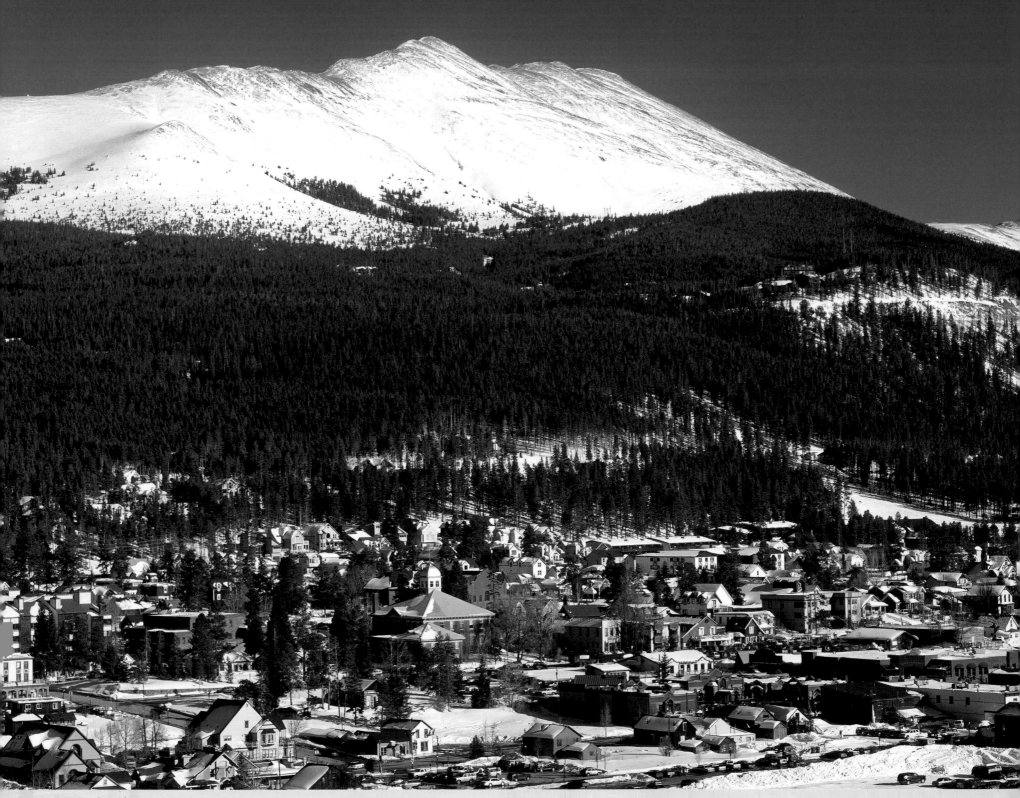

Breckenridge.

BRECKENRIDGE WAS yet another progeny of the Pikes Peak gold rush; it was founded in 1859 as a result of placer mining along the Blue River. But low-yield placer techniques limited the potential of the town until the hydraulic mining boom of the 1870s. Then, in 1879, silver was discovered in the area. The fresh boom gave rise to new riches for the town, and the years that followed saw the town's greatest growth. In the early 1900s, the focus was back on gold and yet another mining technique: dredgeboats. This highly destructive form of mining worked the riverbeds and creeks relentlessly until World War II silenced the last one in 1942.

Almost two decades later, after a period of decline, investors from a Kansas lumber company opened the Breckenridge ski area on December 16, 1961, and a new era was born. Along with the other Summit County ski areas, such as Keystone, Arapahoe Basin, and Copper Mountain, Breckenridge is a popular destination for weekend ski enthusiasts from the Front Range. (Interstate 70 passes nearby, and Denver is but an hour and a half away.) Breckenridge's historic mining character is somewhat elusive today but can still be found in places such as the Gold Pan Bar, which was popular with miners back in the day.

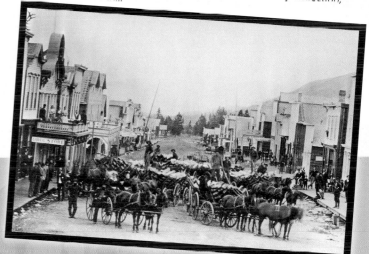

Main Street, 1880s. *Denver Public Library, Western History Collection, photo: W. D. Churchill*

Breckenridge

Main Street.

Breckinridge's Gold Pan Bar is the oldest continuously operated bar west of the Mississippi River.

The piles of river rock exposed by dredgeboat mining of the 1900s are permanent features of Breckinridge.

Harrison Avenue.

Hydraulic mining crew, 1879. *Lake County Public Library*

FOUNDED IN 1878, Leadville was the crown jewel of Colorado's silver boom. Between 1879 and 1889, Leadville's mines produced more than $82 million worth of silver, turning the mining camp into a full-blown city that was second only to Denver in population by the late 1800s. Tent saloons and log cabins were soon replaced by grandiose buildings, such as the Tabor Opera House, fancy hotels, and dining halls, all built in beautiful Victorian splendor. Mining money also propelled the careers of many businessmen, including Horace Tabor, whose mining investments catapulted him to great fame and riches and even a short term as a U.S. senator. His scandalous divorce and subsequent marriage to "Baby Doe" Tabor made headlines across the country. Baby Doe became a legend in her own right by stubbornly defending and living in a mining shack at the Matchless Mine for thirty-five years after her husband's death and the loss of their fortune.

Harrison Avenue, 1879. *Lake County Public Library*

The Leadville 100 mountain-bike race has made headlines since cyclist Lance Armstrong, of Tour de France fame, competed in the race here in 2008.

Leadville

Leadville is the home of the National Mining Museum and Hall of Fame.

Sitting at an elevation of 10,152 feet (3,094 meters), Leadville is the highest incorporated city in the United States. Because it was located in a high mountain valley and surrounded by 14,000-foot peaks, transporting supplies to the mining camp was difficult, to say the least. Today, these same forces of geology make Leadville a stunning destination for year-round recreation.

Since Leadville is on a major highway through the mountains, it is a common tourist stop. Along with charming and historic buildings, the town boasts excellent restaurants, coffee shops, and antique stores for the visitor to peruse. Annual festivals include Leadville Boom Days, a celebration of Leadville's mining past that includes contests of mining skill and a world-famous burro race. In winter, the town hosts a skijoring competition, where competitors on skis are towed behind galloping horses over jumps and around obstacles down the main street, Harrison Avenue. Most recently, Leadville has become a mecca for mountain-bike riders.

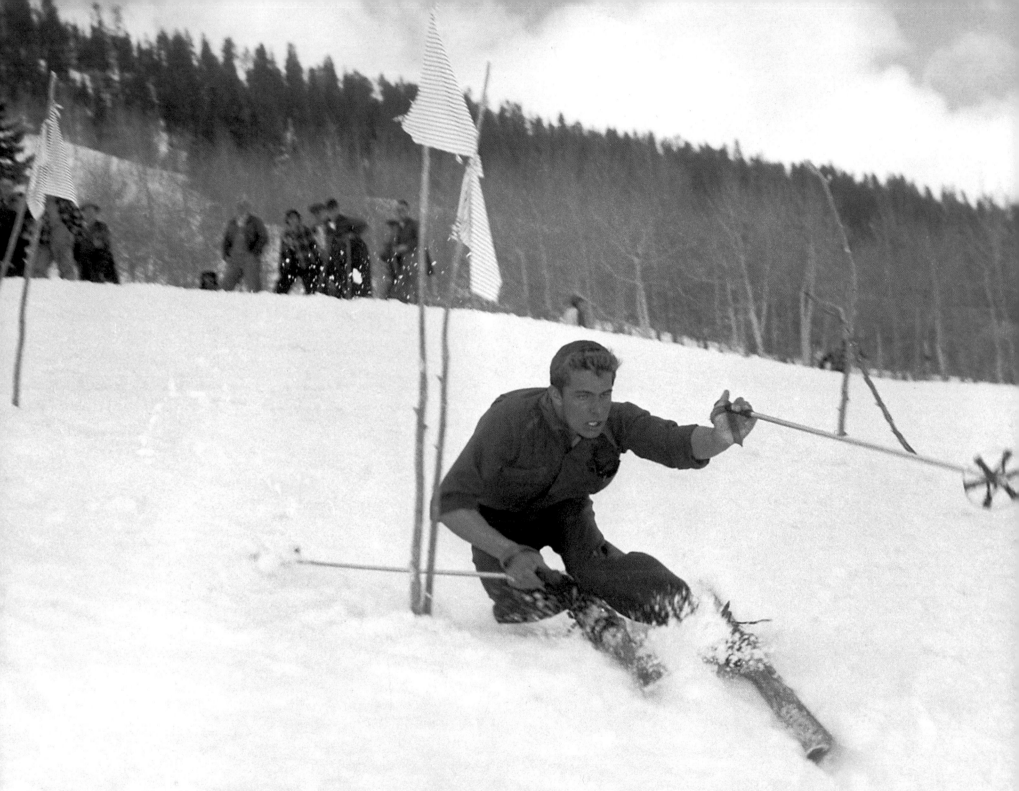

Ski racer Steve Krizmanich, Pershing Mine Hill, Crested Butte, 1951. *Crested Butte Mountain Heritage Museum*

Skiing

SKIING BEGAN in Colorado not as a sport but as a form of transportation made necessary by the deep snows of the Rocky Mountains. Often, access to the various mining camps in the high country in winter was possible only with snowshoes fashioned of long heavy planks and leather straps, which, in such dry snow, were superior to the webbed variety. It is thought that the idea for skis was brought over by Scandinavian miners.

Some of the more legendary and daring early skiers were mail carriers. The most notable were Father John Lewis Dyer, who combined his fiery Methodist preaching with delivering letters between Buckskin Joe and Oro City over Mosquito Pass, and Al Johnson, who delivered mail between Crystal City (near Marble), Gothic, and Crested Butte over Schofield Pass.

(CONTINUED ON PAGE 70)

Sean Crossen skiing Third Bowl, Mt. Crested Butte.

Mr. and Mrs. V. E. Metzler, Crested Butte, 1897. *Crested Butte Mountain Heritage Museum*

Mail carrier Al Johnson's skill as a skier was legendary. A fierce competitor, he was involved in one of the first recorded ski races in Colorado, which took place among the Irwin, Crested Butte, and Gunnison snowshoe clubs in 1886.

Mountain guide Jim Baker is the first person recorded to have used skis in Colorado; he did so while leading a party over Cochetopa Pass, near Gunnison, in 1857.

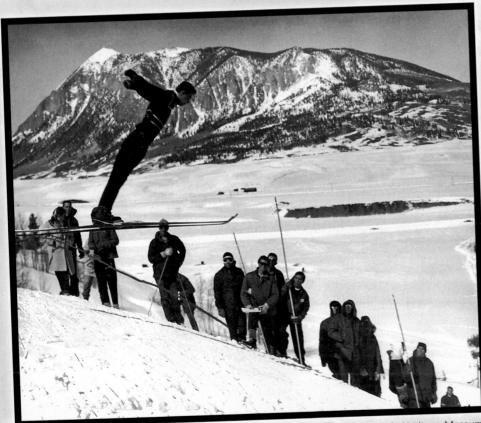

Collegiate ski jumper on Rozman Hill, Crested Butte, 1954. *Crested Butte Mountain Heritage Museum*

(CONTINUED FROM PAGE 69)

Skiing in Colorado would remain an informal and practical activity until the arrival of Carl Howelson in 1911. Howelson, a stonemason and champion skier in his home country, Norway, astonished the people of Hot Sulphur Spring that year with his aerial feats on skis, and a new craze was born. In 1914, he moved to Steamboat Springs and helped start Steamboat's Winter Carnival and Howelson Hill, the oldest Colorado ski area in continuous use.

The Tenth Mountain Division, a specially trained mountain and ski-fighting division of the U.S. Army, was significant not only for its fighting exploits in World War II, but also for its influence on Colorado's ski industry in the years that followed. Trained at Camp Hale, located between Leadville and Redcliff, many of the Tenth Mountain Division's veterans saw the potential for a skiing industry in Colorado and returned from World War II to contribute to it (see pages 74-75). Two of the more notable veterans were Friedl Pfeifer, who cofounded the Aspen ski area in 1947, and Pete Seibert, who founded Vail Ski Resort in 1957.

Although the Aspen, Arapahoe Basin, Berthoud Pass, and Winter Park ski areas were established earlier, the heyday of big resorts did not begin until the 1960s. In that era, Colorado truly became a skiing mecca. The early sixties saw the openings of ski resorts at Breckenridge, Vail, Steamboat Springs, and Crested Butte. Snowmass, Keystone, and Copper Mountain were not far behind, and by the early 1970s, Colorado's resorts offered the best skiing opportunities in the country.

Today, Colorado still offers the best and biggest variety and quality of skiing and snowboarding anywhere, with sun-filled "bluebird" days and dry, fluffy powder on breathtakingly scenic slopes. Colorado's ski towns offer a prime ski experience, with après ski activities, world-class bars and restaurants, and the charming Victorian ambiance of Colorado's mining past.

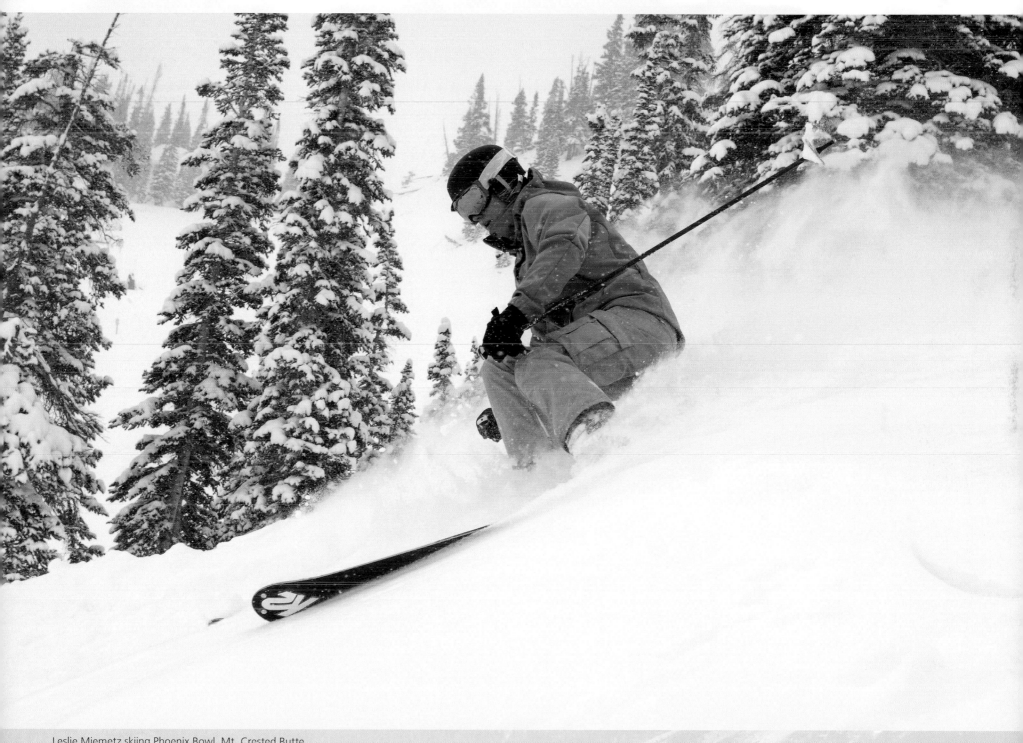

Leslie Miemetz skiing Phoenix Bowl, Mt. Crested Butte.

Winter Sports

Snowshoe brigade at Irwin, 1883. *Crested Butte Mountain Heritage Museum*

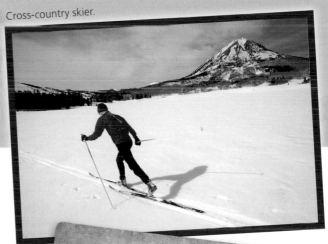
Cross-country skier.

EVER SINCE mountain men and miners strapped sets of boards on their feet to travel in the deep snows of the Colorado Rockies, the state has been a winter-sports playground. For skiers and snowboarders, the options are numerous, with a multitude of world-class resorts to choose from (see pages 68-71). For cross-country skiing and snowshoeing enthusiasts, the Rockies offer an almost limitless array of possibilities, from long backcountry tours to groomed classic- and skate-ski trail networks, such as Devil's Thumb near Winter Park.

A sport that has grown in popularity is backcountry skiing, where skiers use either telemark skis or alpine touring skis (with a detachable heel) to "skin" up mountains and ski down untouched powder. Snowmobiling, a fast and exhilarating way to explore the backcountry in winter, is also a popular winter sport in Colorado, and many forest service trails are available for snowmobilers' use.

Almost every Colorado ski town offers some kind of groomed trails for cross-country skiers and snowshoe enthusiasts, though some prefer to go on ungroomed trails.

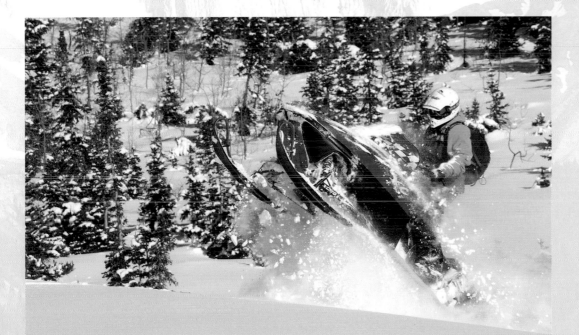
Snowmobiler getting air.

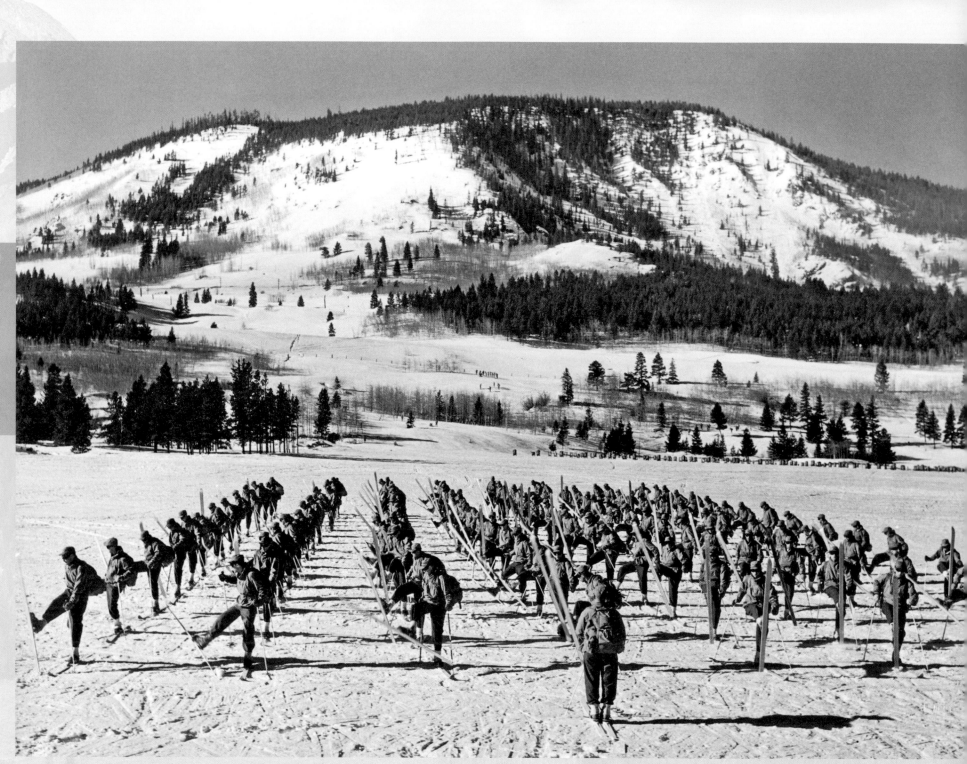

Soldiers training on skis, Camp Hale, 1943. *Denver Public Library, Western History Collection*

THE TENTH MOUNTAIN DIVISION of the U.S. Army was formed after the head of the National Ski Patrol, Charles Minot Dole, observed how Finnish soldiers on skis managed to destroy two Soviet armored divisions during the U.S.S.R.'s attempted invasion of Finland in November 1939. Dole successfully lobbied the U.S. War Department to create a unit specially trained for mountain fighting in harsh terrain and weather conditions. Dole used his ski-patrol connections to recruit expert skiers and mountaineers from around the country and from Europe.

Camp Hale and the Tenth Mountain Division

To help the men of the Tenth Mountain Division hone their skiing skills, the U.S. Army built a ski lift to the top of Tennessee Pass at Cooper Hill, which is now a commercially operated ski area.

In 1943, the Tenth Mountain Division activated at Camp Hale, located along Highway 24 between Leadville and Redcliff. After a brief stint of rock-climbing training in West Virginia, the division relocated to the high valley location (elevation 9,200 feet) of Camp Hale and trained for a year here. The troops were trained in mountain climbing, skiing, and cold-weather survival. The training was brutal but fitting preparation for what was to come. The unit arrived in Italy in early 1945 and entered combat almost immediately in what would be some of the most deadly engagements in the war, taking Riva Ridge, Buio, Prada, Mount Belvedere, and Mount della Vedetto, and leading the attack across the Po River. In the hard fighting, the division suffered terrible casualties, and 992 men were killed. The "Ski Club Boys" returned to the United States to a hard-earned heroes welcome in the summer of 1945.

Though the camp was used for some training by various army units and the CIA after the Korean War, it was essentially left to decay and was dismantled in 1965. Today all that's left of the camp are decaying concrete and rebar ruins—a sad and desolate reminder of a unique and heroic chapter of Colorado's ski history. Visitors can tour the ruins, read interpretive plaques, and visit the monument to the Tenth Mountain Division at the base of Ski Cooper.

Ruins of Camp Hale.

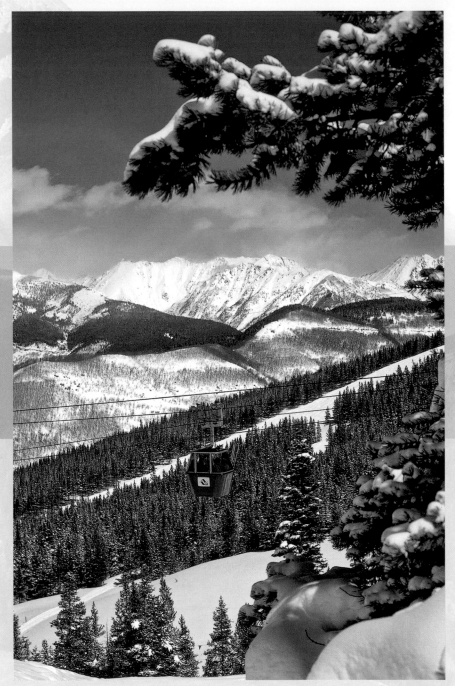

Gondola, 1970s. *Courtesy of Colorado Ski & Snowboard Museum and Hall of Fame, Vail, Colorado*

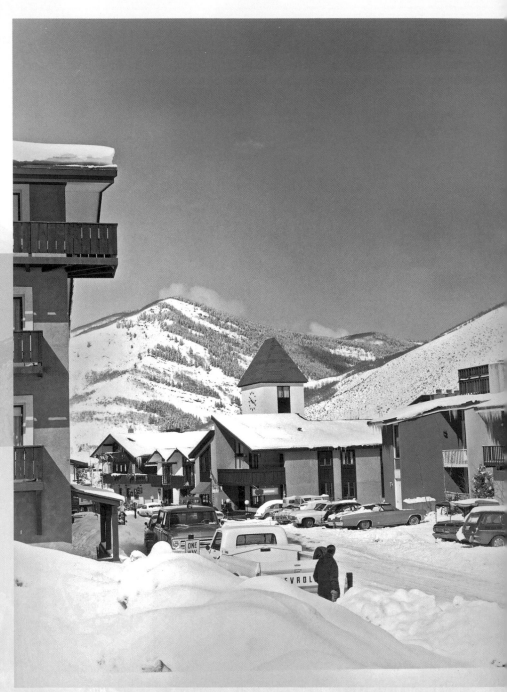

Vail Village, early 1970s. *Courtesy of Colorado Ski & Snowboard Museum and Hall of Fame, Vail, Colorado*

Skiers at the base of the Vail ski area.

Vail

UNLIKE MOST of its counterparts in the ski industry, Vail did not start out as a mining town. In fact, the actual town of Vail was preceded by the ski area, which was born of ranch and forest lands. Vail was started by Tenth Mountain Division veterans Pete Seibert and Earl Eaton after they had explored the area in 1957. After they had rounded up investors, Vail Resort began running its lifts in December 1962. The base area, Vail Village, was designed as a pedestrian mall with Swiss-style buildings, and though it has expanded over the years, it still retains that original kitschy charm. Nevertheless, it also maintains an Aspen-like allure for the affluent, with its world-class dining, shopping, and cultural events.

The growth of both the town (officially incorporated in 1966) and the ski area has exploded over the years, affecting towns down valley, such as Eagle and Avon, and inspiring the creation of another world-class ski area, Beaver Creek.

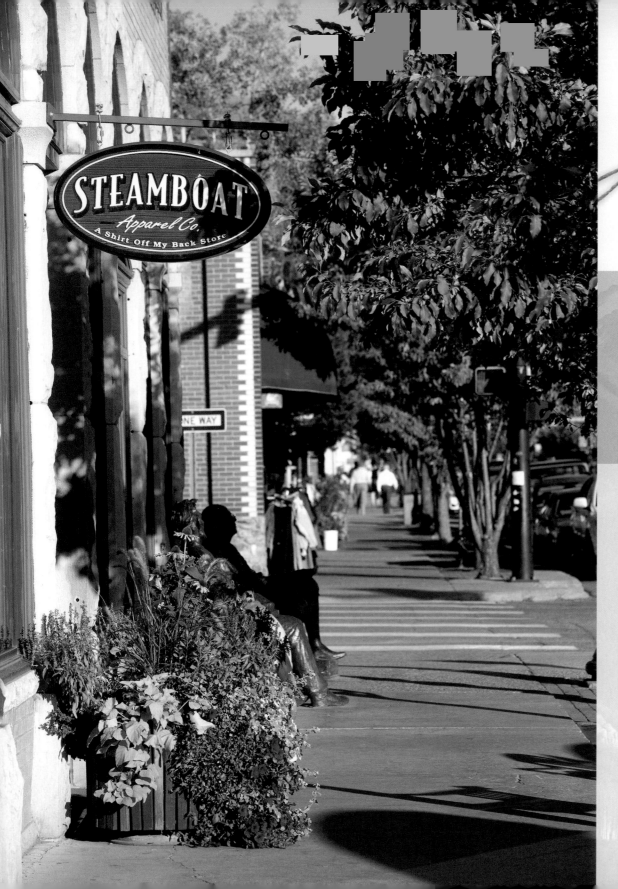

Steamboat Springs

IN 1875, rancher James Crawford settled his family in the Yampa Valley. Crawford lived peaceably among the local Ute Indians, who used the valley as a summer hunting ground. After the Utes were removed to reservations, mostly outside Colorado, ranchers and some miners began to settle in the area. Although the community that took root here was primarily ranching based, the hot springs also became a draw after the railroad arrived in 1909.

It was in 1914 that a newcomer from Norway would forever change the face of Steamboat Springs. Carl Howelson, the man who introduced the sport of skiing to the state (see pages 68-71), founded the Steamboat Springs Winter Carnival and the ski resort Howelson Hill. In the late 1950s, a local rancher's son and ski (CONTINUED ON PAGE 80)

Sidewalk along Lincoln Avenue.

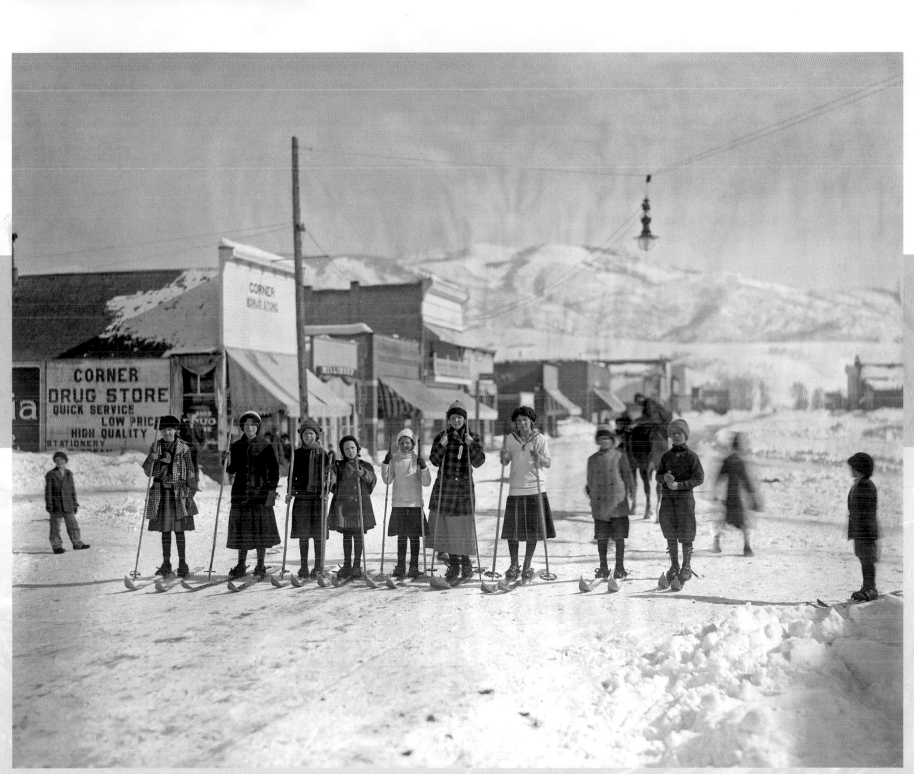

Kids on skis, Steamboat Springs, 1916. *Denver Public Library, Western History Collection, photo: L. C. McClure*

(CONTINUED FROM PAGE 78)

patroller, James Temple, saw the skiing potential on Storm Mountain, just east of town, and by 1963, the mountain become home to a full-blown ski area. The mountain was renamed Mt. Werner a couple of years later, for local ski racer Buddy Werner, who was killed in an avalanche while filming a movie called *Ski-Fascination* in Switzerland.

Today, Steamboat Springs is also home to one of Colorado's best and biggest ski resorts, but it still retains much of its original ranching character.

Steamboat Springs is also home to the Perry-Mansfield Performing Arts Camp. The acclaimed camp was founded in 1913 and is the oldest continuously running performing arts school and camp in the nation.

Lincoln Avenue on a summer evening.

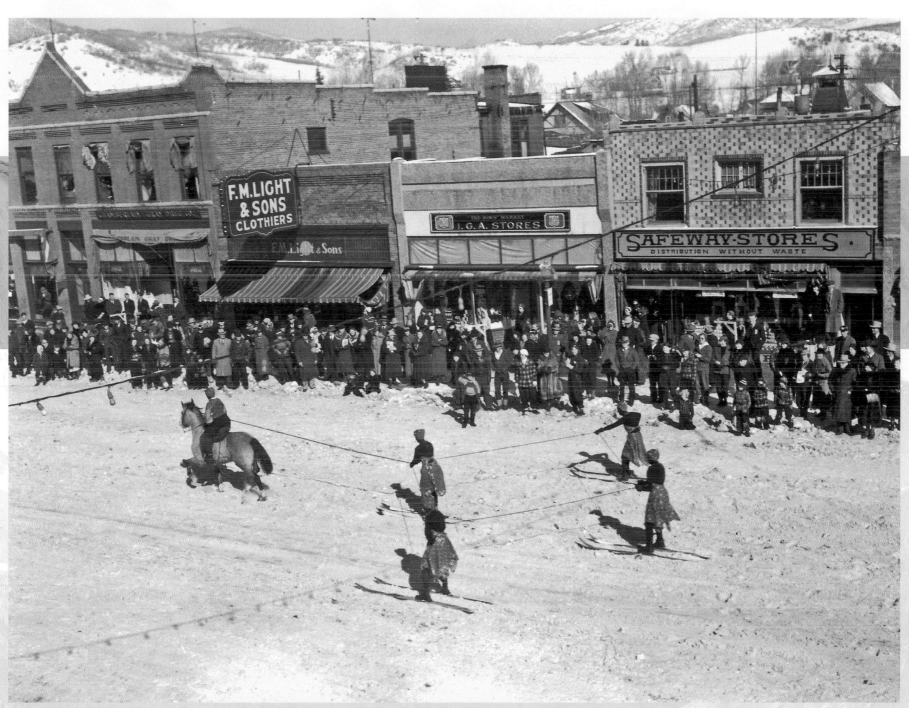

Skijoring at the Steamboat Springs Winter Carnival, 1940s. *Denver Public Library, Western History Collection*

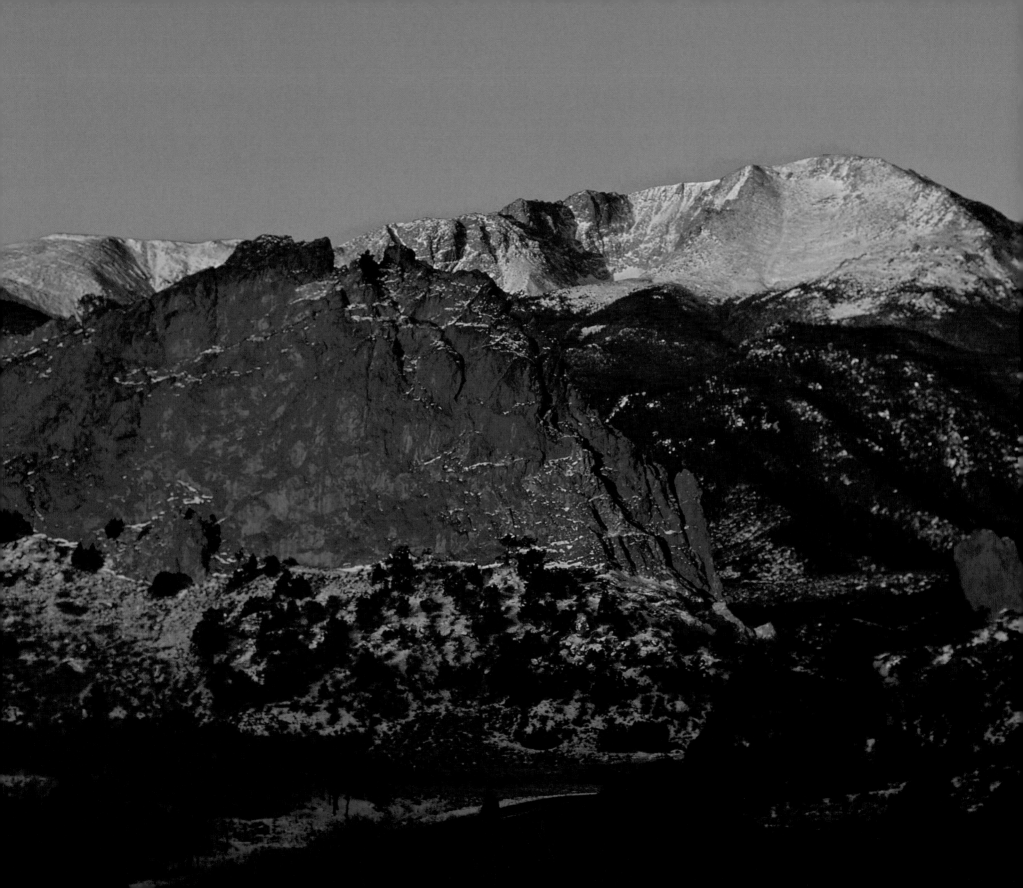

Pikes Peak Region

This region is home to one of Colorado's largest cities, Colorado Springs, and one of its best-known mountains, Pikes Peak. Visitors can climb or drive to the top of Pikes Peak (at over 14,000 feet), and then wine and dine in Colorado Springs at the mountain's base in the space of a day. If mining history is your thing, Cripple Creek and its sister city, Victor, are the places to go, with their charming historic buildings and streets that recall the Wild West days of yesteryear. Just over the Wet Mountains lies the stunning Wet Mountain Valley, where the glorious Sangre de Cristo Mountains provide a breathtaking backdrop. Visitors can also check out the Royal Gorge Bridge, one of the world's highest suspension bridges, which spans the spectacular Royal Gorge of the Arkansas River.

Pikes Peak, seen from Garden of the Gods.

Will Rogers Shrine of the Sun.

Colorado Springs

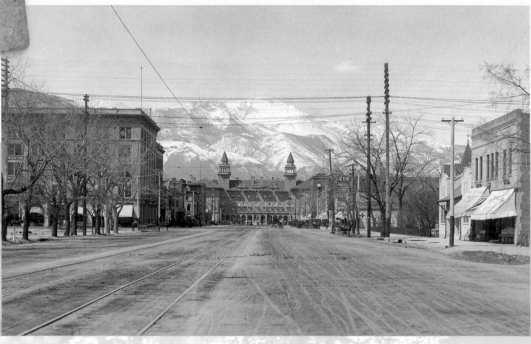

Pikes Peak Avenue, 1901. *Denver Public Library, Western History Collection, photo: L. C. McClure*

Balanced and Steamboat Rocks, Garden of the Gods.

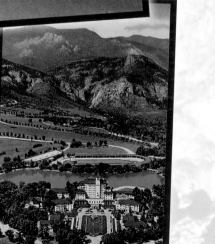

Broadmoor Hotel.

SITTING NEAR THE BASE of Pikes Peak and south of Denver, Colorado Springs, with a population of around 400,000, is the second most populous city in the state. It was founded in 1871 by General William Palmer, who intended it to be a high-end resort town. The local mineral waters, the nearby and spectacular rock formations of Garden of the Gods, and Pikes Peak towering above made for an ideal location.

Within two years of founding the town, Palmer opened the grandiose Antlers Hotel, and visitors soon came from all over the world. Like many other railroad towns in Colorado, the Springs also gained revenue by supplying nearby mining operations with food, clothing, hardware, lumber, tools, machinery, and other provisions. Many of the state's wealthy built large houses along its wide tree-lined boulevards.

In later years, the Springs became a booming town, fueled by high-tech industry, tourism, and the presence of the U.S. Army's Fort Carson, as well as the prestigious United States Air Force Academy, established by President Dwight D. Eisenhower in 1954. In addition, it is the site of Peterson Air Force Base, and the North American Aerospace Defense Command (NORAD) is located under Cheyenne Mountain.

With its scenic location, mild climate, vital downtown, and easy access to a multitude of recreational opportunities—such as whitewater rafting, skiing, mountain biking, road biking, and hiking, to name a few—Colorado Springs is an attractive place to live or visit. Among its major attractions, for locals and tourists alike, is Garden of the Gods, a beautiful park full of red-rock formations and hiking trails. Nearby Manitou Springs also attracts visitors with charming shops, restaurants, and Victorian architecture.

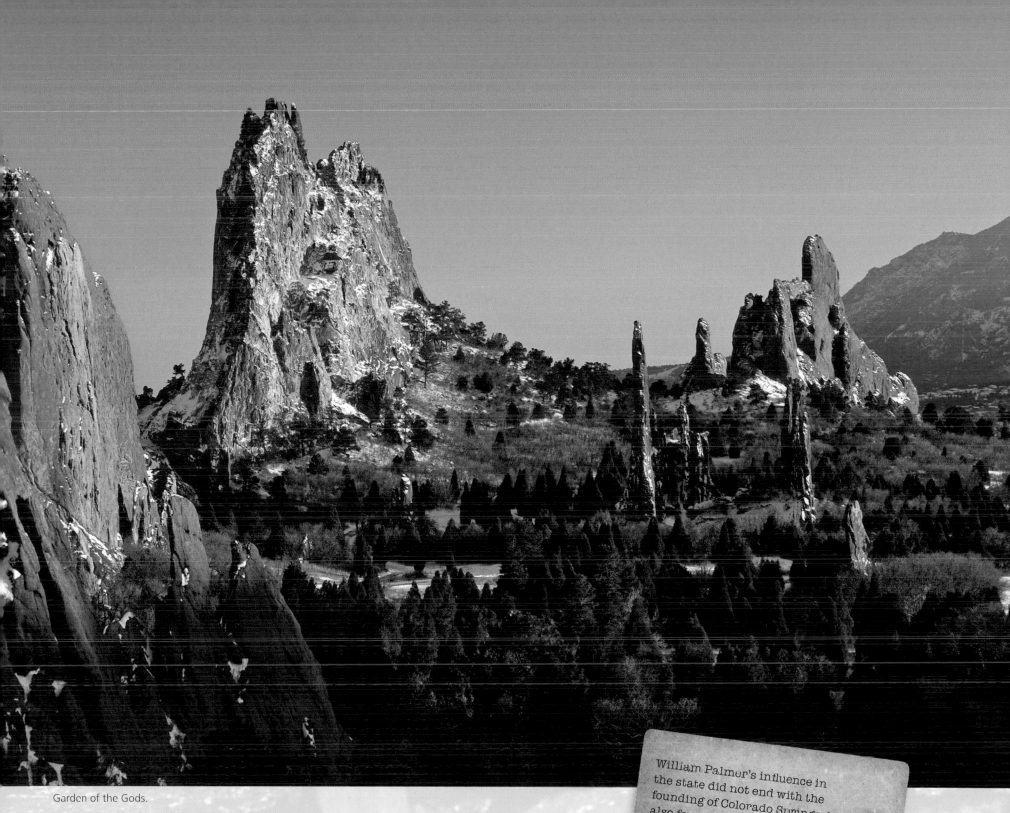

Garden of the Gods.

William Palmer's influence in the state did not end with the founding of Colorado Springs; he also founded the Denver & Rio Grande Railroad and acquired Colorado Fuel and Iron.

PIKES PEAK, located west of Colorado Springs, not only is a prominent peak that can be seen from many parts of Colorado (especially from the plains to the east), but it also has significant historical importance. At an elevation of 14,115 feet, it is the easternmost of Colorado's fifty-four Fourteeners.

The first European Americans to encounter the peak were the members of the Pike Expedition, led by Zebulon Pike in November 1806. Pike's party attempted to climb the peak, but members were thwarted by deep snow and frigid temperatures. The first white man to attain the summit was Edwin James, a young botanist with the Long Expedition, in the summer of 1820. Along the way, James was the first to record the presence of blue columbine, now Colorado's state flower.

In 1858, gold was discovered in the Denver area, which newspapers referred to as the Pikes Peak region. Though no gold was actually found near the peak, the ensuing 1859 gold rush will forever be known as the Pikes Peak Gold Rush.

Today, visitors can drive to the top of the peak and visit gift shops and restaurants on the way. They can also ride a cog railroad that operates out of Manitou Springs year-round (weather permitting). The Barr Trail, a popular hiking/biking trail to the top of Pikes Peak, also starts at Manitou Springs and is the route for the annual Pikes Peak Marathon.

Timber line, Pikes Peak Cog Road.

Glencove Inn on the Pikes Peak Auto Highway.

Pikes Peak

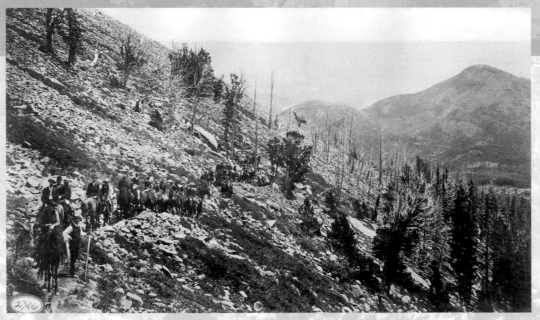

Riding up Pikes Peak, 1880s. *Denver Public Library, Western History Collection, photo: William Henry Jackson*

The nineteen-mile road ascending Pikes Peak is the route for the world-famous annual Pikes Peak International Hill Climb auto race.

Katherine Lee Bates wrote the famous patriotic song "America the Beautiful" after a carriage ride to the top of Pikes Peak. The trip was no doubt the inspiration for the famous lyrics, "For purple mountain majesties/Above the fruited plain."

Pikes Peak, seen from Garden of the Gods.

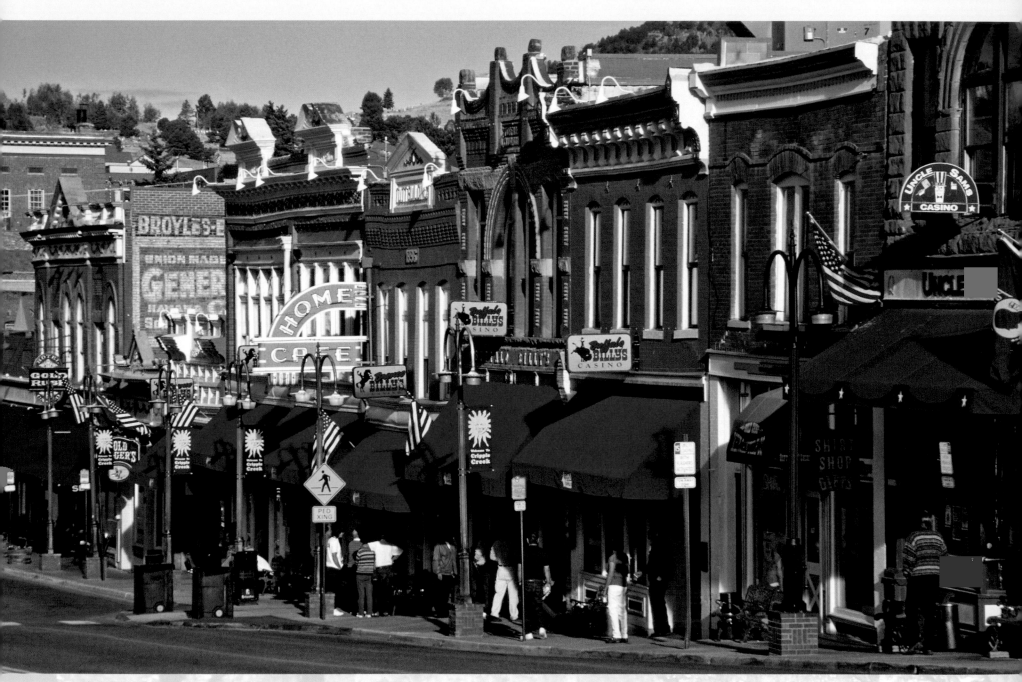

Main Street, Cripple Creek.

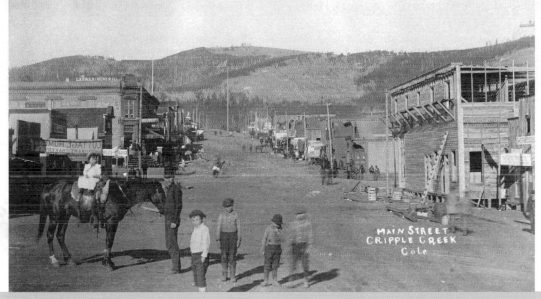

Main Street, Cripple Creek, 1880. *Denver Public Library, Western History Collection*

Cripple Creek

CRIPPLE CREEK, perched high the mountains southwest of Colorado Springs, is the location of one of the largest gold strikes in history. Gold ore was originally discovered there in 1890, and before long, thousands of gold seekers were flocking to the area. In 1891, W. S. Stratton found one of the richest gold veins ever found. His Independence Mine and, later, the Washington Mine would quickly make him a multimillionaire. But labor unrest in the mid-1890s took its toll, and the town, along with its sister city, Victor, began a long decline as ore yields dwindled.

By the 1980s, Cripple Creek's population had dropped to a few hundred and was promoted as a photogenic ghost town to the few tourist who ventured there. That all changed in 1994, when Colorado voters allowed Cripple Creek, Black Hawk, and Central City to have limited-stakes gambling. Now many of the old buildings house gambling casinos, and the town is flush with money and tourists. It has retained its historical look, however, unlike its gambling brethren, Black Hawk and Central City.

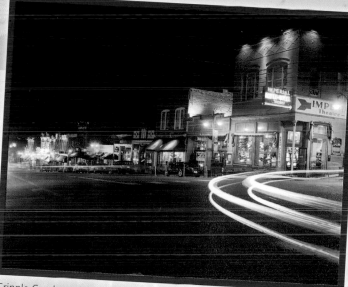

Cripple Creek at night.

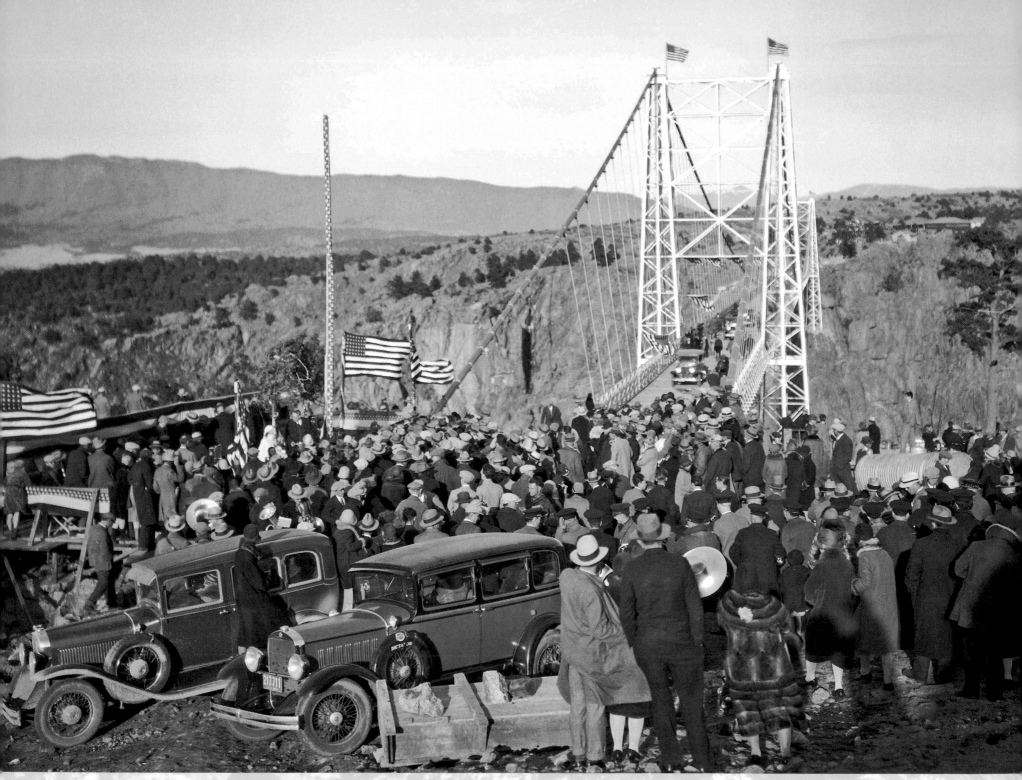

Royal Gorge Bridge opening ceremony, 1929. *Denver Public Library, Western History Collection, photo: George Beam*

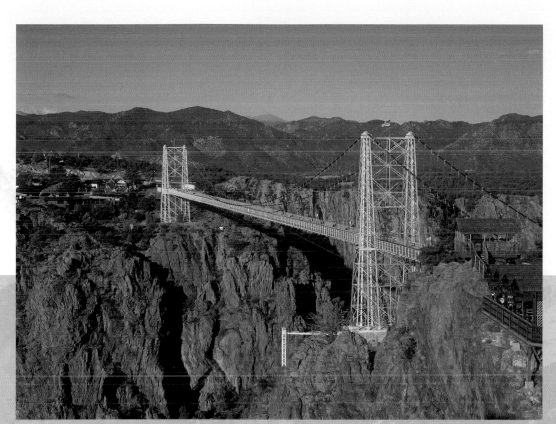
Royal Gorge Bridge.

Whitewater rafting is a popular activity in the Royal Gorge. Numerous boating companies offer tours through the gorge in the summer months, and the rapids here are some of the best on the Arkansas River.

The Royal Gorge

THE ROYAL GORGE, located near Canyon City in southcentral Colorado, is one of the deepest and most spectacular canyons in the state. Plains Indian tribes originally used it as an access point to hunting grounds in South Park. Railroad companies sought to use the gorge as a transportation route during Leadville's silver and gold boom, which began in 1877.

Unfortunately, there was room in the narrow gorge for only one railroad, and the Atchison, Topeka & Santa Fe Railway and the Denver & Rio Grande Western Railroad both wanted to be that one. Federal intervention eventually settled the Royal Gorge Railroad War with the Treaty of Boston in 1879. The Denver & Rio Grande Western Railroad completed its line and leased it back to the Santa Fe.

As alternate routes through the mountains were established, the Royal Gorge route fell out of use. It is now used for a sightseeing train; the Royal Gorge Route Railroad operates trains in the Royal Gorge year-round.

In 1929, Canyon City commissioned the building of the Royal Gorge Bridge, which, at 1,053 feet above the Arkansas River, is still the highest suspension bridge over water in the world. The spectacular and scenic bridge is the heart of a theme park owned and operated by the city.

The Royal Gorge Route Railroad sightseeing train travels twelve miles through the canyon, from Canyon City to Parkdale, and then returns.

Westcliffe Feed Store building.

The Sangre de Cristo Mountains contain ten Fourteeners (peaks higher than 14,000 feet), including the popular Crestone Peak and Crestone Needle.

The Wet Mountain Valley is named after the Wet Mountains, which comprise the eastern part of the valley (with the Sangre De Cristo mountain range to the west). The Wet Mountains were named for the amount of snow they receive in winter.

The Wet Mountain Valley

Westcliffe, 1902. *Denver Public Library, Western History Collection*

A LUSH, HIGH VALLEY with unobstructed views of the Sangre de Cristo Mountains, the Wet Mountain Valley is truly one of Colorado's scenic gems. Separated from major cities by the mountains on either side, this large, almost linear valley maintains a slow-paced, pastoral flavor that harkens back to days long past.

There are but two towns in the valley, Silver Cliff and Westcliffe. Silver Cliff, as the name implies, was a bustling silver mining town, founded in 1878, while Westcliffe, a mere half mile away, was created next to the railroad. (The Denver & Rio Grande Railroad had a habit of buying the cheaper land just outside of town centers to lay its rail; many a town relocated to be nearer the railroad, or new towns, such as Westcliffe, arose next to the rails.) After the silver crash of 1893 and the removal of the railroad, Silver Cliff and Westcliffe went quiet and the valley gradually evolved into a peaceful ranching community.

This valley, fed by streams from both sides, sustains excellent hay production and cattle grazing, and ranching is a major industry here. The Sangre de Cristo Mountains provide not only a stunning backdrop, but also numerous sightseeing and recreational opportunities. The valley's quiet scenery and abundance of thirty-five-acre "hobby ranch" properties also make it an attractive destination for retirees, who are lured here by the spectacular views and laid-back western lifestyle.

Opposite: Beckwith Ranch.

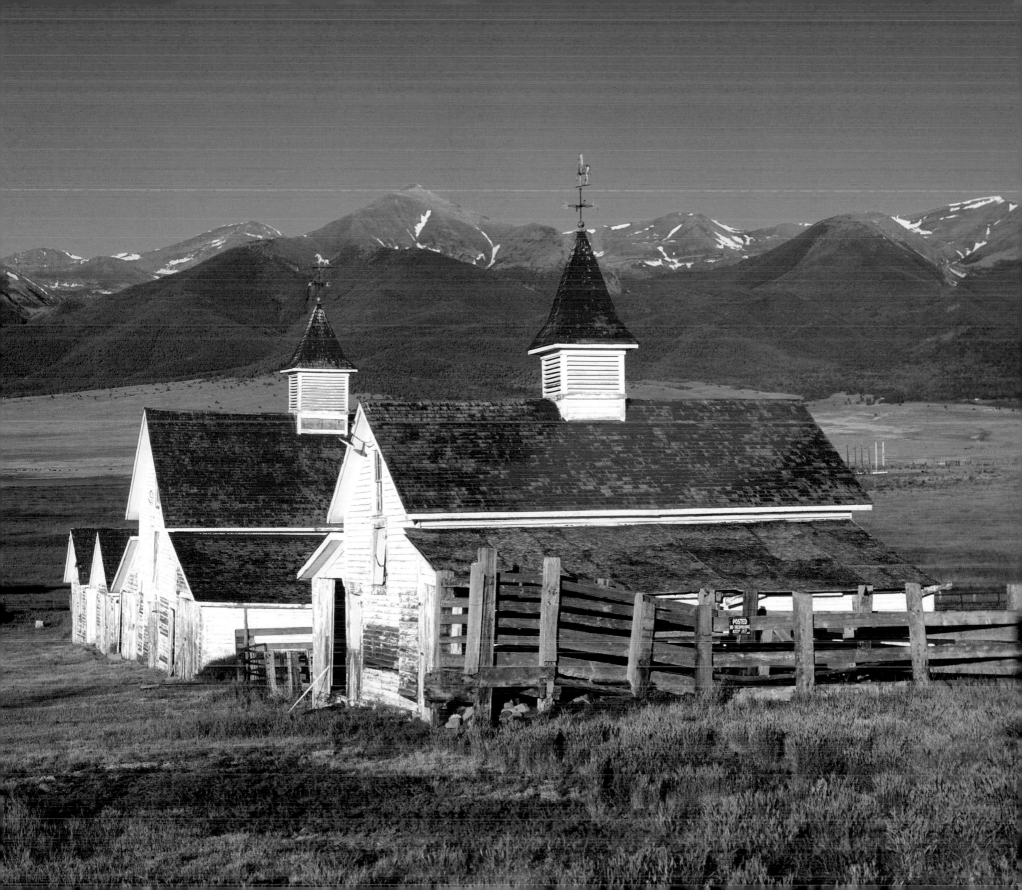

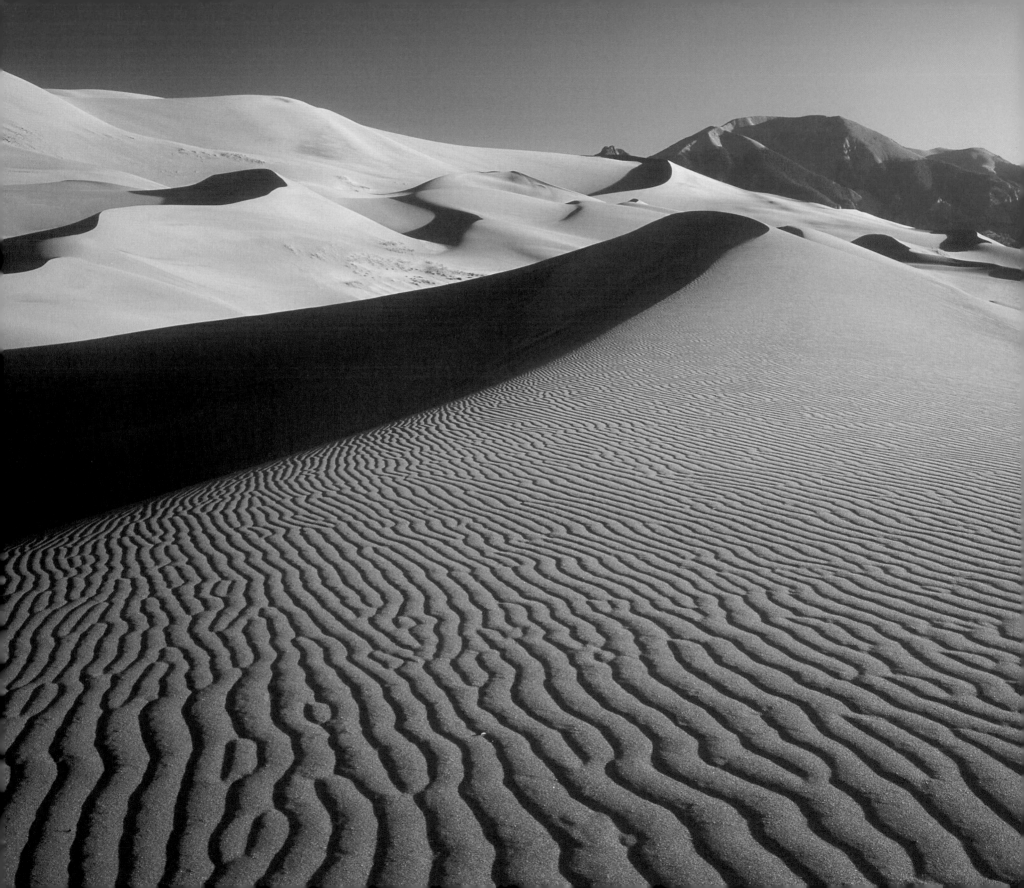

Southern Colorado and the San Luis Valley

Home to Colorado's oldest settlement, San Luis, and steeped in history, lore, and scenery, southern Colorado is a land of diversity. Pueblo, the oldest of Colorado's larger cities, is a bustling center of business. The formerly rowdy Old West town of Trinidad still holds much of its historic charm. To the west is the fascinating landscape of the San Luis Valley and the amazing sand dunes of Great Sand Dunes National Park. Farther south, near the border with New Mexico, visitors can experience the West of yesterday with a ride on the historic Cumbres & Toltec Scenic Railroad, which winds its way on narrow-gauge tracks through verdant valleys and up to the high peaks.

Great Sand Dunes National Park.

San Luis

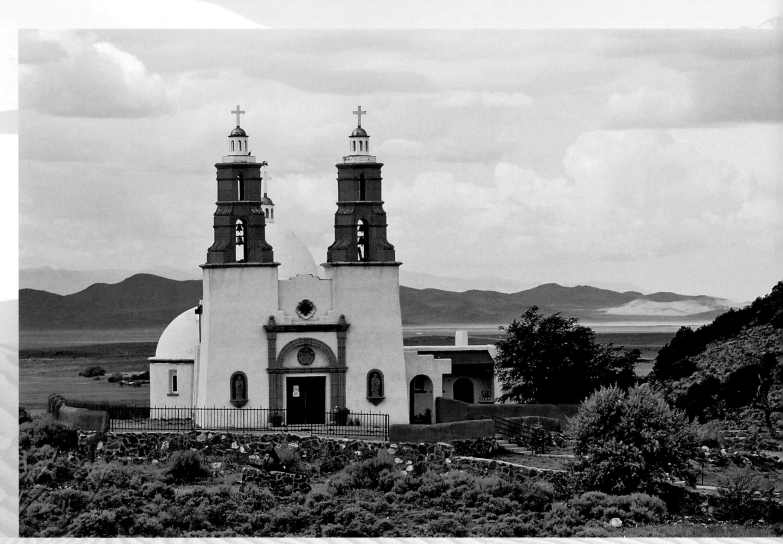

Stations of the Cross Shrine and chapel. *Shutterstock*

LOCATED ON Colorado Highway 159, this picturesque town is situated at the foot of Culebra Peak and the Sangre de Cristo Mountains, at the mouth of the expansive valley of the Ventero.

San Luis was founded in 1851 when Carlos Beaubien, owner of the Sangre de Cristo Land Grant, convinced fifty families from Taos, New Mexico, to settle in southcentral Colorado. San Luis became the first significant town in the state and is the oldest town in Colorado.

Today, one of the major attractions here, drawing visitors far and wide, is the Stations of the Cross Shrine, or *La Mesa de la Piedad y de la Misericordia* (Hill of Piety and Mercy). The shrine consists of a trail leading up to the church at the top of a hill. Dramatic sculptures, created by local artist Huberto Meastas, depict the last days of the life and the resurrection of Jesus Christ. Dedicated in 1990, the shrine symbolizes the role of Catholic religion in southern Colorado's Hispanic communities.

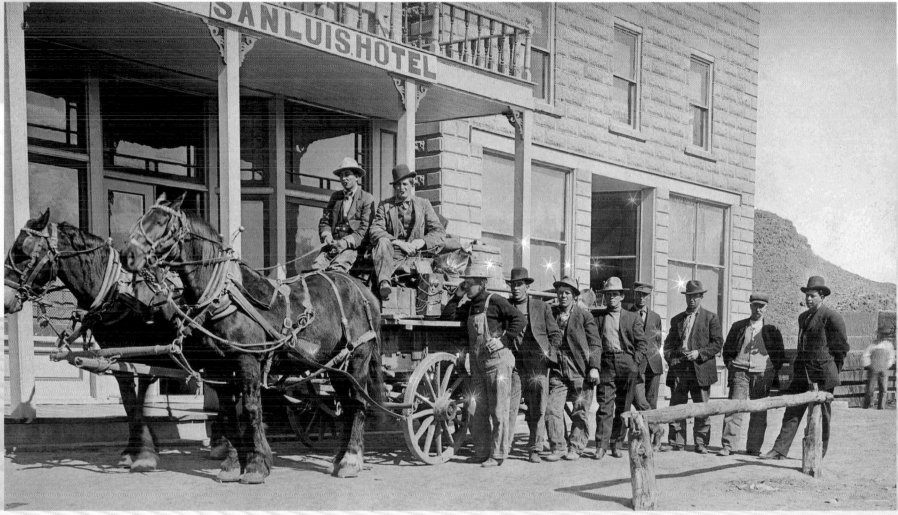

Telephone workers with a horse-drawn wagon, 1910. *Denver Public Library, Western History Collection*

San Luis is home to the state's oldest continuously operated business, the R & R Grocery (now the R & R Supermarket), which first opened its doors in 1857.

Built in 1851, the **acequia** (irrigation ditch) system in San Luis is the first ditch and oldest recorded water right in the state.

SURROUNDED BY the Sangre de Cristo Mountains to the east and the San Juan Mountains to the west, the San Luis Valley is one of the largest high-desert valleys in the world, with an average altitude of 7,500 feet. Originally part of the Ute Indian lands, the valley was the first part of Colorado to be settled, beginning in the 1840s, by Hispanic settlers from New Mexico when it was still part of Mexican lands. The United States government purchased it from Mexico at the end of the Mexican-American War as part of the Treaty of Guadalupe Hidalgo in 1848.

The San Luis Valley is 125 miles long and 65 miles wide.

The San Luis Valley

Broadwell Hotel in Alamosa, 1880. *Denver Public Library, Western History Collection, photo: O. T. Davis*

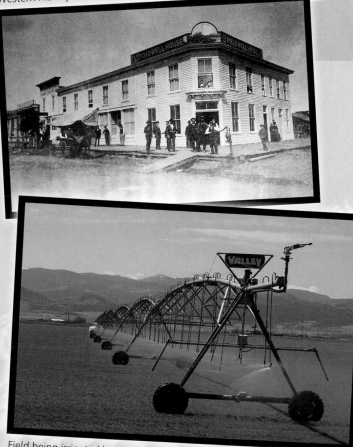

After the construction of Fort Massachusetts in the 1850s to protect settlers from hostile Indians, settlement by Hispanic peoples from the south began in earnest. The San Luis Valley has the largest population of Hispanics in Colorado, and most are direct descendants of the early Spanish settlers. By 1878, the railroad reached Alamosa, which became a major rail hub for the area.

Today, the San Luis Valley is a major agricultural region for the state of Colorado. One of the valley's unique properties is the fact that numerous streams come down from the surrounding mountain ranges and essentially sink into the ground of the relatively flat valley floor, creating a huge aquifer. Thus, most valley's irrigation systems are fed from deep wells, and huge rotating sprinkler systems are a common sight.

Major towns in the valley include Alamosa, Monte Vista, Del Norte, South Fork, and Fort Garland. Visitor attractions include Colorado Gators Reptile Park in Mosca, the UFO Watchtower in Hooper, and Great Sand Dunes National Park.

Field being irrigated by sprinkler, near the town of Center.

The primary crops grown in the San Luis Valley are hay, alfalfa, potatoes, and beans.

Opposite: Barn near Del Norte.

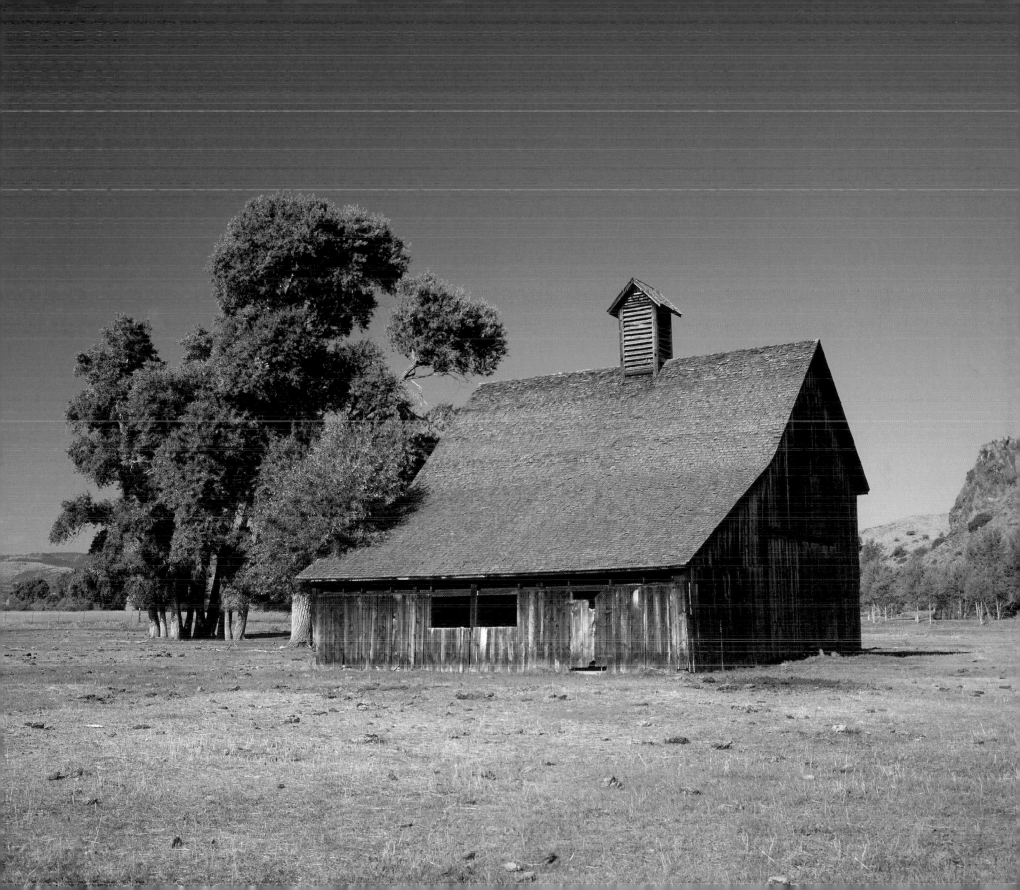

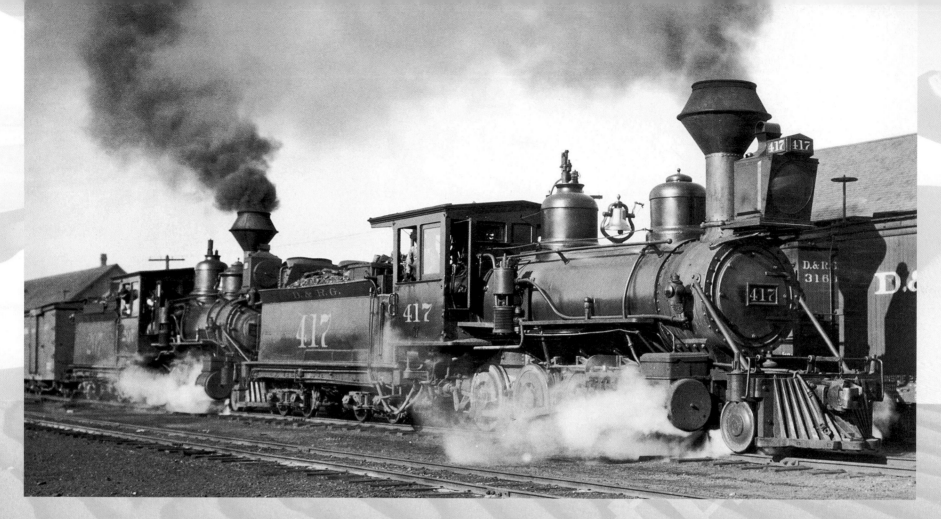

The Cumbres & Toltec Scenic Railroad

Above: Train on the San Juan Extension of the Rio Grande Railroad, predecessor of the Cumbres & Toltec Scenic Railroad, 1908. *Denver Public Library, Western History Collection, photo: Fred Jukes*

THE CUMBRES & TOLTEC Scenic Railroad was originally built as part of the San Juan Extension of the Denver & Rio Grande Railroad in 1880 to serve the silver and gold mines in the San Juan Mountains. It is part of the same line that makes up the Durango & Silverton Narrow Gauge Railroad, which is still preserved today (see pages 136-137).

The railroad was built as a narrow-gauge railroad (with rails 3 feet wide), which at the time was thought to be superior to regular-sized railroads (with rails 4 feet, 8½ inches wide) for navigating Colorado's winding mountain grades. When standard-gauge rail lines began to eclipse narrow gauge in the 1890s, the Denver & Rio Grande Railroad began to replace its narrow-gauge lines with the wider width. Unfortunately for the San Juan branch, rail traffic there had declined precipitously after the 1893 silver crash, and the Denver & Rio Grande Railroad decided not to convert it to standard rail. After decades of decline and neglect, the line was abandoned in 1969.

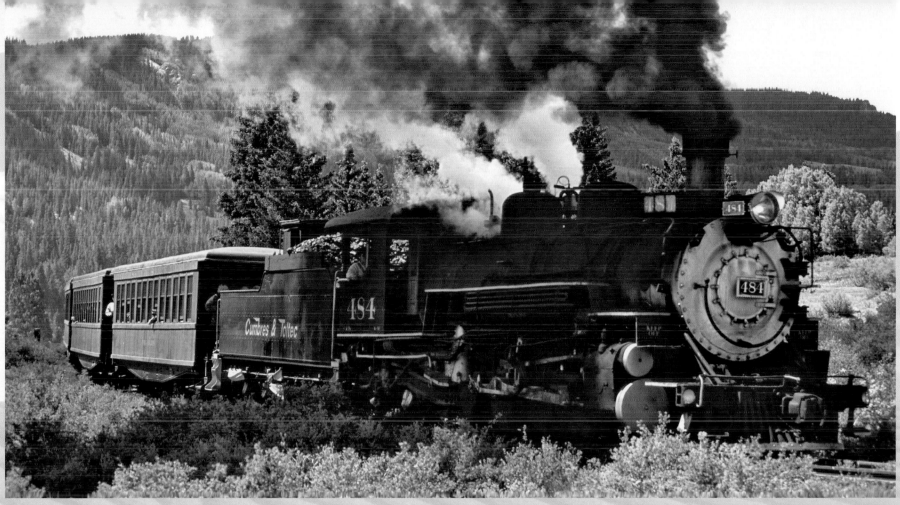

Train on the Cumbres & Toltec Scenic Railroad.

The Cumbres & Toltec Scenic Railroad line is sixty-four miles long and runs up and over Cumbres Pass at an elevation of 10,015 feet.

Most of the San Juan rail line ended up being dismantled. However, a devoted group of history buffs, local civic leaders, and railroad preservationists convinced the states of Colorado and New Mexico to jointly acquire, for just over $500,000, the track and structures from Antonito, Colorado, to Chama, New Mexico, as well as 9 steam locomotives, 130 rail cars, and the Chama rail yard.

Today, tourists and rail enthusiasts can take the train from either Chama or Antonito to Osier, Colorado. Each train then returns to its respective city. Riders can either make a one-way trip across the entire line (then take a bus back to their starting point) or take a round trip. The scenery varies from open, big-sky mountain meadows and sagebrush to sheer rock and spectacular alpine vistas as it crests the summit of Cumbres Pass. This historic journey is a piece of living history—the history of the wild and romantic American West.

Union Avenue.

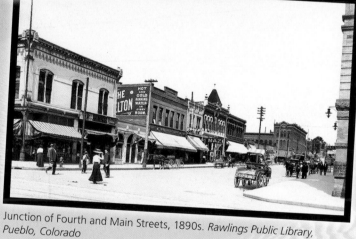

Junction of Fourth and Main Streets, 1890s. *Rawlings Public Library, Pueblo, Colorado*

PUEBLO IS THE SOUTHERNMOST of Colorado's Front Range cities. Like its brethren, it was born in part to supply mining exploits after the Pikes Peak Gold Rush of 1859. Founded in 1860, Pueblo provided access to and supplies for the California Gulch area at the headwaters of the Arkansas River.

In 1881, when mining and the expansion of railroads were at full tilt, railroad tycoon General William Palmer formed the Colorado Coal and Iron Company and used its coal profits to make Pueblo the "Pittsburgh of the West." This steel plant was the first of its kind west of the Missouri River and was rolling out rails for the railroad by 1882.

Pueblo

In Pueblo's earliest days, its proximity to the Arkansas River made it a stop for Indians and for fur trappers and traders coming from the plains and up from New Mexico.

Another booming industry of the time was saddle making. S. C. Gallup and R. T. Frazier made some of the best saddles in the West, and by 1917, Frazier was the largest producer of saddles in the United States.

Pueblo's boom days came to a tragic end with the Great Flood of 1921, when one third of Pueblo's businesses, 600 houses, and 100 lives were lost.

Today, Pueblo is a thriving and somewhat sprawling city with a population of over 100,000. Its Union Avenue Historic District project, along with the new Historic Arkansas Riverwalk, has revitalized Pueblo's downtown. These areas offer a lively mix of coffee shops, restaurants, and retail stores, all contained within some of the most beautiful historic buildings in Colorado. Pueblo's proximity to the Arkansas River and the mountains make it an access point for numerous recreational opportunities, including kayaking, whitewater rafting, fishing, and mountain biking.

Pueblo's climate is mild and warm compared to that of other Front Range cities farther north.

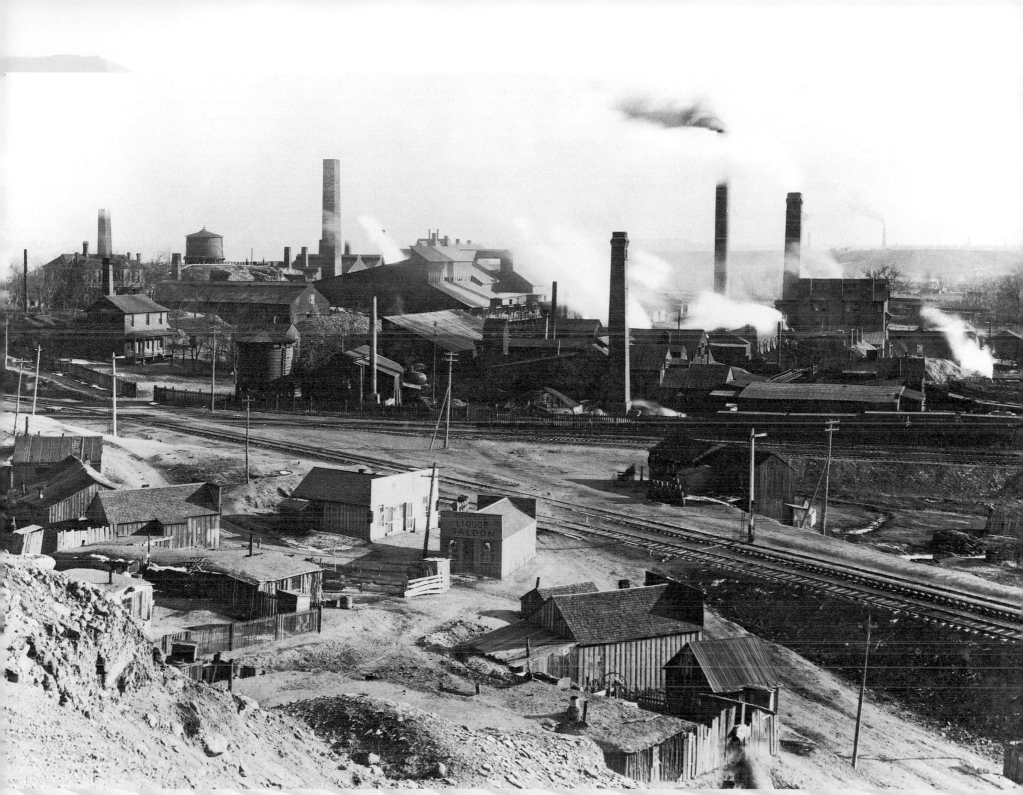

Colorado Coal and Iron Company, 1890s. *Rawlings Public Library, Pueblo, Colorado*

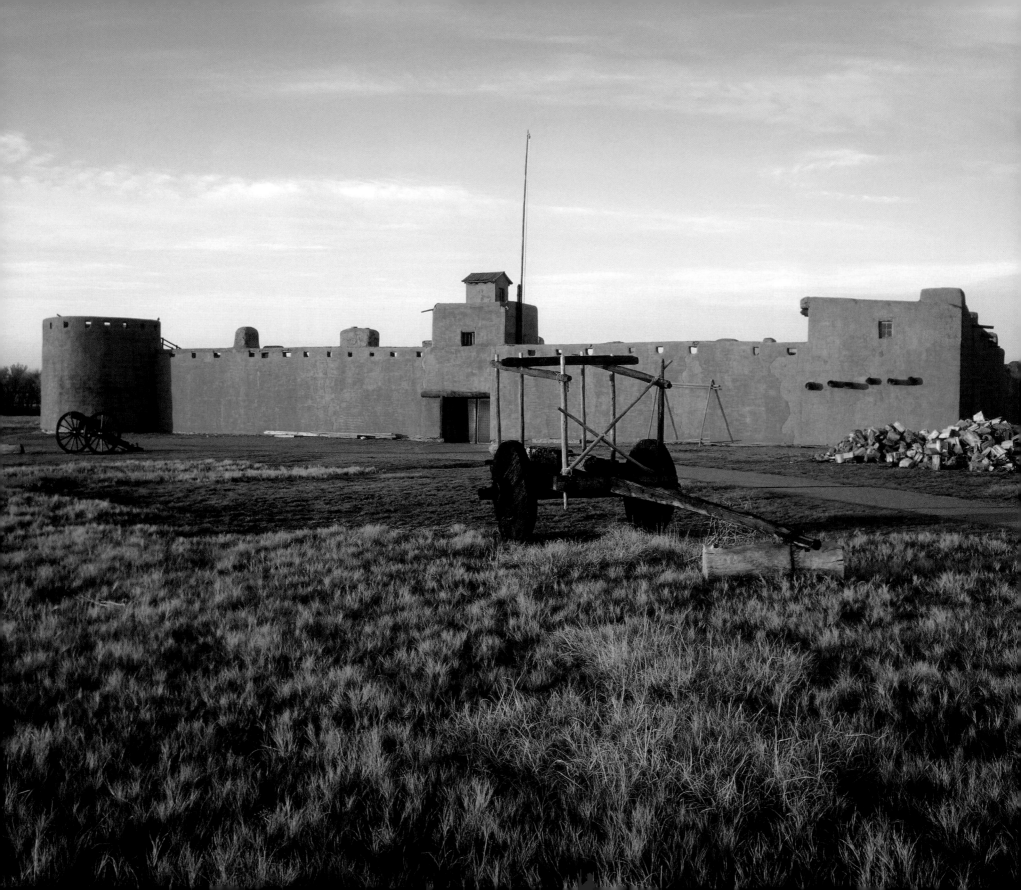

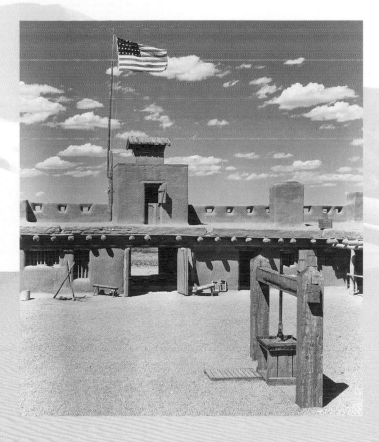

Left. Courtyard of Bent's Fort, 1942. Denver Public Library, Western History Collection, Photo: Don Koch

Opposite: Bent's Old Fort National Historic Site.

Before the Mexican-American War (1846-1848), Bent's Fort was located on the United States-Mexico border.

Many historical accounts of Bent's Old Fort mention its billiard room.

Bent's Old Fort National Historic Site

Buffalo postcard.

BENT'S OLD FORT, near present-day La Junta in southeastern Colorado, was originally built by William and Charles Bent, with Ceran St. Vrain, along the Arkansas River in 1833 to facilitate trade with the Southern Cheyenne and Arapahoe Indians, trappers, and travelers. The bulk of the adobe fort's trade was with the Indians for buffalo robes. Along with Fort Adobe to the south and Fort St. Vrain to the north, it soon became the heart of an early western trading empire, the St. Vrain Company. At the time, it was the only permanent settlement on the Santa Fe Trail between Mexico and Missouri. The fort was a welcome respite for travelers needing supplies, wagon repairs, livestock, good food, and camaraderie out in the middle of the vast "Great American Desert" of the Great Plains. During the war with Mexico in 1846, it became a temporary base for Colonel Stephan Watts Kearney's Army of the West. The fort was destroyed or abandoned under mysterious circumstances around 1849.

The current fort was reconstructed in 1976 using information from archeological excavations, original sketches, paintings, and diaries. Today, visitors, guided by interpreters dressed in period clothing, experience living history and rooms decorated with historically authentic supplies, foodstuffs, and tools. Bent's Fort truly gives the visitor a window to the wild and wooly past when the West was ruled by mountain men and Indians and the plains were plentiful with game and buffalo.

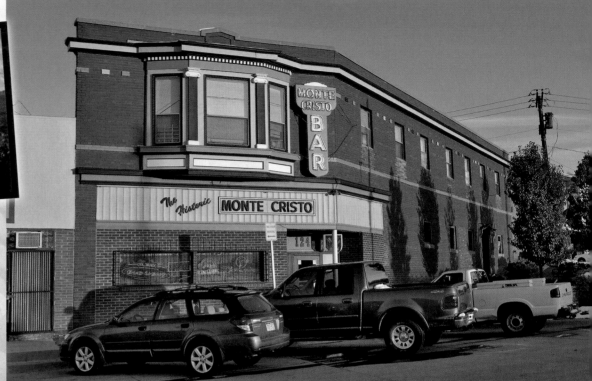

Man standing above Trinidad, early 1900s.
Denver Public Library, Western History Collection

Trinidad

Above: Monte Cristo Bar.
Opposite: First National Bank Building.

TRINIDAD, LOCATED IN SOUTHCENTRAL Colorado, was essentially founded because of its location north of Raton Pass, an important route to and from New Mexico and Santa Fe. It was initially settled in 1860 by twelve families from New Mexico, led by Felipe and Dolores Baca, who saw potential in the fertile soils of the Purgatoire Valley. Over the years that followed, the toll road over the treacherous pass grew increasingly busy with the demand for goods and supplies for Colorado's mining expeditions, and the town did a booming business servicing all the freightmen and cowboys passing through.

The route over Raton Pass was much desired by the railroad companies, and in 1878, the Atchison, Topeka & Santa Fe Railroad arrived in Trinidad. The following year, the train reached Raton, then made it all the way to Santa Fe in 1880.

Today, Trinidad is located along Interstate 25 and bears close to the same population as it did in its heyday: about 10,000. Its collection of old Victorian building and houses is one of the best in the West, and it is well worth a wander to get a sense of the Old West in all its frontier glory and charm.

Trinidad was truly a Wild West town, and many a famous western figures passed through it. Lawman Bat Masterson was sheriff here when the Earp brothers and Doc Holliday stopped for a time after their infamous 1881 shootout at OK Corral in Tombstone, Arizona.

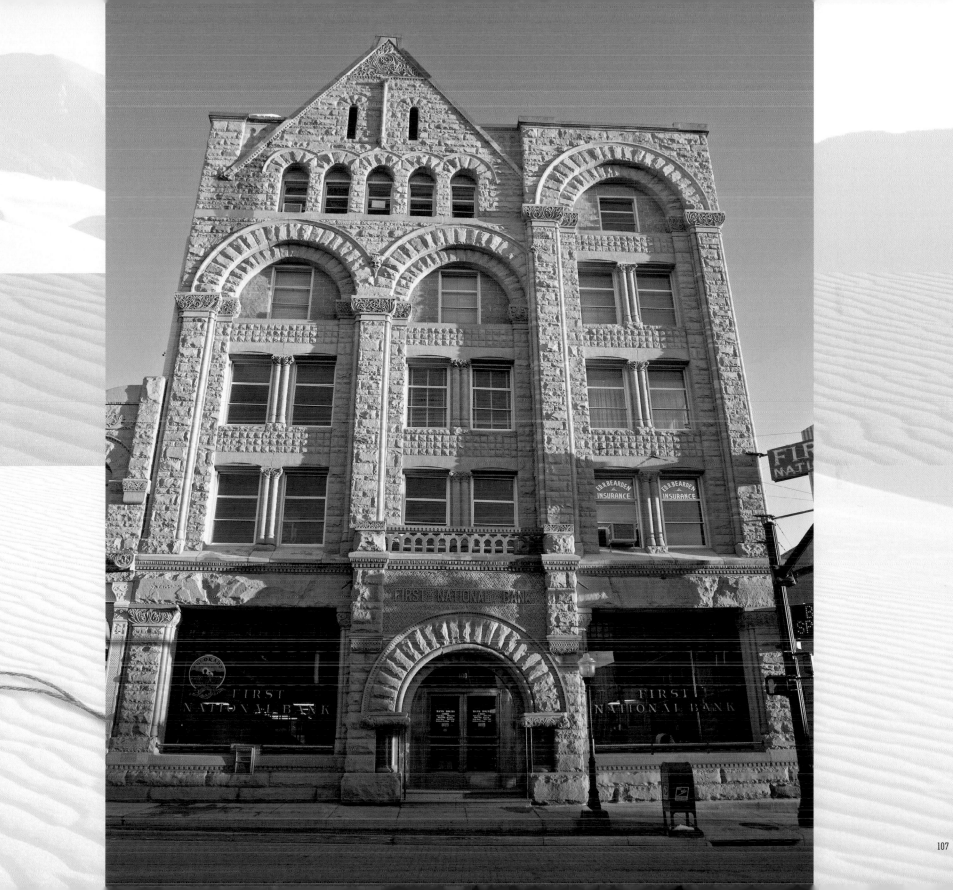

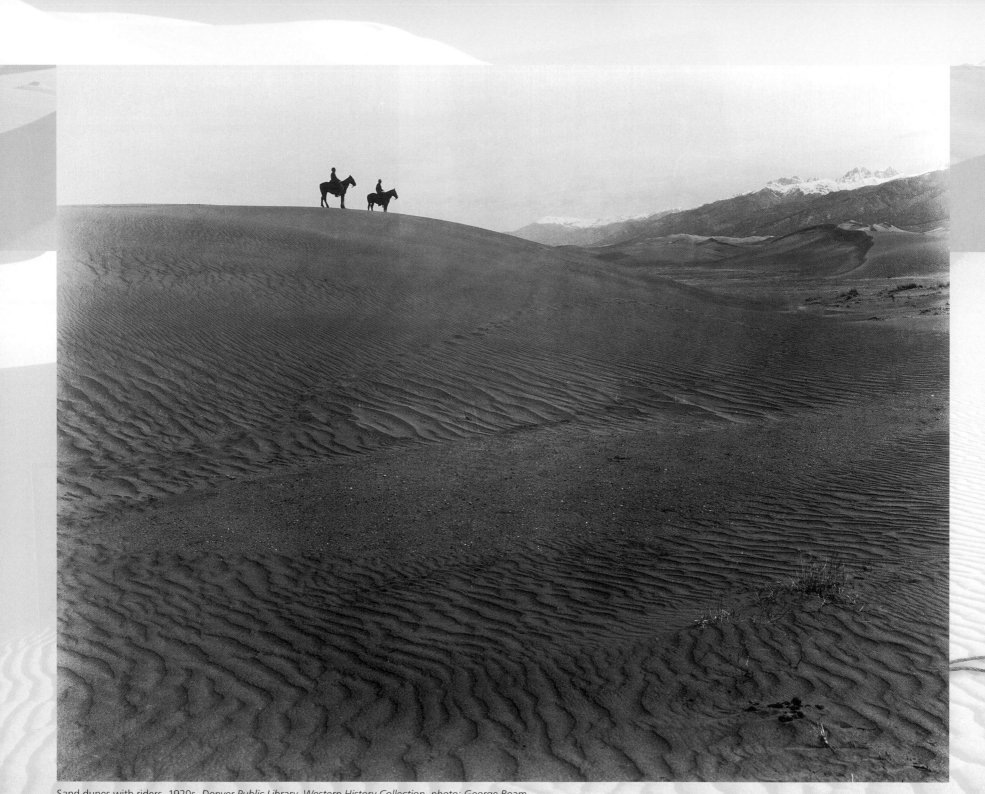

Sand dunes with riders, 1920s. *Denver Public Library, Western History Collection, photo: George Beam*

Great Sand Dunes National Park

GREAT SAND DUNES National Park, created initially as a national monument in 1932, is home to the largest sand dunes in North America; the dunes reach heights of up to 750 feet above the floor of the San Luis Valley in southcentral Colorado. The dunes were formed from windborne sand particles picked up from the valley floor. As the prevailing wind reaches the Sangre de Cristo mountain range to the east, it loses velocity and deposits the sand it carries at the base of the mountains.

At the base of the dunes, Medano Creek flows out of the mountains, and due to the shifting nature of the creek's pure sand bottom, a phenomenon known as "surge flow" occurs; that surge flow creates constantly changing waves and troughs within the creek. This phenomenon is best observed during high steam flows in spring and summer.

Other popular activities in the park include hiking/scaling the high dunes, sliding, sand boarding, and skiing the sandy slopes, as well as exploring the mountains and alpine lakes above. The park also has an excellent camping area near the base of the dunes.

On November 22, 2000, President Bill Clinton signed the Great Sand Dunes National Park and Preserve Act, ultimately leading to the area's national park status. With the aid of the Nature Conservancy, which purchased the adjacent Baca Ranch in 2004, the federal government added the ranch's 97,000 acres to the park, effectively tripling its size and adding Fourteener Kit Carson Mountain (14,165 feet) to it.

The wind that forms the dunes is a constant agent of change, causing the dunes to evolve and shift from day to day and erasing the footprints of yesterday's visitors.

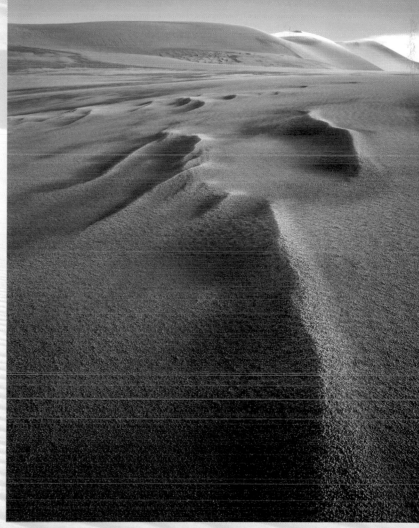

Sand dunes under frost.

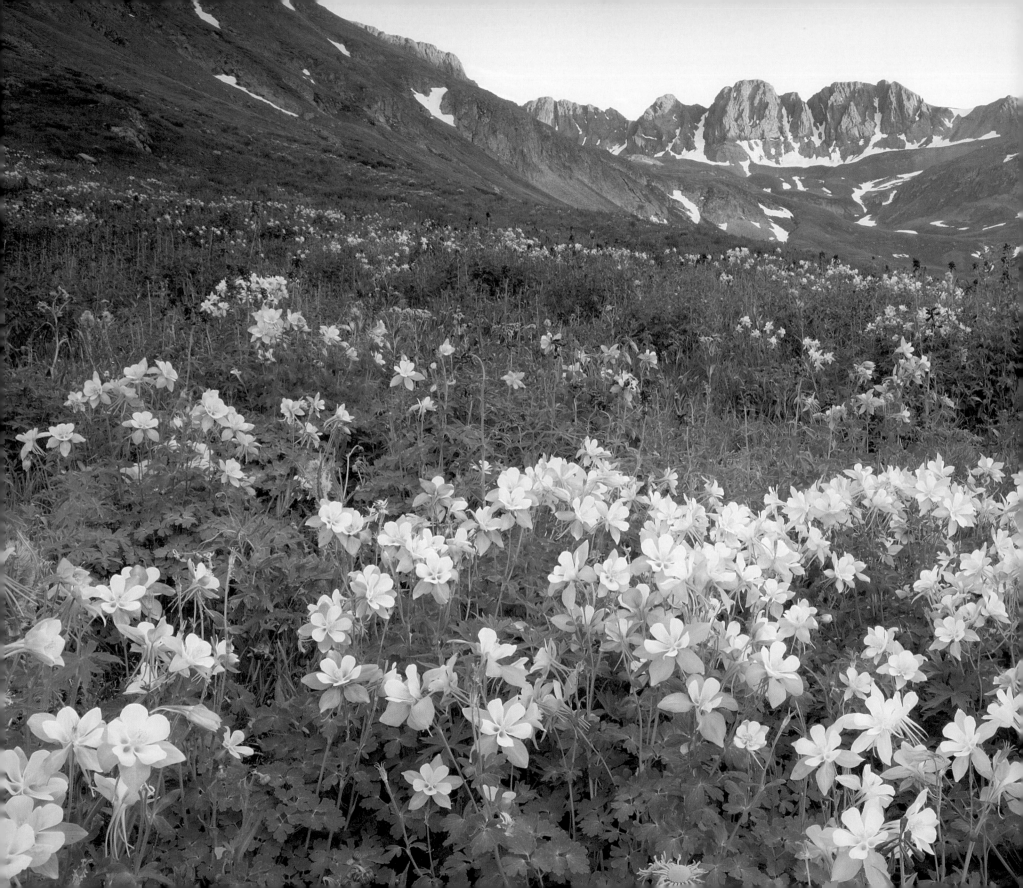

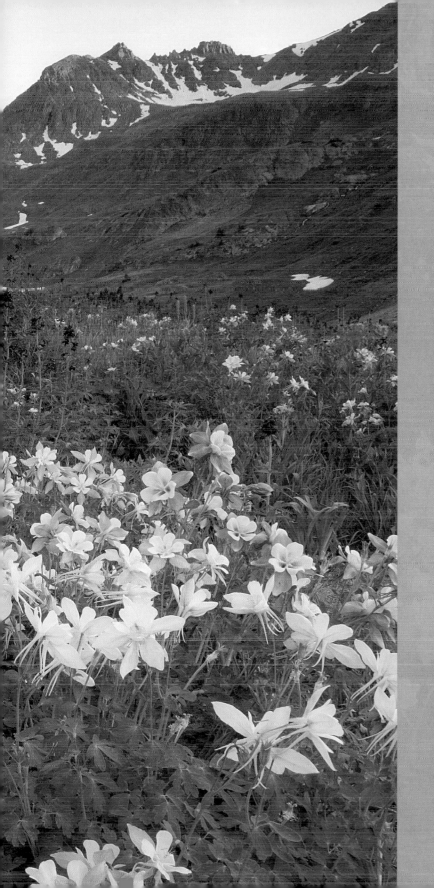

PART 6

Southwestern Mountains

After visiting the Southwestern Mountains of Colorado, you might ask yourself, "Does it get any better?" With some of the most spectacular scenery in the state, possibly the two best ski towns in the country (Crested Butte and Telluride), historic towns and railroads, plus world-class fishing, hunting, mountain-biking, hiking, and whitewater-rafting opportunities, the whole region inspires a level of enchantment hard to find anywhere.

Start in laidback, charming, and friendly Crested Butte, with its verdant valleys and peaks, epic mountain-biking trails, and incomparable skiing. Just to the south, Gunnison is a fly fisherman's paradise. Head farther south to the majestic San Juan Mountains and their historic trio of towns, Ouray, Silverton, and Telluride—all accessible from the famous Million Dollar Highway and all rich with history, scenery, and skiing terrain. Finish in classy, beautiful Durango, for whitewater recreation or a narrow-gauge train ride.

Any way you look at it, the Southwestern Mountains are a gold mine of experiences.

Handy Peak, seen from American Basin with wildflowers in bloom.

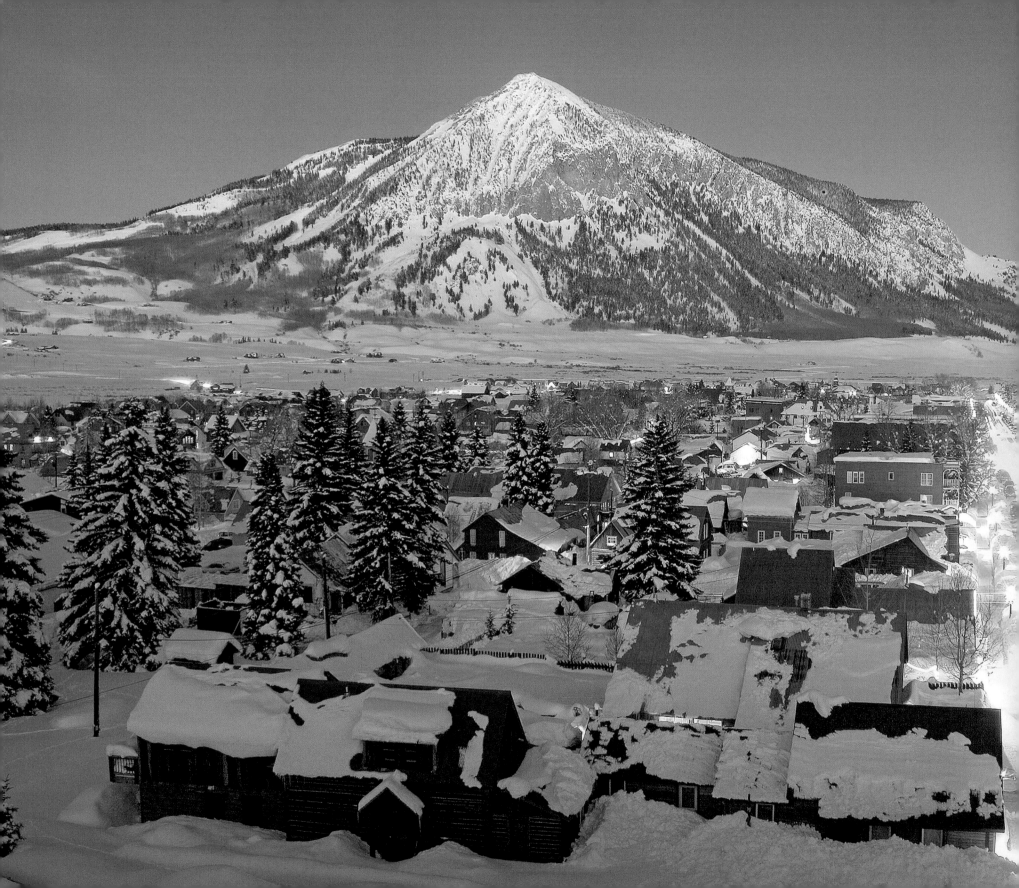

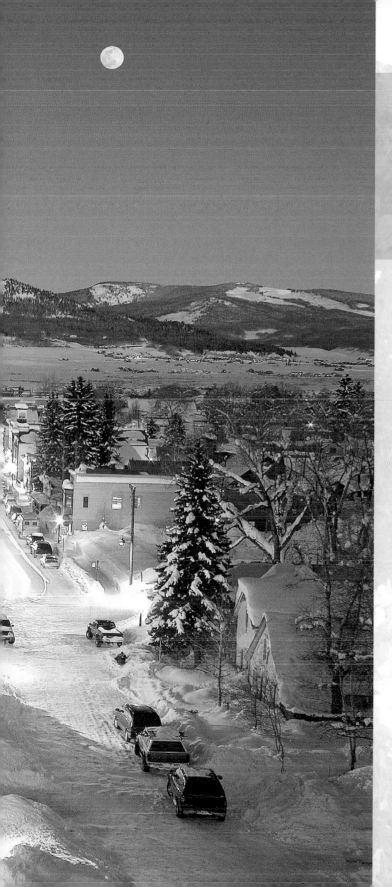

Crested Butte

COLORADO'S SKI RESORTS are, for the most part, old mining towns, as is Crested Butte. Crested Butte was not a "hardrock" mining town that got rich on gold and silver (although it started with high hopes of such riches). Rather, Crested Buttians made their living by mining coal and providing supplies to nearby towns and mining camps. As a result, most of the town's buildings weren't built from brick or stone, and no grandiose opera houses and hotels existed. But the town's small, wooden, Victorian-style houses and false-front western-style edifices are precisely what makes it so quaint, charming, and unpretentious.

(CONTINUED ON PAGE 114)

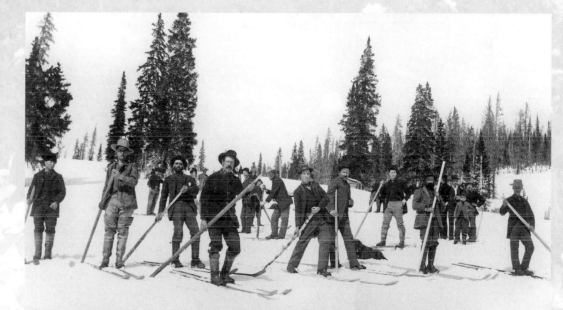

Above: Early skiers, 1883. *Crested Butte Mountain Heritage Museum*
Left: The moon rises over the town of Crested Butte and Mt. Crested Butte.

Crested Butte is well known for its steep extreme-limits runs on the Headwall and North Face, which attract extreme skiers from all over the world.

The National Mountain Biking Hall of Fame is located in Crested Butte, and the town touts itself as one of the birthplaces of the sport.

(CONTINUED FROM PAGE 113)

After the decline of coal mining in the late 1940s, Crested Butte's population declined precipitously, and only a few miners and ranchers remained to call it home. At the same time, skiing in Colorado was starting to catch on in a big way, and Crested Butte, with its cold climate and high average snowfall, had all the ingredients for this growing sport. In 1961, two investors from Kansas, Dick Eflin and Fred Rice, recognized the town's potential and built a rope tow three miles north of town, followed by a gondola in 1963. (Vail edged out Crested Butte for the honor of having the first gondola in the nation, by about a month.) So Crested Butte transformed from a dying mining town to a thriving ski-resort town, supplemented by a new town at the base of the ski area, Mt. Crested Butte, in 1974.

Today, Crested Butte is often spoken of as Colorado's last great ski town. Indeed, Crested Butte's laid-back, authentic, small-town attitude, along with its historic downtown, exudes a character rarely found in Colorado's other ski towns. The skiing here on the scenic peak of Mt. Crested Butte provides variety for all levels of skiers.

In summer, visitors to Crested Butte have access to numerous hiking trails, fishing, camping, horseback riding, and spectacular mountain biking.

Elk Avenue.

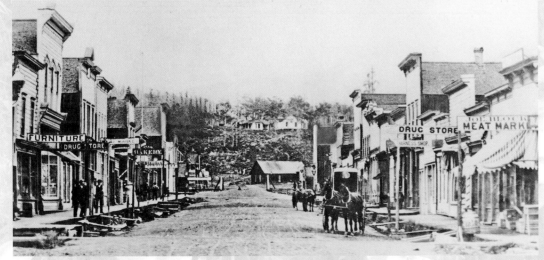

Elk Avenue, early 1880s.
Crested Butte Mountain Heritage Museum

Mountain Biking

Mountain biker,
Gunnison National Forest.

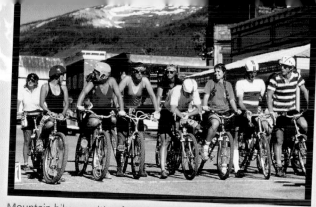

Mountain hikers waiting for race to start, Crested Butte, late 1970s.
Crested Butte Mountain Heritage Museum, photo: Sandra Cortner

COLORADO HAS LOTS of mountains, so it is no surprise that the state had a big influence on the inception and development of the sport.

One small town in particular, Crested Butte, has a layout that makes bicycling a simple and easy way to get around it. Locals in Crested Butte started tinkering with their old clunkers, adding fat tires and multiple gears, and taking their bikes out on the numerous mountain roads and trails that radiate from town. At one point, a group of these budding enthusiasts, who hung out at the Grubstake, a bar in Crested Butte, had the idea of riding these souped-up clunkers over Pearl Pass to Aspen to the Hotel Jerome. The first annual Pearl Pass Tour happened in September 1976, and despite the bent rims, burned-out brakes, and sore bodies that resulted from riding the rough and grueling four-wheel drive road, the event was a raging success.

News of the event spread fast and inspired a group of likeminded enthusiasts from Marin County, California, to join the tour, including Gary Fisher, the editor of *Bicycling Magazine* (a publication whose name is now synonymous with mountain biking). The Californians, after trying their latest inventions on this rough, mountainous ride, were inspired. Suddenly Crested Butte was part of the birth of a new sport, and though the sport's new gains were to continue in California, Colorado's influence was without question.

Today, mountain biking is an extremely popular sport in Colorado, and enthusiasts can access an endless variety of spectacular trails to ride—from dirt roads to single tracks.

An offshoot of cross-country mountain biking, downhill mountain biking has also become popular in Colorado. Many ski resorts have built trails with jumps, ramps, and obstacles for these bikers, who utilize the ski lifts to access the trails.

The first Pearl Pass Tour is said to have been Crested Butte cyclists' response to a group of motorcycle riders from Aspen, who made a trip in the opposite direction and came to the Grubstake bar to "steal all our women," as one Crested Buttian put it.

Gunnison

GUNNISON IS A SMALL but vibrant community along Colorado Highway 50 and dominated by Western State College (founded in 1911), tourism, and ranching. The proximity of spectacular fishing rivers and mountain biking, hiking, and skiing opportunities at nearby Crested Butte and Monarch ski areas makes Gunnison an ideal place to both live and visit.

Many mountain towns in Colorado were born of the western boom mentality, and Gunnison was no exception. In 1874, Sylvester Richardson, a restless entrepreneur out of Wisconsin and Denver, formed a party of ambitious settlers to found the town that he envisioned would become the hub of all of Colorado. The first couple of years proved rough going, with cold, snowy winters. In addition, the attraction of mining in the nearby San Juan and Elk Mountains lured settlers away, and the threat of Utes from the nearby reservation lands was a problem. Slowly, however, ranchers and others began to filter in to the "Gunnison Country," and with the San

Above: Enjoying a summer day on Main Street.
Below: Tomichi Avenue, 1881. *Photo courtesy Bruce Hartman*
Opposite inset: Ute Indians and one white man on horseback in front of Preston & Verry News Depot, 1880. *Photo courtesy Bruce Hartman*

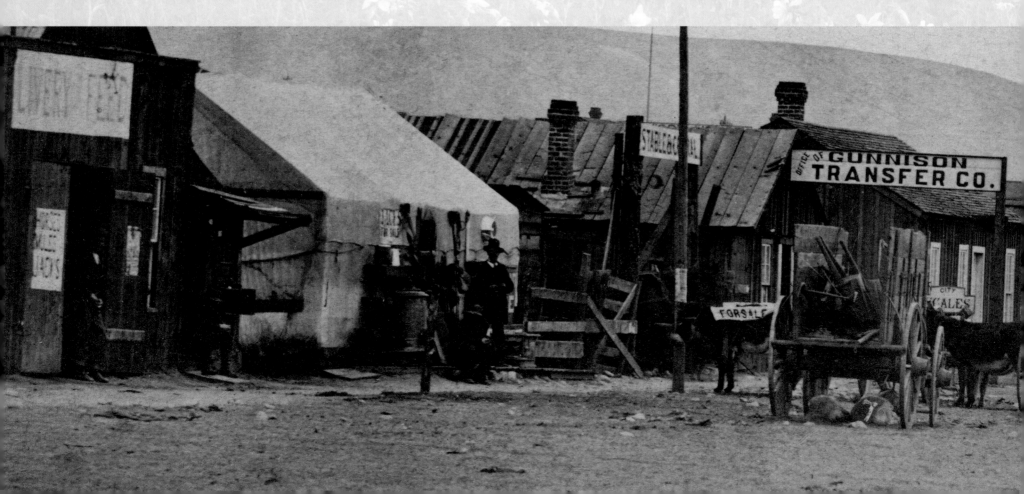

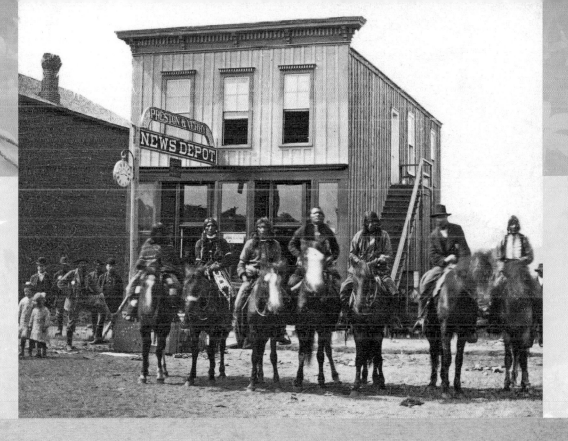

Juan and Leadville mining booms on the wane and new silver and gold discoveries nearby, Gunnison was poised to be the next big boomtown.

And boom it did. Within the next few years, thousands descended upon the town from every direction, braving the mountain passes. In addition, in 1881, the Denver & Rio Grande Railroad, in a race with the Denver South Park Railroad, beat the latter in laying track into Gunnison. Although the boom was short lived, Gunnison was not as dependent on gold and silver production as other towns in the area, and it survived as a ranching and supply town for nearby coal mines.

Hiking, Climbing, and Backpacking

FOR ADVENTURES ON FOOT, there is no place like Colorado. With eleven national forests, thirty-three wilderness areas, Bureau of Land Management lands, four national parks, four national monuments, more than two hundred state and federal wildlife areas, and forty-one state parks, the state was made for hiking. Thousands of trails wind through the state, particularly in the mountains, where high-altitude trails above tree line can take your breath away. For peak baggers, there is the additional lure of fifty-three Fourteeners—peaks above 14,000 feet. Longs Peak, at an altitude of 14,259 feet, is perhaps the most famous (see pages 50-51).

The first recorded rock climb in Colorado was of the Third Flatiron, above Boulder, in 1906. By the 1940s, the Flatirons, Boulder Canyon, and Eldorado Canyon had become national climbing meccas and are still renowned for the sport today.

Backpackers also have a plethora of wilderness areas for their high-country adventures. The Colorado Trail, completed in 1987, winds its way from just outside of Denver 483 miles to Durango.

Colorado has more Fourteeners than any other state.

Hikers near Sayres Peak, Central Mountains, 1894. *Denver Public Library, Western History Collection*

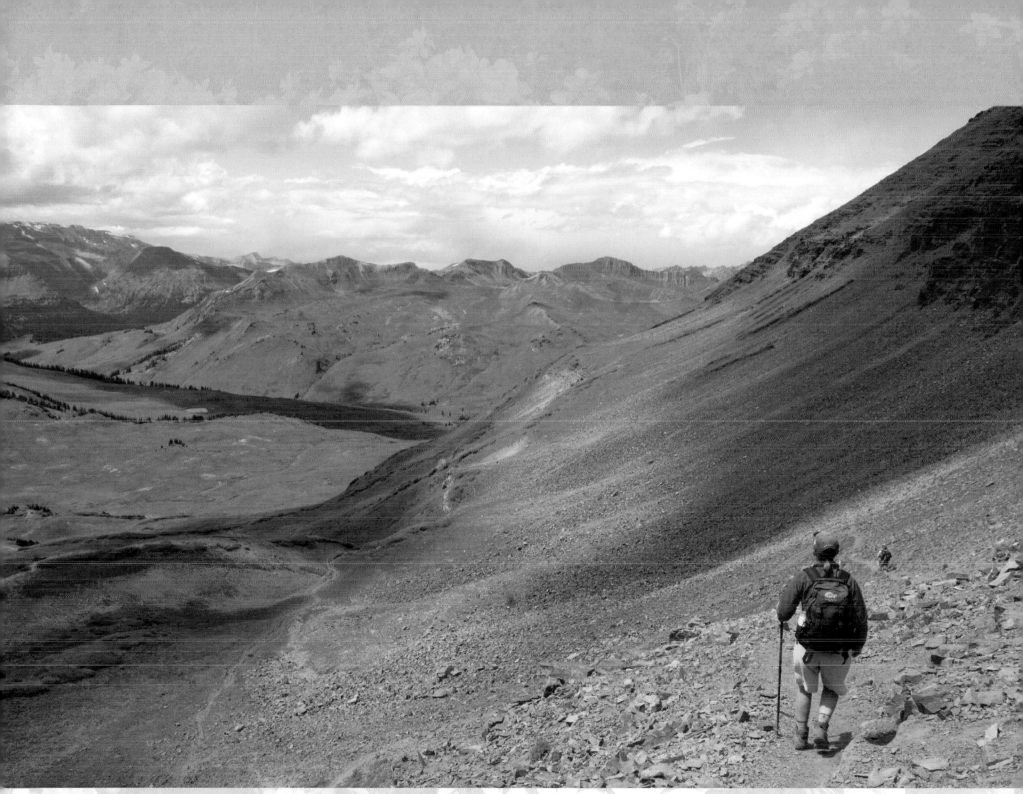

Hikers traveling from Aspen to Crested Butte via West Maroon Pass, White River National Forest.

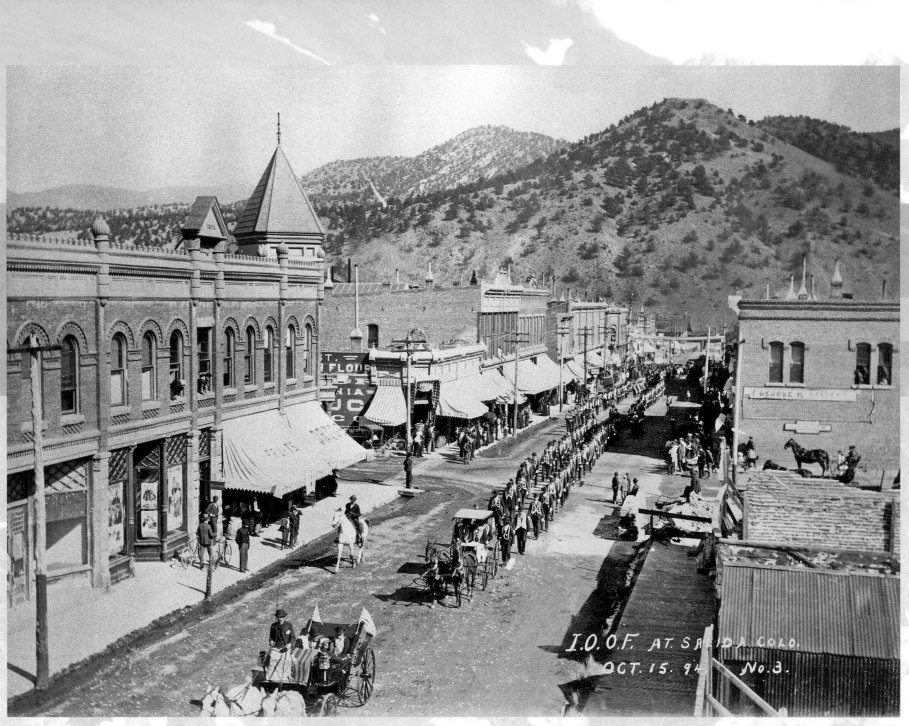

I.O.O.F. AT SALIDA COLO.
OCT. 15. 94 No. 3.

Parade on F Street, 1894. *Denver Public Library, Western History Collection*

Salida

The Salida Whitewater Park runs through the downtown and is the center of FIBArk, an annual festival featuring whitewater competitions, vendors, and music. Begun in 1949, FIBArk (short for "first in boating on the Arkansas") is the nation's oldest whitewater festival. It was that year that six boats entered the river to race 57 miles down to Canyon City through the treacherous rapids of the Royal Gorge.

Boaters on the Arkansas River.

THOUGH GOLD WAS FOUND in the Arkansas Valley in 1860, it was the silver rush to Leadville in the late 1870s that was responsible for the formation of Salida. Once the Denver & Rio Grande Railroad won the rights to access the route up the Royal Gorge of the Arkansas River, the company quickly laid track up the Arkansas valley to Leadville. As it did, it bought homesteaders' lots and laid out the town of Salida in May 1880.

Salida became a major junction for the railroad, and for a time, the town thrived. But like most mining-dependent towns in Colorado, it saw significant economic decline at the turn of the nineteenth century as mining became less profitable. The Denver & Rio Grande's presence declined sharply after the 1950s, and the line over Tennessee Pass now sees little use. But agriculture, both ranching and farming, has remained a dominant economic factor in this fertile valley.

Today, the charming town of Salida is known as somewhat of a laid-back recreational destination. The Arkansas River is a major attraction for its whitewater rafting, kayaking, and world-class fly-fishing. The mountainous surroundings provide numerous hiking and mountain-biking trails, including access to a number of 14,000-foot peaks. Winter-recreation enthusiasts have close access to Monarch Ski Area and surrounding cross-country ski and snowmobile trails.

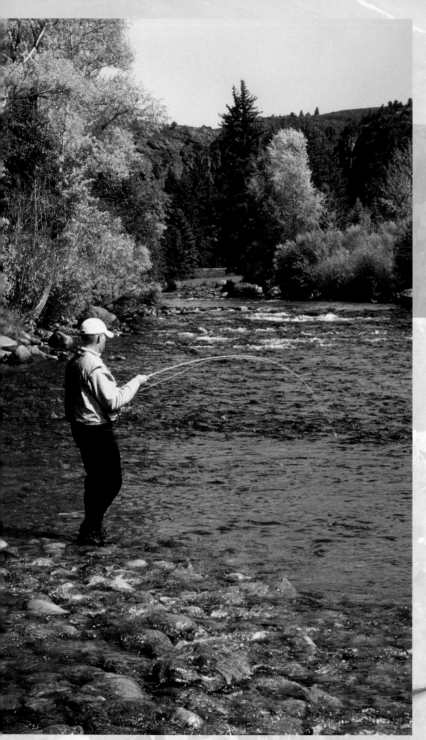

Fly-fishing the Gunnison River.

Trout fisherman can rest assured that 168 miles of Colorado's streams are "Gold Medal" waterways, designated as excellent angling opportunities by the Colorado Wildlife Commission.

Fishing

FISHING IN COLORADO is truly world class. Attracting enthusiasts from around the globe, the state is known for its cold, fast-flowing waterways and amazing trout fishing. Species include rainbow, brook, brown, cutthroat, and lake trout. Kokanee salmon can be fished in fall spawning season as they make their way up rivers such as the Gunnison and the East River.

From the famous rainbow trout in a high mountain stream to the walleye in an Eastern Plains lake, Colorado's diversity topography provides fishermen with endless opportunities. In addition to its 9,000 miles of streams, Colorado has more than 2,000 lakes and reservoirs. There are numerous opportunities to fish warm-water species on the Eastern Plains. In all, the state has some thirty-five fish species.

From high mountain tarns to swift rivers perfect for catch-and-release fly-fishing to warm-water reservoirs on the plains, Colorado is a fishing mecca. Not only is the fishing excellent, but the scenery that surrounds you is, in short, a fisherman's paradise.

Colorado's warm-water fish include walleye, yellow perch, crappie, largemouth bass, channel catfish, northern pike, bluegill, carp, and bullhead.

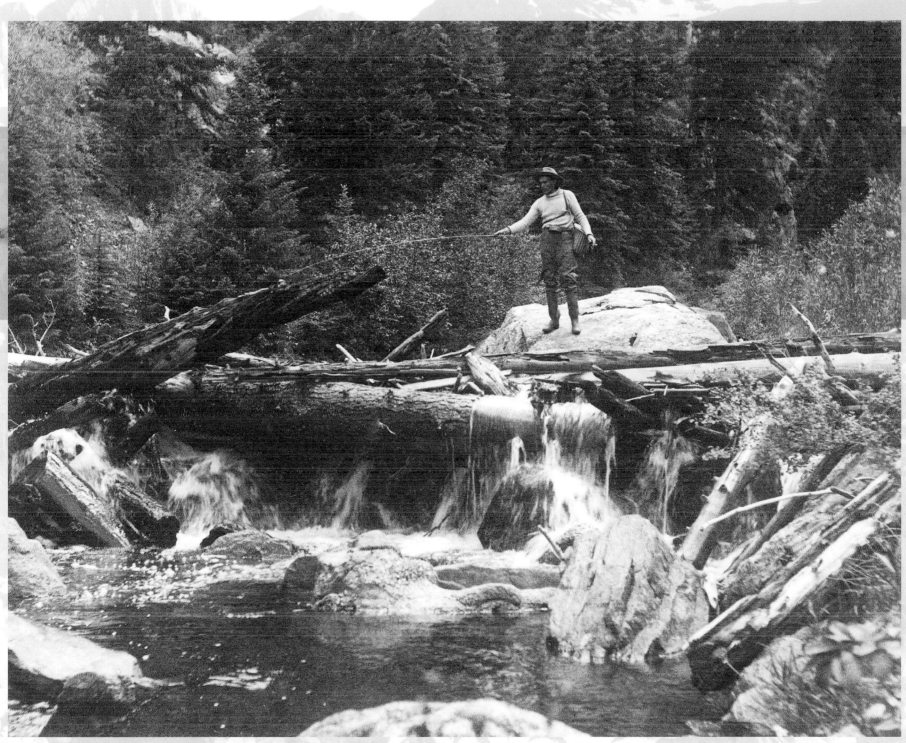

Fisherman on the South Platte River, 1900. *Denver Public Library, Western History Collection, photo: James B. Brown*

LAKE CITY, surrounded by the formidable San Juan Mountains, is one of the more isolated towns in the state, but also a popular tourist destination. Like most of the towns in the San Juans, it was founded as a gold and silver mining camp in the early 1870s, and when the railroad finally arrived in 1889, the town flourished. When the silver boom ended in the mid-1890s, the town population dropped precipitously.

Lake City is famous for the state's most renowned cannibal, Alferd Packer. In 1874, Packer and five other prospectors set out to find gold in the San Juans. The problem was, it was January and no time to be entering the high country on foot. But set out they did, and they soon found themselves starving and desperate in the deep snow a couple of miles from present-day Lake City. By spring, the only person to come out of the mountains was Packer, looking relatively fit. Although the stories diverge from there, one thing is certain: Packer survived by eating the flesh of his companions.

Today, the well-preserved Victorian town is a draw for summer tourists exploring the San Juans. Numerous old mining roads radiate from Lake City, providing access to some of the most breathtaking scenery in Colorado. It is an ideal jumping off point for four-wheel enthusiasts, hikers, mountain bikers, fisherman, hunters, and sightseers. The Silver Thread Scenic Byway, connecting Lake City to Creede and South Fork, is also stunning.

Lake City was named after nearby Lake San Cristobal, which was formed when a rare natural earthflow, now called the Slumgullion Slide, blocked the Lake Fork of the Gunnison River. It is the second largest natural lake in Colorado.

Lake City

Lake City is one of Colorado's largest historic districts.

Lake City, 1880s. *Denver Public Library, Western History Collection*, photo: William Henry Jackson

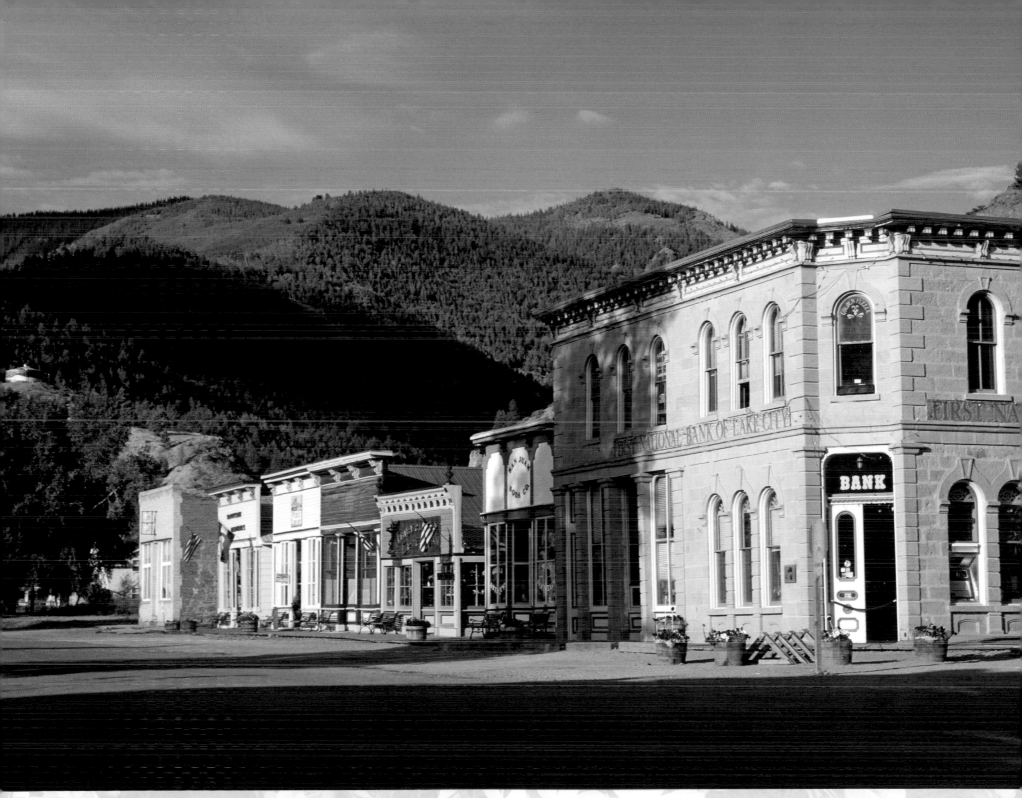

Historic buildings in Lake City.

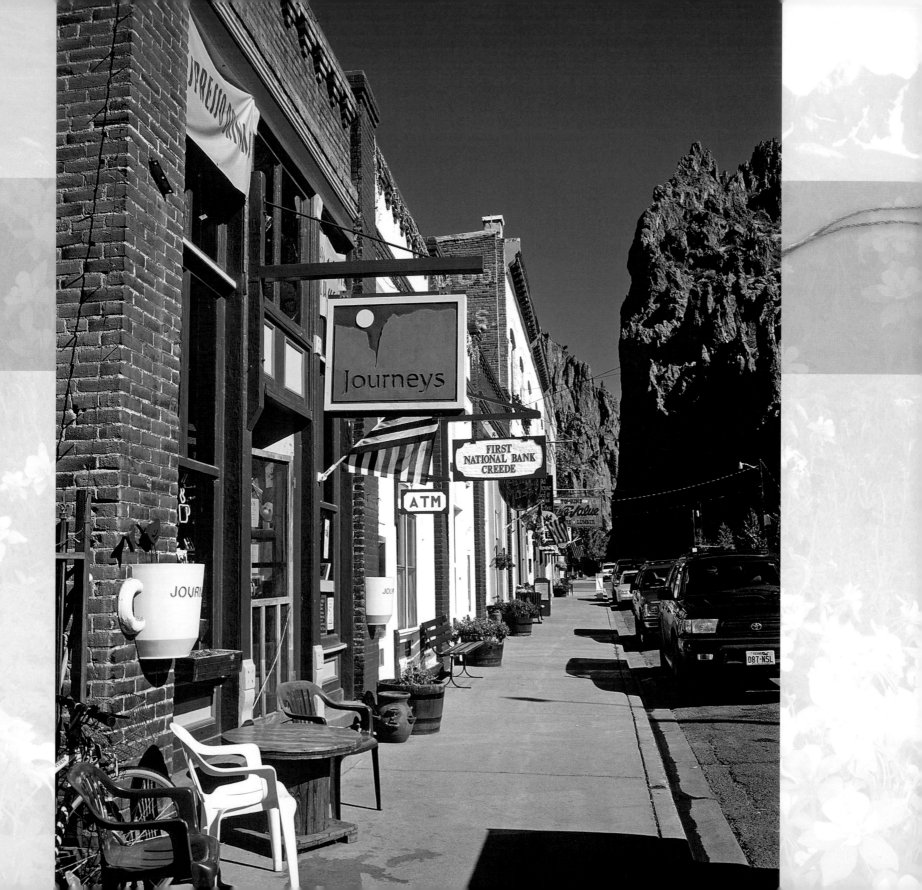

Left and below: Main Street at the height of the mining boom, 1890. *Denver Public Library, Western History Collection*

Creede

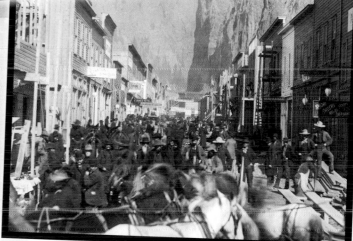

THOUGH CREEDE SHARES a common history with other mining towns in Colorado, its background is perhaps just a shade more colorful. Though ranchers and farmers began to move into the fertile bottomlands provided by the Rio Grande in the 1870s, the area's real boom days begin with the discovery of silver in Willow Canyon in 1889 and arrival of the railroad. By the end of 1891, Creede's population had soared to 10,000 souls.

At about this time, Denver city officials were implementing major reforms to restrict gambling clubs and saloons. Many owners of the threatened establishments apparently saw an opportunity in Creede and moved their businesses there. Among them was the infamous con man Jefferson Randolph "Soapy" Smith. Using prostitutes to con property owners, Soapy soon became de facto town boss, with law enforcement in tow. Other famous characters of the Wild West that spent time here include lawman Bat Masterson and Bob Ford, the assassin of Jesse James. Ford would later be gunned down in his Creede tent saloon in 1892 by Edward O'Kelley.

Like all Colorado silver towns, Creede experienced a major decline after the Sherman Silver Act was repealed in 1893. Mining—for zinc and lead ores—continued, however, until 1973.

Today, Creede is a quaint historic mining town, set at the mouth of spectacular Willow Canyon and popular with tourists visiting the San Juan Mountains.

Opposite: Shops and businesses on Main Street.

SITTING AT THE END of a box canyon in the rugged San Juan Mountains of southwestern Colorado, Telluride is a spectacularly located town. Founded in 1878, it was named for the chemical element tellurium, which is often found with gold and silver deposits. Though no actual tellurium was found in the area, plenty of gold and silver was, and as a result of the mines that extracted it, the town thrived.

Growth was slow at first; given the precipitous nature of the terrain, supplies at first arrived only by mule train, then by toll road, and finally, in 1891, by rail, enabling the mines and the town to expand to their full potential. The City of Gold, as it was known, bustled with saloons, a busy red-light district, fancy hotels, restaurants, and a plethora of successful businesses.

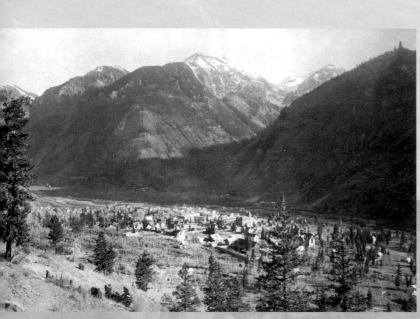

Telluride, 1892. *Denver Public Library, Western History Collection, photo: William Henry Jackson*

Telluride

The Telluride Film Festival has been drawing movie lovers to the mountain town since 1973. The festival program, including what films will be shown and which filmmakers will be attending, is never announced in advance but revealed to the press and visitors only on opening day.

Telluride Ski Resort.

A downturn in Telluride's fortunes followed—one that included labor strikes, World War I, and the disastrous influenza epidemic of 1918 (where Telluride lost 10 percent of its population). And by 1929, mining, and the riches that it brought, had all but ended.

Telluride struggled to make ends meet through the years until entrepreneur Joe Zoline saw its potential as a ski resort, and in 1972, its first lift opened. Telluride's growth as a ski area was steady over the years, but the 1990s saw the development of the new Mountain Village nearer to the ski slopes, and the town enjoyed a newfound popularity among the rich and famous. Suddenly, Telluride was the place to be, and it found itself in the ranks of Aspen and Vail. Fortunately, the locals have fought hard to keep the town's funky character intact, and in many respects, they have succeeded. Telluride's wonderful music festivals (such as the world-famous Telluride Bluegrass Festival), classic historic architecture, and laid-back attitude, along with a world-class ski area, combine to make this one of Colorado's great resort towns.

Opposite: Telluride in winter.

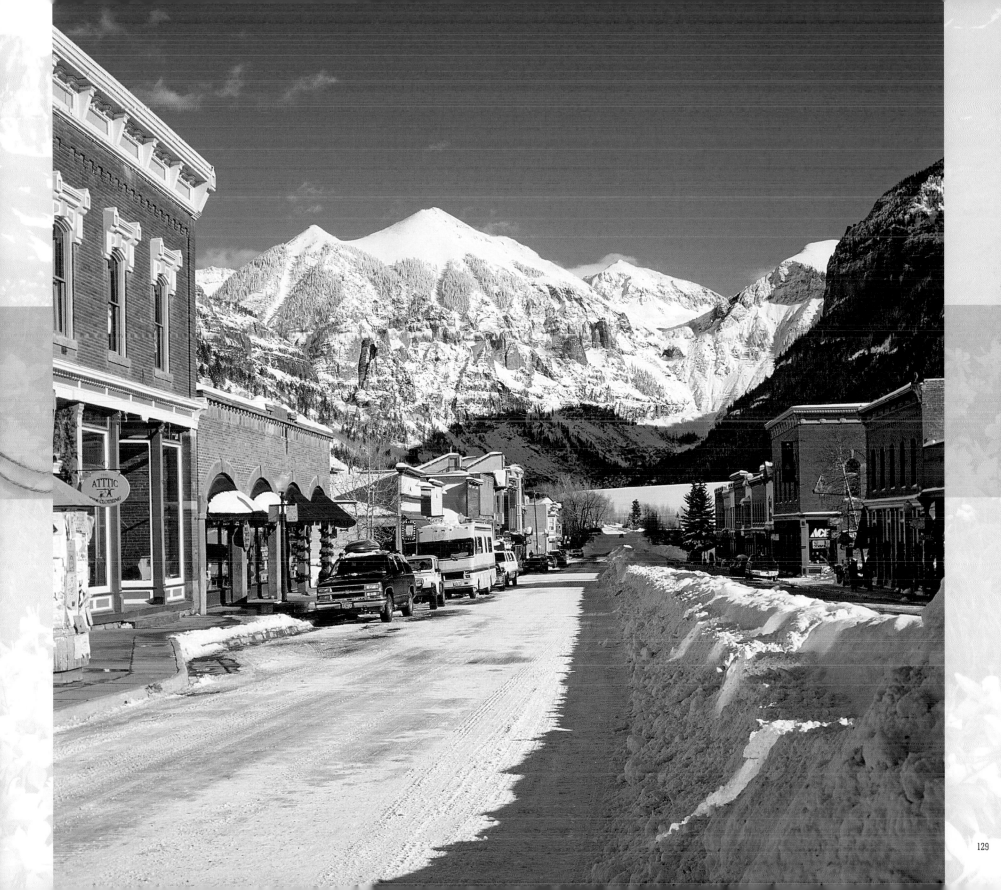

IN 1873, the Ute chief, Ouray, with a heavy heart, signed the Brunot Treaty relinquishing much of the San Juan Mountains to white settlers. The town of Ouray, founded in 1876, was named in his honor. Just a few years later, due to multiple discoveries of precious metals in the area, the town brimmed with businesses and grandiose Victorian architecture. In 1888, the town greeted the arrival of the Denver & Rio Grande Railroad, and its fortune as a booming mining town seemed secure. However, when the price of silver fell in 1893 with the repeal of the Sherman Silver Act, the future of the town suddenly seemed in peril. Fortunately, silver was not the only precious metal in the area, and in 1896, Thomas Walsh discovered a highly productive gold lode in what became the Camp Bird Mine.

Because of its location among the dramatic peaks of the rugged San Juan Mountains and along Colorado's "Million Dollar Highway" (Colorado Highway 550), which rolls over spectacular Red Mountain Pass and Molas Pass to Silverton, Ouray's current economy is fueled almost exclusively by tourism. The "Switzerland of America," as the town calls itself, is a prime location for hiking, four-wheeling, and, in July, wildflower viewing, particularly up at Yankee Boy Basin. In winter, Ouray becomes a mecca for ice climbers. For a more relaxing activity, tourists can soak in Ouray's famous hot springs, the reason Chief Ouray and the Uncompahgre Utes treasured the area so many years ago.

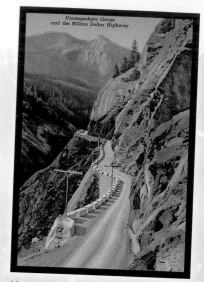

Uncompahgre Gorge and the Million Dollar Highway.

Ouray

The Camp Bird Mine made its owner, Thomas Walsh, a millionaire. He generously shared his wealth with the town of Ouray, donating the funds to build its library.

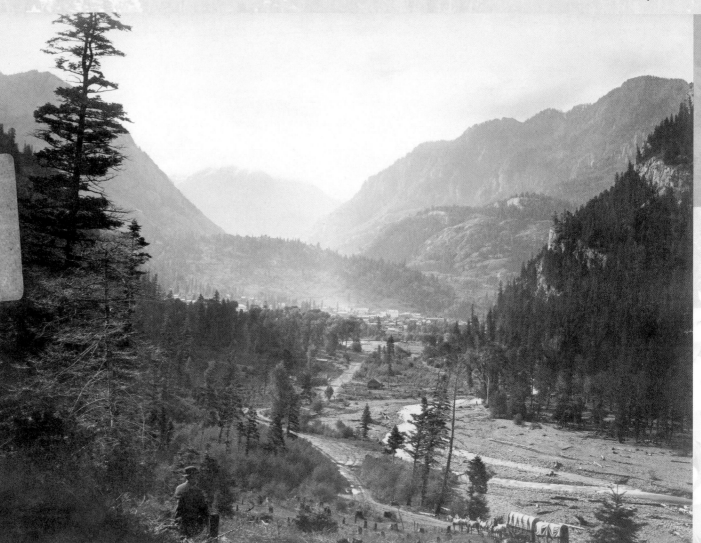

Ouray, 1874. *Denver Public Library, Western History Collection, photo: William Henry Jackson*

Ouray.

Ouray is home to the world's first ice-climbing park and hosts the annual Ouray Ice Festival.

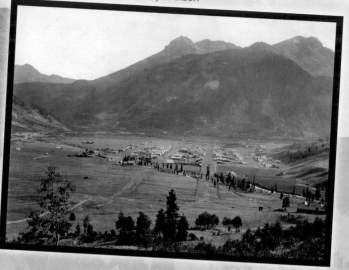

Silverton, 1890s. Denver Public Library, Western History Collection, photo: William Henry Jackson

At 13,487 feet, Silverton Mountain is the highest ski area in North America.

Silverton

AS ITS NAME implies, Silverton, or "silver by the ton," was a mining town. But it was gold, not silver, that was originally found in 1860 by Charles Baker and party of prospectors. They established a camp, but their finds did not pan out with placer mining techniques. With the advent of hard-rock mining and the Utes' removal from the San Juan Mountains after the Brunot Treaty of 1873, the area soon swarmed with prospectors and fortune seekers. Access to the region's rich mineral resources were many, and as mines began popping up everywhere, Silverton was a major center. Because the town is located in a valley at over 9,000 feet, the winters were harsh, and death from snowslides was a common occurrence for the miners. Nevertheless, they persevered, and the town thrived, particularly after the arrival of the railroad in 1882, which eventually connected the town to Durango. Mining in Silverton saw a decline after 1893, but it continued longer than it did in most towns; Silverton's last mine closed in 1991.

Located along the "Million Dollar Highway" (Colorado Highway 550) and home to the historic Durango & Silverton Narrow Gauge Railroad (see pages 136-137), Silverton is today primarily a tourist stop, particularly for the crowds who arrive on the Durango & Silverton narrow gauge train several times a day. Silverton's broad streets and historic Old West architecture reflect a rough-and-ready ambiance from its mining heyday, and the dramatic mountain scenery provides a fitting, rugged backdrop.

In winter, Silverton Mountain provides one of the most distinctive ski experiences in the country. The mountain receives an average annual snowfall of more than 400 inches. Access to it is via just one ski lift; however, this lift provides access to 1,819 acres of off-piste, ungroomed, advanced-level powder skiing (both guided and unguided).

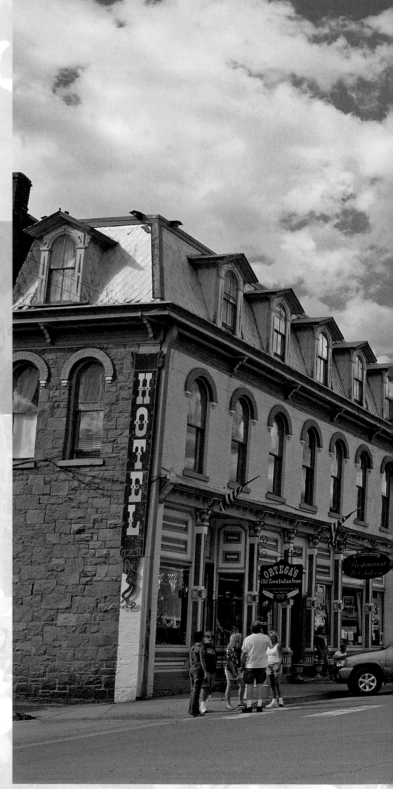

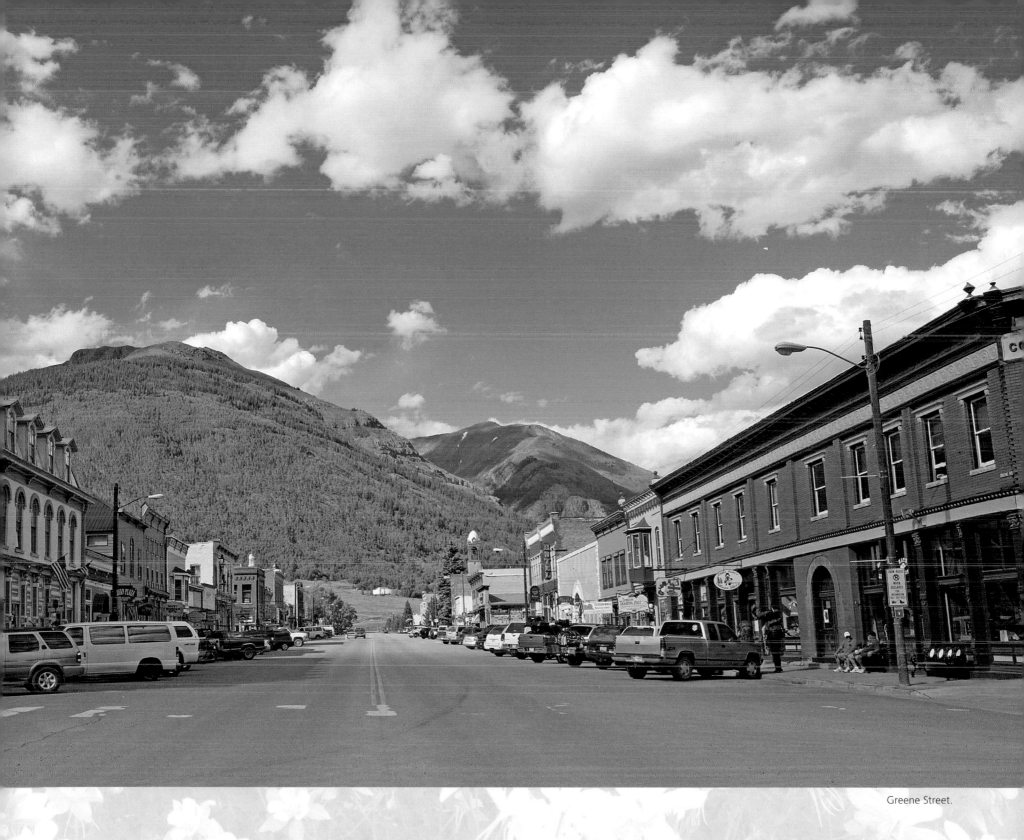

Greene Street.

AS MINING PRODUCTION in the San Juan mining district developed and increased in the late 1870s and 1880s, towns such as Silverton, Telluride, Rico, and Ophir demanded supplies, agricultural products, livestock, and timber. The Denver & Rio Grande Railroad saw this new market and made its railhead in what would become Durango in 1880; it later extended its line to Silverton and Ouray, with spurs to Telluride and other smaller towns. The owner of the Denver & Rio Grande, William Palmer, also built a smelting facility in Durango and bought a limestone quarry and several coal mines in the area.

Durango boomed from the resulting mining-fueled business and grew rapidly. When the mines' outputs later dwindled and the market for gold and silver declined, Durango became more of an agricultural town, where ranching and logging dominated.

Today, the town's economy still depends on the bounty of the mountains, but mostly in the form of tourism. The famous Durango & Silverton Narrow Gauge Railroad (see pages 136-137) makes Durango its base, drawing thousands of tourists every year. The Animas River runs right through town and provides excellent whitewater opportunities, and the surrounding mountains are replete with numerous recreational options, including hiking, camping, and mountain biking. In winter, the nearby Durango Mountain Resort and Wolf Creek Ski Area provide fantastic skiing. With its laid-back attitude, beautiful and well-preserved Victorian architecture, and dozens of cafes, restaurants, brewpubs, and art galleries, Durango is well worth a visit.

Musicians on Main Street.

Most of Durango's first buildings were built of wood, but in 1889, a disastrous fire destroyed much of the downtown area. Many of the subsequent buildings were built of more fire-retardant brick, which is why so much of the town's resplendent Victorian architecture survives today.

Durango

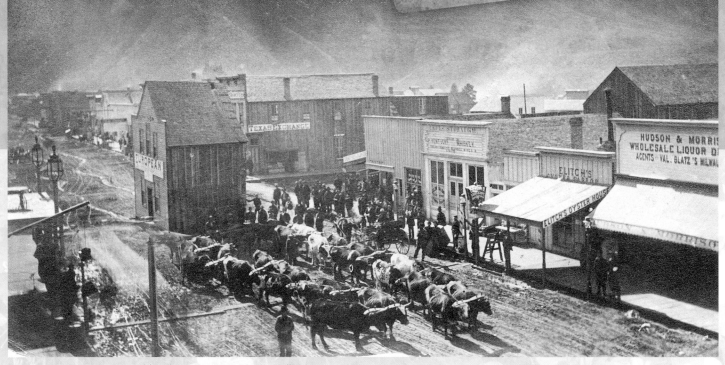

Main Street, 1881. *Denver Public Library, Western History Collection*

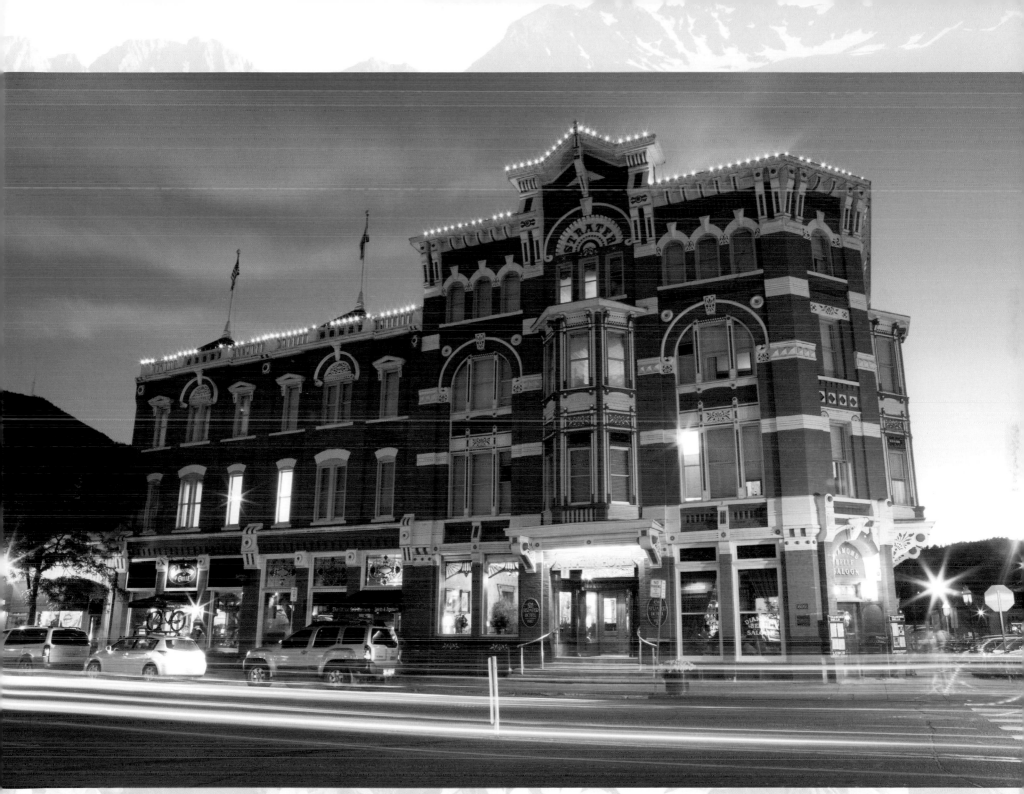

The Strater Hotel.

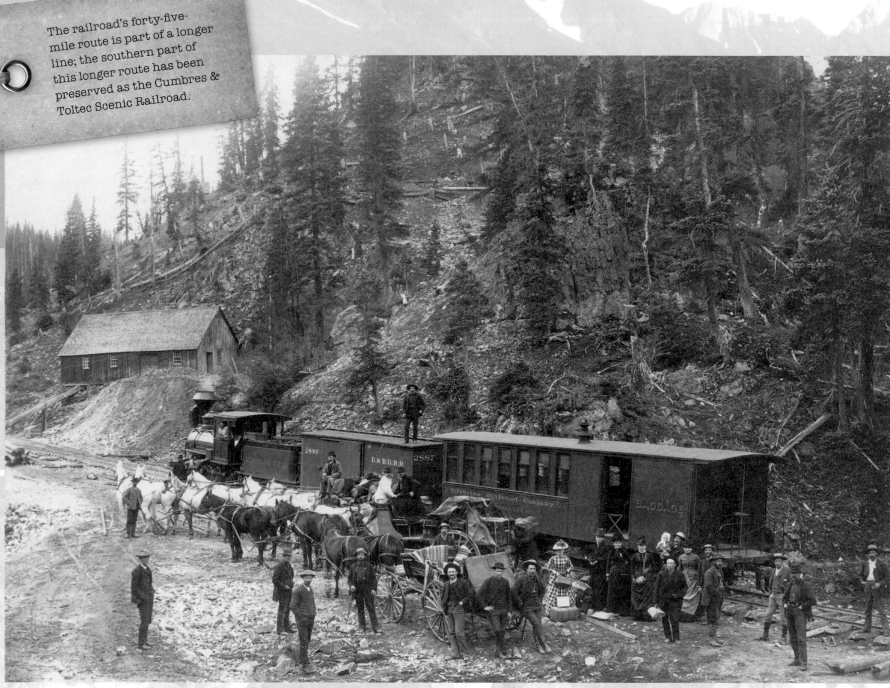

The railroad's forty-five-mile route is part of a longer line; the southern part of this longer route has been preserved as the Cumbres & Toltec Scenic Railroad.

Silverton Train, 1888. *Denver Public Library, Western History Collection, photo: William Charles Goodman*

The Durango & Silverton Narrow Gauge Railroad

WINDING ITS WAY through the stunning scenery of the towering San Juan Mountains, to and fro between what used to be major mining centers in the 1880s, the Durango & Silverton Narrow Gauge Railroad offers riders a peek into the rugged, romantic days of the Wild West. The railroad was originally built as part of the Denver & Rio Grande Railroad to service the mining towns in the San Juans, hauling silver and gold ore, as well as supplies, for the mines and towns.

The railroad first arrived in Durango in August 1881 and reached Silverton by July 1882. This relatively fast construction was a major feat considering the mountainous terrain, weather obstacles, and water crossings that had to be overcome. This engineering accomplishment was recognized in 1968 by the American Society of Engineers, which designated the line a National Historic Civil Engineering Landmark.

The steam-powered locomotives used today on the line were built in the 1920s, and some of the cars and equipment date as far back as the 1880s. The train makes a round trip once a day, leaving Durango in the morning and making a two-hour, fifteen-minute stop in Silverton before heading back to Durango. The entire journey takes three and a half hours. The train operates in winter, but on a more limited schedule, and does not go all the way to Silverton.

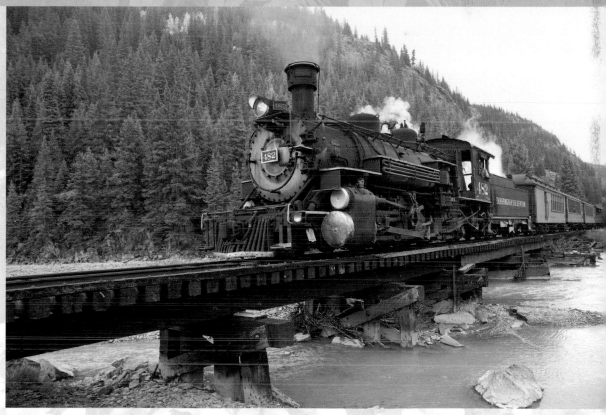

A Durango & Silverton Narrow Gauge Railroad train.

On its journey between Durango and Silverton, the railroad crosses the Animas River five times.

137

Train engine, Grand Junction.

Railroads

THE DEVELOPMENT OF railroads in Colorado, and their ability to access and transport people, hardware, supplies, and ore, was probably the most important factor in the modern evolution of the state. After gold was discovered, starting in the Denver area and progressing into the mountains, pressure to transport men and materials grew. Horses and wagons proved slow and inefficient, particularly with the increasingly modern mining techniques and the equipment and materials they required.

In 1890, Colorado gained its first railroad when the Denver Pacific built a spur to meet the Union Pacific in Cheyenne, Wyoming, and the Kansas Pacific built a line directly to Denver from Kansas City. The rush was on.

General William Jackson Palmer, founder of the Denver & Rio Grande Railroad, was one of the first to see the potential of laying narrow-gauge track into the mountains to tap the lucrative mining opportunities there, and his network of rails dominated the passes and canyons of the Rockies. Not that he was without competition; several railroads competed for the rights to access places like the Royal Gorge, Black Canyon, and Gunnison—often with violent outcomes.

Towns were made or broken by the presence of the railroads, and some towns, if the tracks were not close enough to it, literally pulled stakes and moved to where the rails were. Other towns, like Salida or La Junta, were purely a creation of the railroad company, which would buy cheap land and sell platted lots.

Today, only three small but scenic sections of the original narrow-gauge mountain railroads still exist: the Durango & Silverton Narrow Gauge Railroad, the Cumbres & Toltec Scenic Railroad, and the Georgetown Loop Railroad. These trains provide a glimpse into the exciting and romantic time when mines and railroads ruled Colorado.

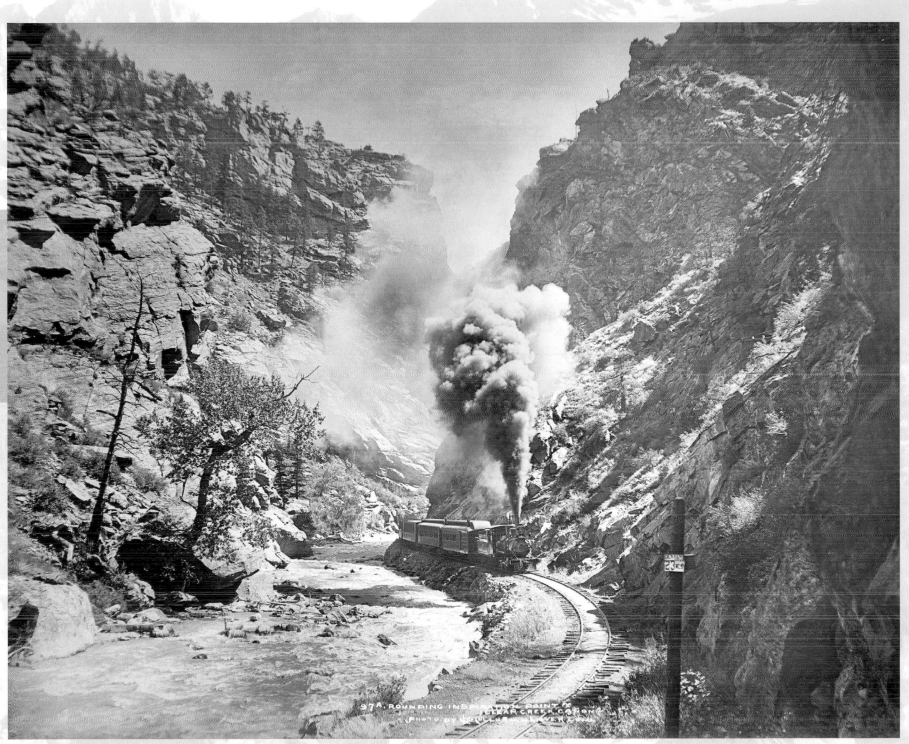

Train in Clear Creek Canyon, 1905. *Denver Public Library, Western History Collection, photo: L. C. McClure*

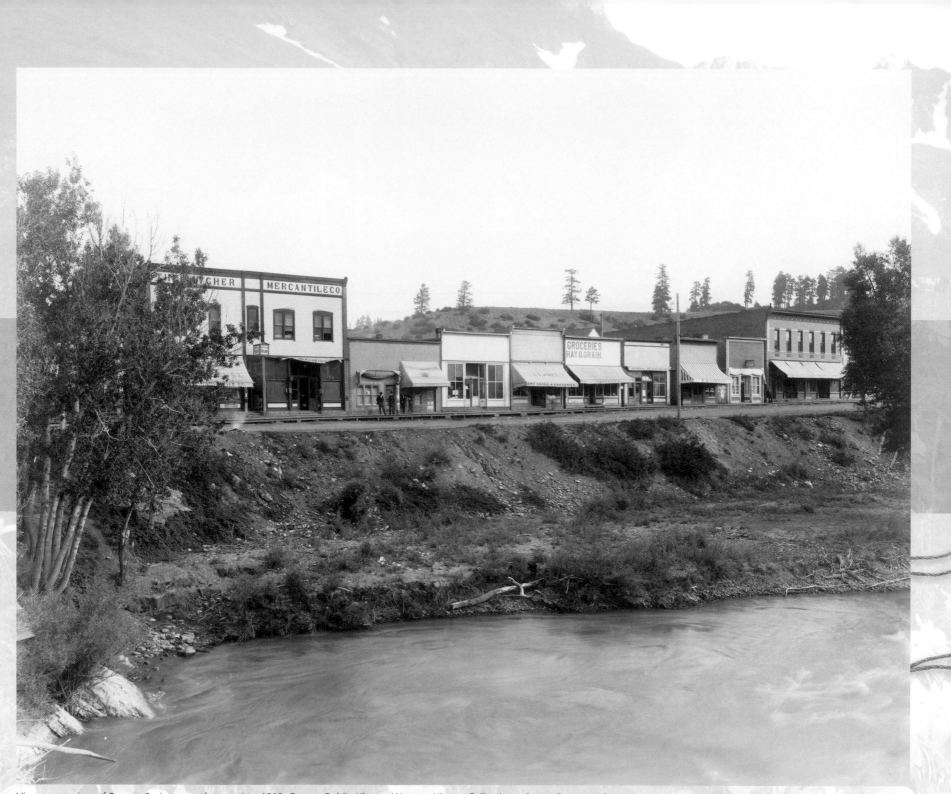

View across river of Pagosa Springs storefronts, circa 1910. *Denver Public Library, Western History Collection, photo: George L. Beam*

THE WARM, HEALING WATERS of Pagosa Springs in southwestern Colorado, near Durango, were held sacred by both the Utes and Navajo, who fought over the ownership of the springs constantly. In 1866, the two tribes decided to settle the issue permanently by choosing one man from each side to fight to the death for the rights of ownership. The Utes chose Albert Henry Pfeiffer, a longtime friend of the tribe and a notorious mountain man who had fought the Navajo with Kit Carson and had engaged in a bloody feud with Apaches for years in revenge for the death of his wife. With his fighting experience, Pfeiffer dispatched the Navajo champion quickly, winning the hot springs for the Utes.

In 1877, after the Utes had been removed from their lands, the U.S. government claimed ownership of the springs. The first bathhouse was built by Thomas Blair in 1881. The government platted the town, selling lots within it in 1885.

Since then, Pagosa Springs has been primarily a resort town for visitors seeking the warm—and, some say, healing—waters of the hot springs while taking in the pleasant mountain scenery. The nearby Wolf Creek Ski Area, with some of the highest snow amounts and best-quality powder skiing in the state, is also an attraction in winter months.

Pagosa Springs, 1942. *Denver Public Library, Western History Collection, photo: Theodore Fisher*

Pagosa Springs

The water in Pagosa Springs is heated by coming in contact with geothermal heat from the Earth's mantle. The water from a hot spring comes from sufficient depth to be heated by the hot rocks deep in the Earth's crust.

The name Pagosa Springs comes from the Ute words for the hot springs: **pah** means "water," and **gosa** means "boiling."

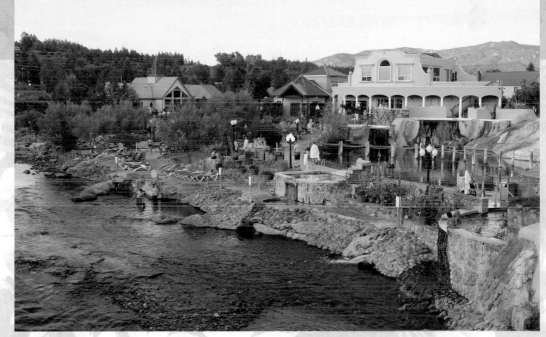

The Springs Resort and Spa.

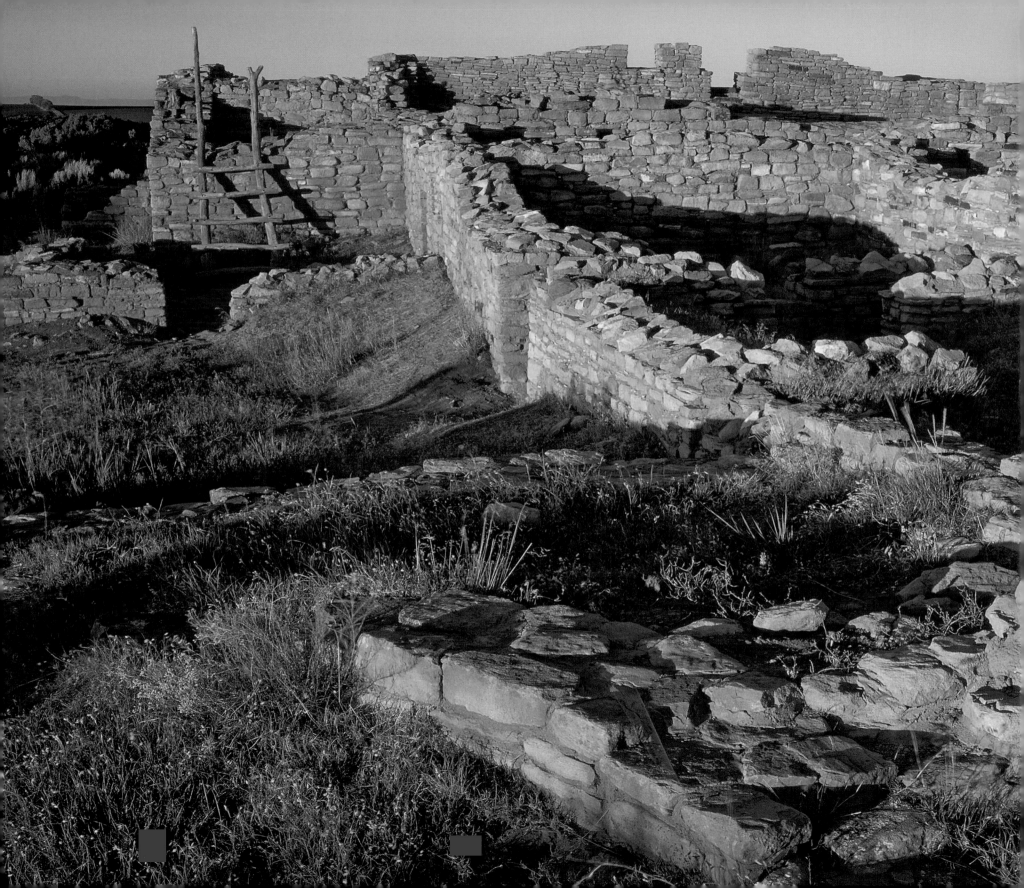

Canyon and Mesa Country

When most people think of Colorado, they think of mountains, not high-desert mesas and red rock. Yet huge areas of the state contain amazing desert scenery and red-rock landscapes. For red-rock spires, buttes, mesas, and canyons rivaling those of Utah, visit Dinosaur National Monument or Colorado National Monument, near the Western Slope's largest city, Grand Junction. Or if you're interested in ancient Native American ruins on a stunning scale, check out Mesa Verde National Park or Canyons of the Ancients and Hovenweep National Monument. The influence of Native American culture and history is especially apparent in this part of the state, and outlets for southwestern arts, crafts, and jewelry can be found everywhere. Recreational opportunities also abound, with amazing mountain-biking trails near Fruita and Grand Junction, whitewater rafting on the Colorado River, and spectacular hiking trails throughout the area.

Lowry Pueblo Ruins, Canyons of the Ancients National Monument.

Right: Train in Black Canyon, 1949. *Denver Public Library, Western History Collection, photo: Robert Richardson*

Opposite: Black Canyon at sunrise.

Black Canyon of the Gunnison National Park

Black Canyon is so named because its steep walls let in little sunlight, and much of the canyon is in shade most of the time.

BLACK CANYON, located in western Colorado, near Montrose, is one of the steepest and deepest canyons in the United States. The canyon was formed over millions of years, as the Gunnison River carved downward while geologic forces pushed upward, exposing rock formed as much as 1.7 billion years ago.

Black Canyon's modern history begins in 1881, after the Denver & Rio Grande Railroad reached Gunnison. The company then routed its narrow-gauge rails through the narrow canyon, taking a year to build the last mile. For a short time, the presence of the rail made Black Canyon part of the transcontinental railroad system, until the route through Glenwood Canyon became more popular. Its use declined over the years, and it was eventually abandoned in 1955.

Today, the main attractions of the canyon are the national park and the drive along the south rim, which provides stunning views of the canyon, the Gunnison River, and the surrounding rugged countryside. The canyon walls are popular with rock climbers, and some of the whitewater stretches of the river provide adventure for expert kayakers.

The Gunnison River descends at an average of forty-three feet per mile through the length of Black Canyon, making one of the steepest drops of any river in North America.

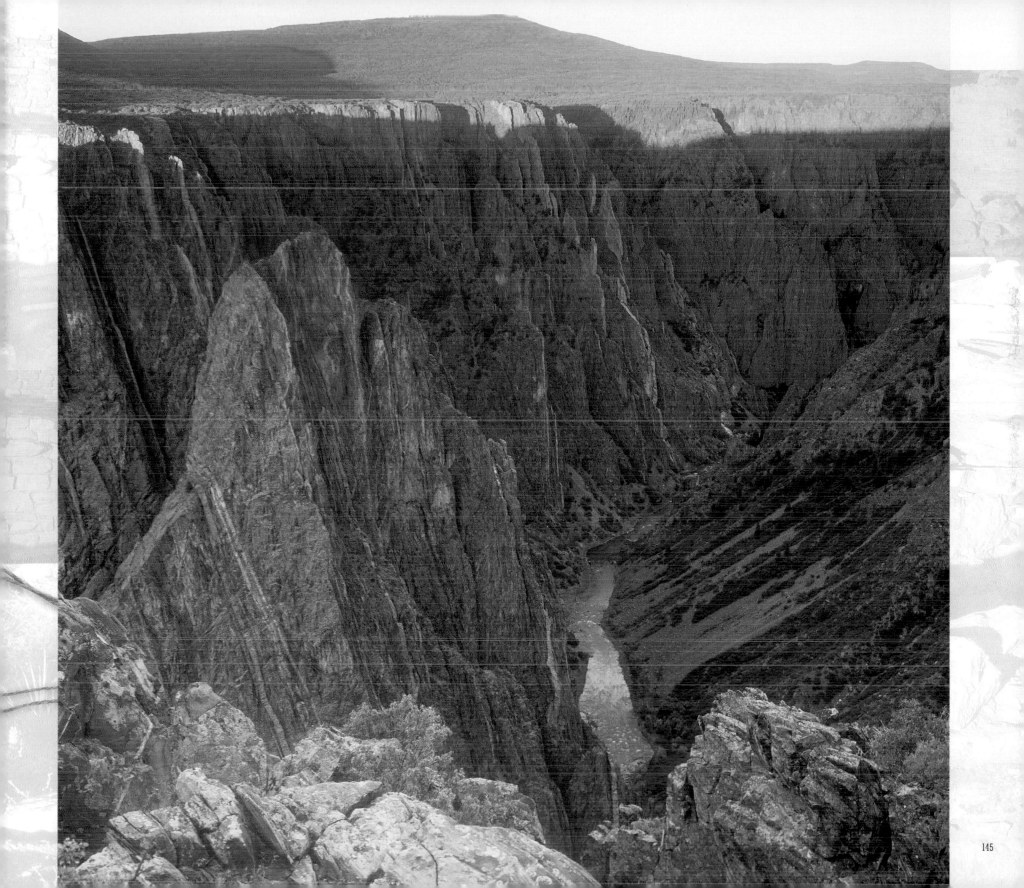

DINOSAUR NATIONAL MONUMENT is located in northwestern Colorado, at the confluence of the Green and Yampa Rivers on the border with Utah. As its name implies, it was created to preserve the large dinosaur quarry here.

The quarry was discovered in 1909 by paleontologist Earl Douglass, who was collecting fossils for the Carnegie Museum in Pittsburgh. President Woodrow Wilson proclaimed the area Dinosaur National Monument in 1915. In 1938, the monument expanded its boundaries to include the spectacular red-rock canyons of the Green and Yampa Rivers.

In 2006, the quarry building was closed because of structural concerns, and as of the beginning of 2011, it is still closed indefinitely. But the park has a temporary outdoor visitor center with replica fossils that visitors can see and touch and a temporary auditorium showing a video about the quarry and the paleontologists working here. The park also contains six camping areas, hiking trails, and stunning viewpoints. Whitewater enthusiasts can take tours down both the Green and Yampa Rivers.

Dinosaur National Monument also preserves Native American petroglyphs and pictographs. Petroglyphs are carved into rock, while pictographs are painted onto rock.

Dinosaur National Monument

Dinosaur National Monument actually straddles the Colorado-Utah border, and the quarry is on the Utah side.

Old outbuilding, Chew Ranch.

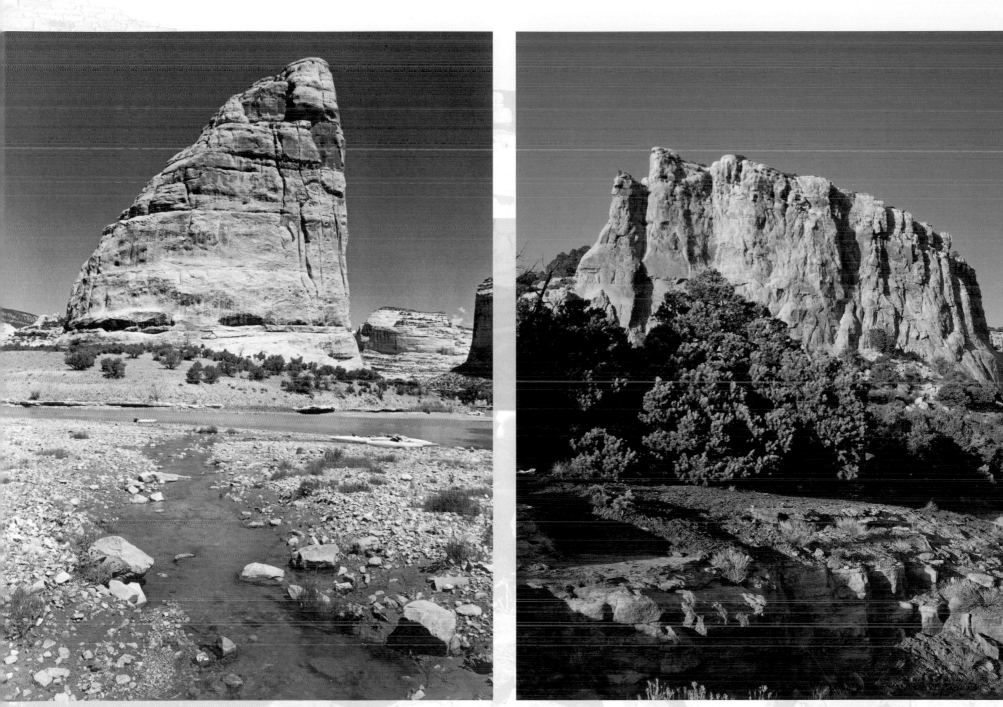

Steamboat Rock, 1975. *Denver Public Library, Western History Collection, photo: Don Koch*

Plug Hat Butte.

Grand Junction

Grand Junction is home to a burgeoning wine industry, which has seen steady growth. The dry climate with warm days and cool nights provides excellent conditions for wine grapes. Award-winning wines are now being produced in the region's vineyards and wineries.

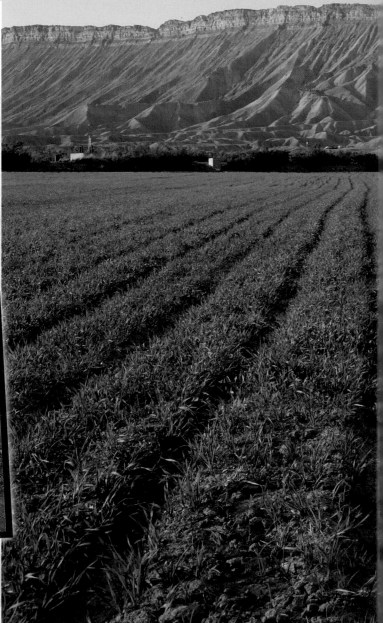

Right: Mt. Garfield.

THE ESTABLISHMENT OF a town at the grand junction of the Colorado and Gunnison Rivers was a direct consequence of the 1881 forced removal of the Uncompagre Utes, who had made the Grand Valley their home for centuries.

A group of investors from Gunnison, headed by George A. Crawford, saw the area's potential for fertile, irrigated farmland, and founded a town that was first named Ute, then West Denver, and finally Grand Junction once the town was incorporated. The arrival in 1883 of the Denver & Rio Grande Railroad's narrow-gauge line, and then the arrival of a standard-gauge line in 1887, cemented Grand Junction's position as the major urban center of the Western Slope. The Grand Valley, with its warm, dry climate, fertile soils, and abundant irrigation, soon became the fruit basket of Colorado, and orchards covered the valley floor.

For the most part, Grand Junction continued its steady pace of growth over the years and is now the largest city in western Colorado. Situated in a sweeping valley, with the Book Cliffs and Mt. Garfield to the northeast and the stunning red-rock spires of Colorado National Monument to the southwest, Grand Junction is in a prime tourism and retirement locale.

Main Street.

Grand Junction, 1908. *Museum of Western Colorado, Loyd Files Library*

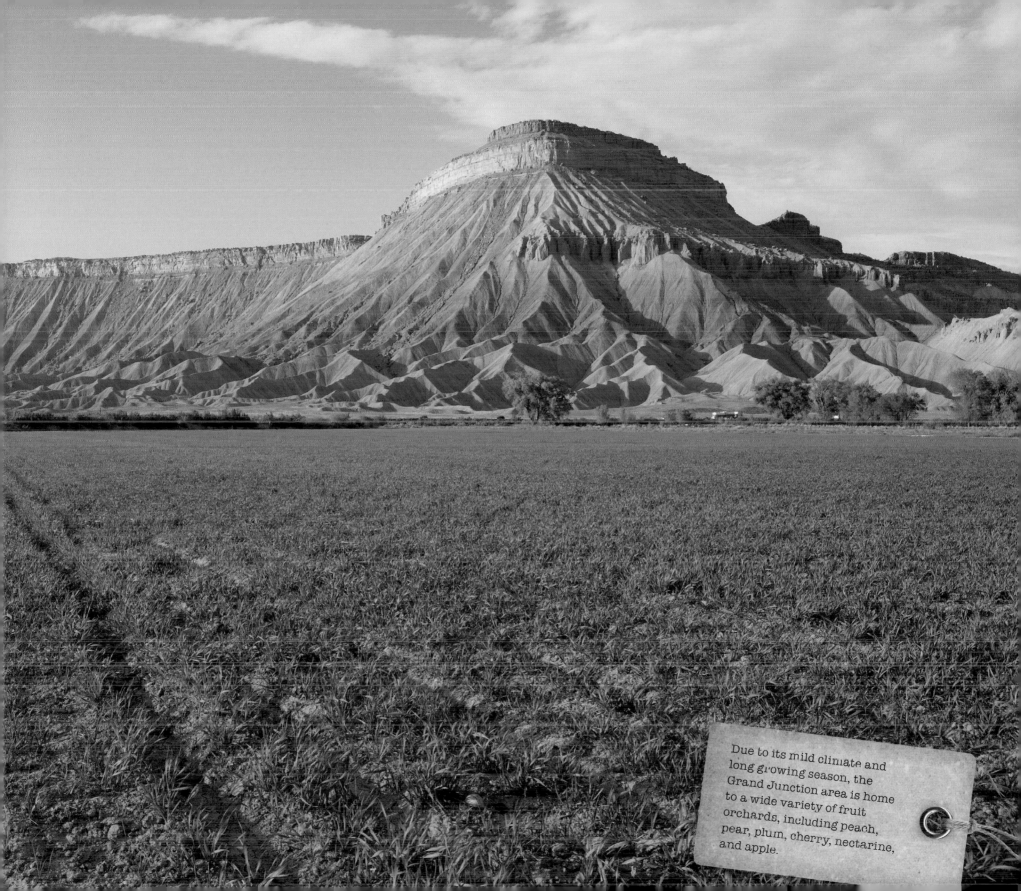

Due to its mild climate and long growing season, the Grand Junction area is home to a wide variety of fruit orchards, including peach, pear, plum, cherry, nectarine, and apple.

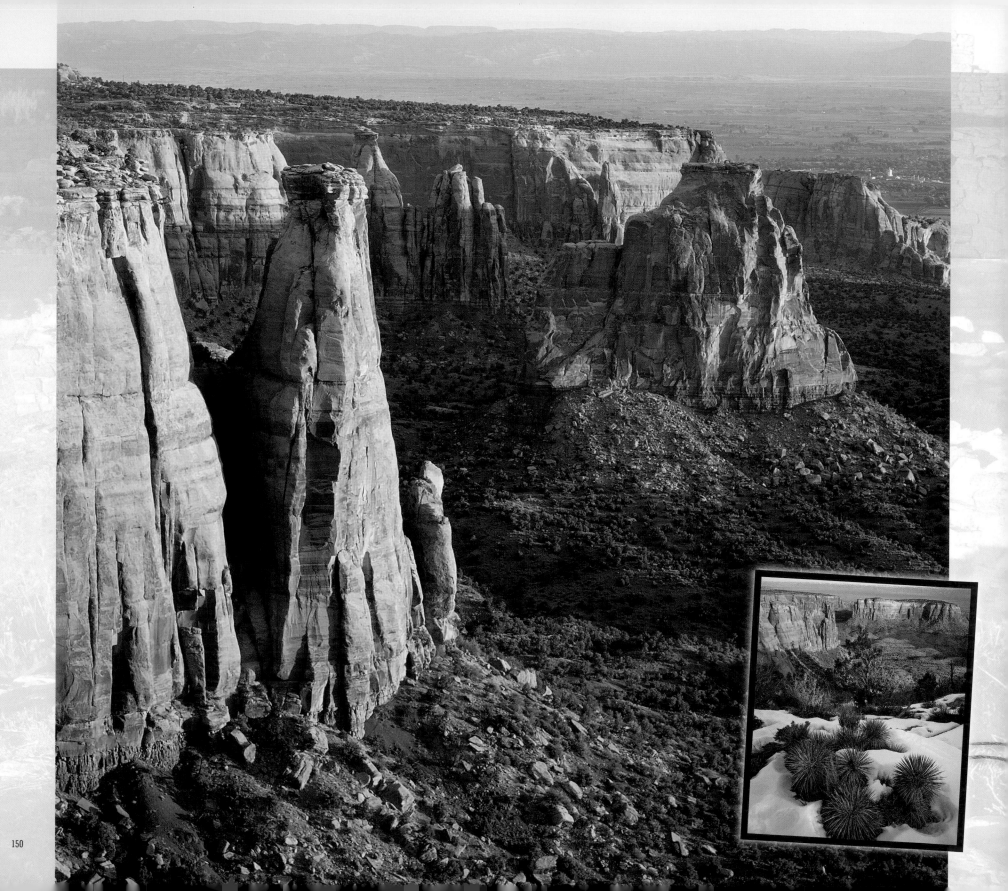

Colorado National Monument

WHEN ONE THINKS of Colorado, the general perception is a state comprising snow-capped peaks and pine trees. But Colorado is an amazingly diverse state with everything from high-plains prairies to mountains to, in the case of Colorado National Monument, red-rock desert. It is as if Utah inserted a little piece of its red rock into western Colorado (and indeed, the Utah border is not too distant).

Colorado National Monument, near Grand Junction, is a gem of a park. Its thirty-two square miles contain spectacular buttes, mesas, and sheer-walled canyons, including rock monoliths and formations such as Independence Monument, the Kissing Couple, and Coke Ovens. The main access to the park is via the twenty-three-mile Rim Rock Drive, which twists and turns through stunning scenery and past viewpoints and features an informative visitors center en route.

The park was founded by John Otto, an enthusiastic and, some would say, eccentric gentleman who explored the area extensively in the early part of the twentieth century and saw its potential as a national park. Otto began to build a system of trails here and got the attention of the Grand Junction chamber of commerce, which lobbied the federal government to make it a national park. In 1911, it became a national monument.

Hiking, camping, road biking, and wildlife viewing are all popular activities at Colorado National Monument.

Opposite: The Kissing Couple and Independence Monument.
Opposite inset: Colorado National Monument in winter.

A 1911 *Collier's* article profiling Colorado National Monument founder John Otto.

Mesa Verde National Park

Sun Temple.

SOUTHWESTERN COLORADO and the Four Corners area are dotted with numerous ruins from various branches of ancient Puebloan peoples, but by far one of the most impressive—and mysterious—concentrations of these ruins lies on top of and around Mesa Verde, near Cortez.

Here, the Puebloan people built extensive and complex habitations from sandstone, adobe, and timbers, initially on top of the mesa around A.D. 550 and then, as some of the parks more spectacular and notable dwellings illustrate, up against the sandstone cliffs and alcoves around A.D. 1200. Cliff dwellings, such as those called Cliff Palace, Balcony House, Long House, and Square Tower House, to name a few, are spectacular testaments to the skill and sophistication of this culture.

The first outsider to officially enter a ruin in this area was the now-famous photographer of the early West, William Henry Jackson, in September 1874. At the time, he was photographing for the U.S. Geological Survey. A prospector named John Moss led him to what is now known as Two-Story Cliff House (now part of Ute Tribal Park). In 1888, two ranchers, Richard Wetherill and Charles Mason, searching for lost cattle found Cliff Palace and Spruce Tree House, and the next day, they found Square Tower House.

The next year, the Wetherill family began exploring the area extensively and collecting archeological artifacts. Their guiding-and-collecting ventures soon began to eclipse ranching as the family's livelihood. In 1891, they guided Swedish scientist Gustaf Nordenskiöld to the ruins. Nordenskiöld was the first scientist to document the archeological record here in detailed photographs, diagrams, and recorded observations. As word spread about the area, looters and curio seekers began to make a detrimental impact on the ruins, and concern for their protection eventually reached the highest levels of government. As a result, in 1906, Congress and President Theodore Roosevelt passed a bill creating Mesa Verde National Park.

Today, Mesa Verde National Park is truly one of the wonders of the American West, providing a look into ancient Puebloan culture in a strikingly beautiful high-desert setting.

Above: A group of visitors at Cliff Palace ruins, 1925. *Denver Public Library, Western History Collection, photo: George Beam*

Opposite: Square Tower House.

Mesa verde means "green table" in Spanish.

Visitors can drive to a view of many of the ruins at Mesa Verde National Park, and tours of Cliff Palace are given daily.

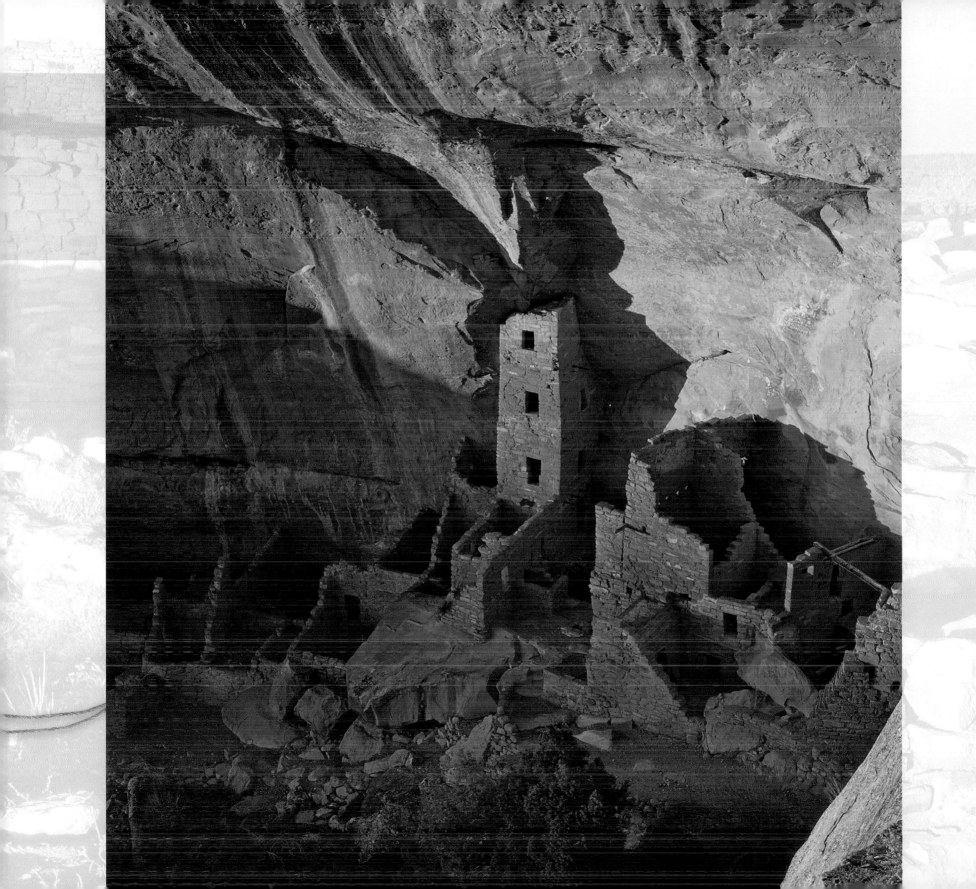

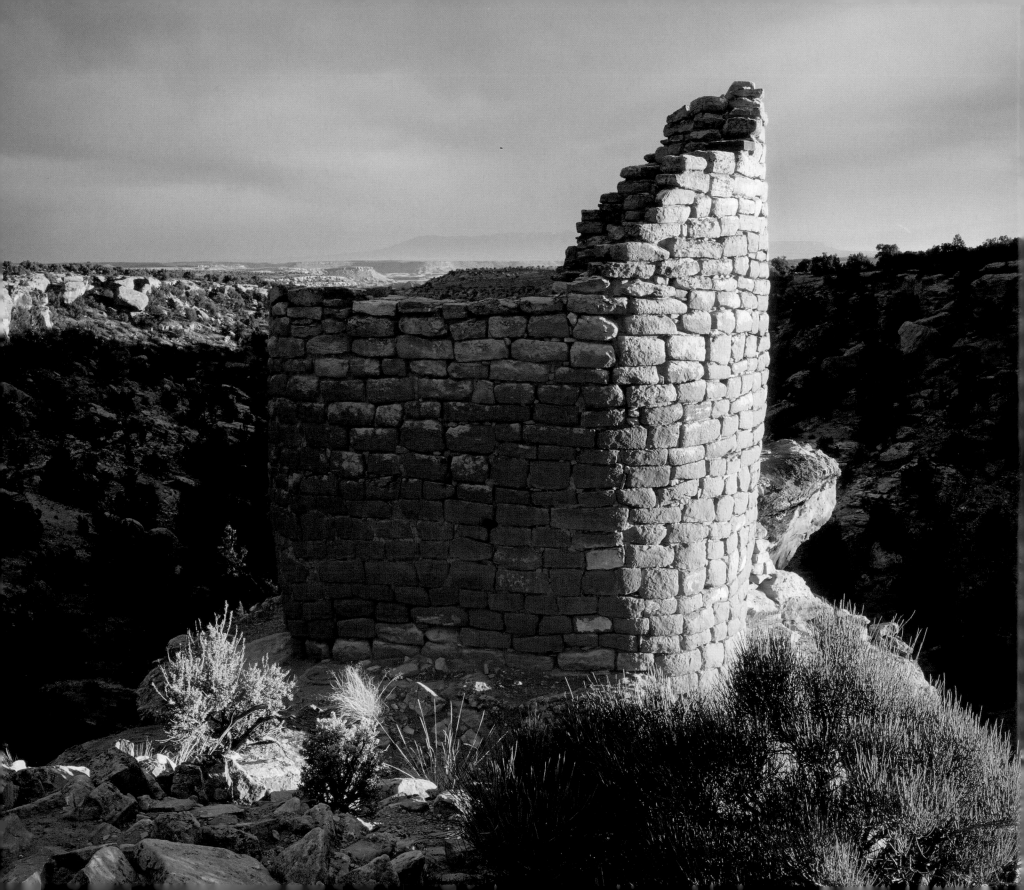

CANYONS OF THE Ancients National Monument, located in southwestern Colorado, is not a traditional park; it was created to encompass and protect a diverse, but scattered aggregation of archeological sites over a large area. Most of the sites contain ancient Puebloan ruins dating from between 750 BC and AD 1300. A presidential proclamation created Canyons of the Ancients on June 9, 2000. As of 2005, more than six thousand archeological sites have been identified within the monument. For the visitor, the most accessible and prominent site is Lowry Pueblo.

Hovenweep National Monument was established in 1923. The name, which means "deserted valley" in Puite/Ute, was first adopted by famous photographer William Henry Jackson in 1874. Puebloan peoples built the towers and pueblos here between AD 1200 and 1300. The structures vary greatly, from circular to square, and display their creators' amazing attention to detail. Many are built as towers on hillsides or on the tops of prominent hills, overlooking the canyons below.

Canyons of the Ancients and Hovenweep National Monuments

Opposite: Horseshoe Ruins, Hovenweep National Monument.

Right: Lowry Pueblo Ruins, 1975. *Denver Public Library, Western History Collection, photo: Don Koch*

155

Acknowledgments

I am a photographer by trade, not a writer or an editor, so researching, writing and acquiring vintage images did not come easy, nor without some serious help. I would like to thank the Denver Public Library for their amazing, extensive image collection, and Coi Drummond-Gehrig for her attentive and friendly service; Brooke Murphy and Glo Cunningham at the Crested Butte Mountain Heritage Museum for their flexible, accommodating, and sincere small-town service and attitude; Duane Vandenbusch, history professor extraordinaire; Rumors Coffee and Tea House in Crested Butte, for providing a quiet (sometimes) yet social place in which to write; Kimbre Woods, for saving me stressful hours of scanning; The Lloyd Files Research Library, for their great image collection and helpful, friendly service; Boulder Carnegie Branch Library; Fort Collins Museum; Lake County Library; and my wife Kriste, for her love and patience.

As of this writing, I've lived in Colorado for twenty-two years, and as a photographer, I have traversed this state that I love many times. Yet this book brought me a new perspective and new eyes with which to see it. Driving over a mountain pass, across the plains or visiting an old mining town will never be the same for me. Now I see horses and wagons dragging their cargo up a rocky, precipitous hand-made road; a raucous, teaming street full of miners; an encampment of teepees by a Sand Creek. The experience of Colorado grows richer through a knowledge of its history. Our view of history shapes the way we view the present, and ourselves. It shapes who we are, and more often than not, we disregard it at our peril.

Historic preservation has new importance for me as well. Too many of Colorado's beautiful old buildings are in disrepair. Wherever you live, I encourage you to support your local and state historical societies.

Aspen trees in early summer, Gunnison National Forest.

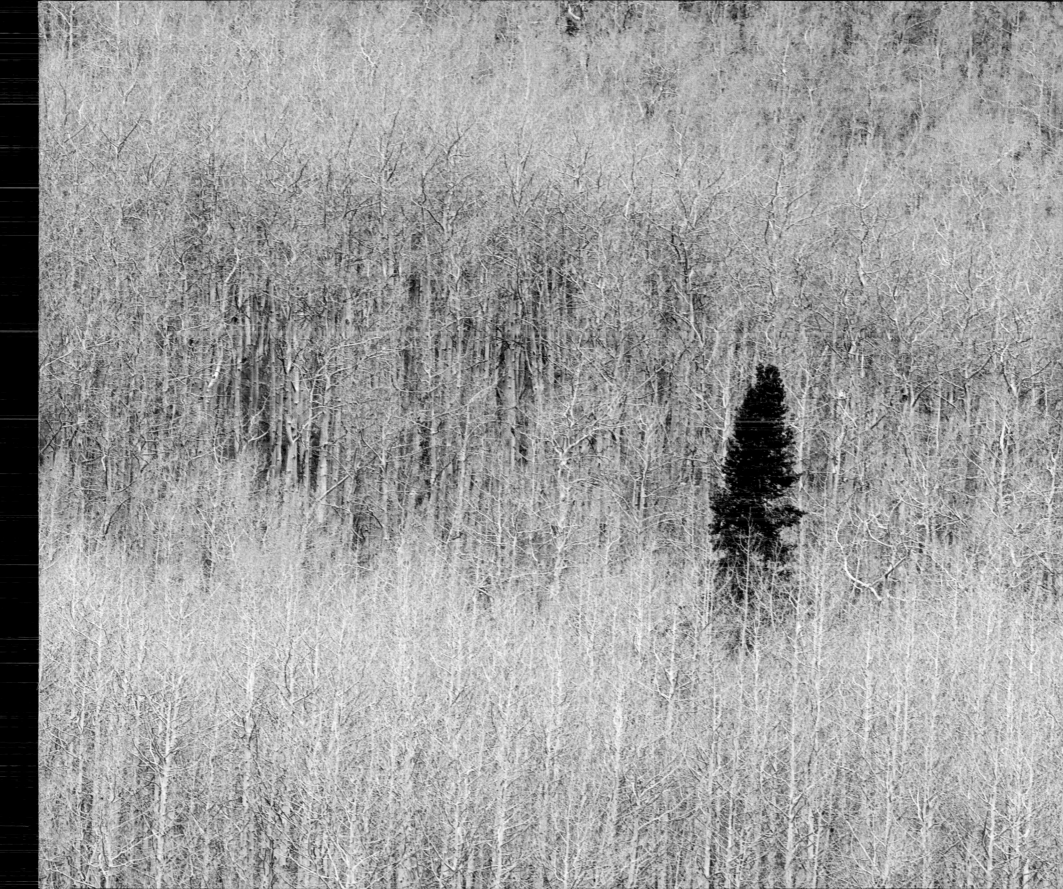

Index

About the Author and Photographer

Since the beginning of his professional career in 1988, J.C. Leacock's creative focus has shifted numerous times, from large format landscapes, to cowboys, to outdoor sports and lifestyles. However, the dominant theme that runs throughout is the American West, for that is where J.C.'s heart and passion lies, in the big skies, prairies, mountains and people of the West. His scenic images capture the magical light, grandeur, and intimacy of the American landscape, while his photographic portrayal of outdoor western lifestyles is both authentic and spirited.

Leacock is widely published nationally, and his images appear in such publications as *Backpacker*, *SKI*, *Sunset*, *Outside*, *Men's Journal*, *Cowboys & Indians*, and *American Cowboy*. His work has been published in numerous calendars including Sierra Club, Audubon, Western Horseman, and BrownTrout. J.C. has published two exquisitely beautiful books on Colorado: *Colorado Closeup* (Fulcrum Publishing, 1997) and *Our Colorado* (Voyageur Press, 2004). A third book, entitled *South Dakota Simply Beautiful* (Far Country Press, 2004), showcases J.C.'s diverse portfolio. Closer to home, J.C.'s photographs frequently appear in *Crested Butte Magazine* and the Colorado State Vacation Guide. He is also represented by several galleries throughout the state of Colorado.

J.C. and his wife Kriste make their home in the scenic ski resort town of Crested Butte, Colorado.

J.C. Leacock. *Photograph © Chris Ladoulis*

Index

About the Author and Photographer

Since the beginning of his professional career in 1988, J.C. Leacock's creative focus has shifted numerous times, from large format landscapes, to cowboys, to outdoor sports and lifestyles. However, the dominant theme that runs throughout is the American West, for that is where J.C.'s heart and passion lies, in the big skies, prairies, mountains and people of the West. His scenic images capture the magical light, grandeur, and intimacy of the American landscape, while his photographic portrayal of outdoor western lifestyles is both authentic and spirited.

Leacock is widely published nationally, and his images appear in such publications as *Backpacker, SKI, Sunset, Outside, Men's Journal, Cowboys & Indians*, and *American Cowboy*. His work has been published in numerous calendars including Sierra Club, Audubon, Western Horseman, and BrownTrout. J.C. has published two exquisitely beautiful books on Colorado: *Colorado Closeup* (Fulcrum Publishing, 1997) and *Our Colorado* (Voyageur Press, 2004). A third book, entitled *South Dakota Simply Beautiful* (Far Country Press, 2004), showcases J.C.'s diverse portfolio. Closer to home, J.C.'s photographs frequently appear in *Crested Butte Magazine* and the Colorado State Vacation Guide. He is also represented by several galleries throughout the state of Colorado.

J.C. and his wife Kriste make their home in the scenic ski resort town of Crested Butte, Colorado.

J.C. Leacock. *Photograph © Chris Ladoulis*

T E X A S

A province of Mexico until 1836

The map locates places in the story. Important events at each place are given with dates.

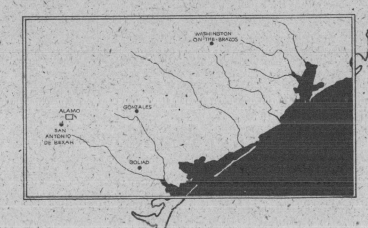

REMEMBER THE ALAMO

Would they have won if I hadn't gone to Gonzales? Susanna sometimes thought with a small, quiet pride as the years passed.

She remarried, and never spoke of the Alamo again until late in her life. Angelina grew up to bear a strong resemblance to her mother.

Susanna lived until 1883. Some forgot her name. No one forgot her story.

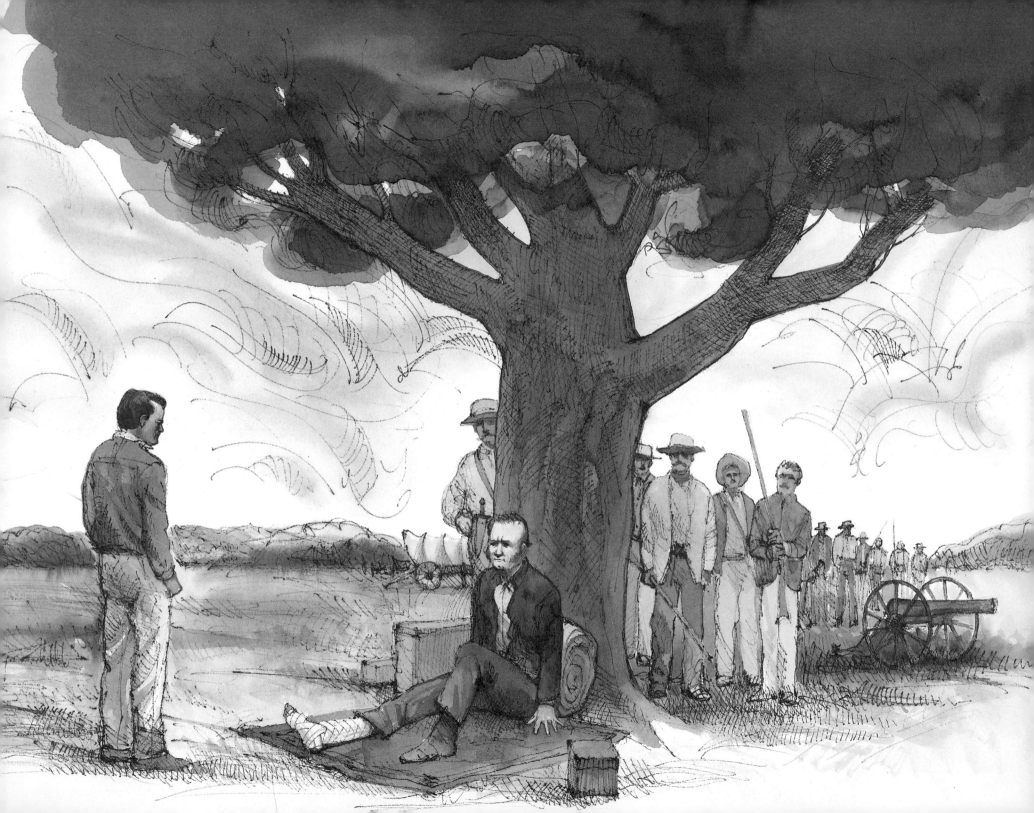

"Sure did, the slippery snake." The storyteller grinned. "Till next day, anyhow.

"Then, our boys found this ordinary-looking fellow hiding in some tall grass. They dragged him to General Houston. This fellow kept saying he was just an army private who escaped and stole some clothes from a slave cabin. Just a plain old private.

"The trick might have worked, but the other prisoners saw him and started yelling."

"Yelling what?" asked Susanna.

The storyteller laughed. *"El Presidente. EL PRESIDENTE!"*

"So he's caught?"

"Yes indeed. And old Sam made him write an order pulling every last Mexican soldier out of Texas."

Susanna clapped her hands. Her eyes filled with joyful tears. "I wish I could have been there. Even for a minute—"

"Oh, but you were. General Houston didn't forget one single word of the story you told. Just before the battle he reminded our boys not to forget, either.

"It stiffened up their backbones. They shouted like wild men when they charged at San Jacinto. Oh, you were there, all right."

"What did they shout?"

"Why—*'Remember Goliad.'* But mostly, *'Remember the Alamo . . .'"*

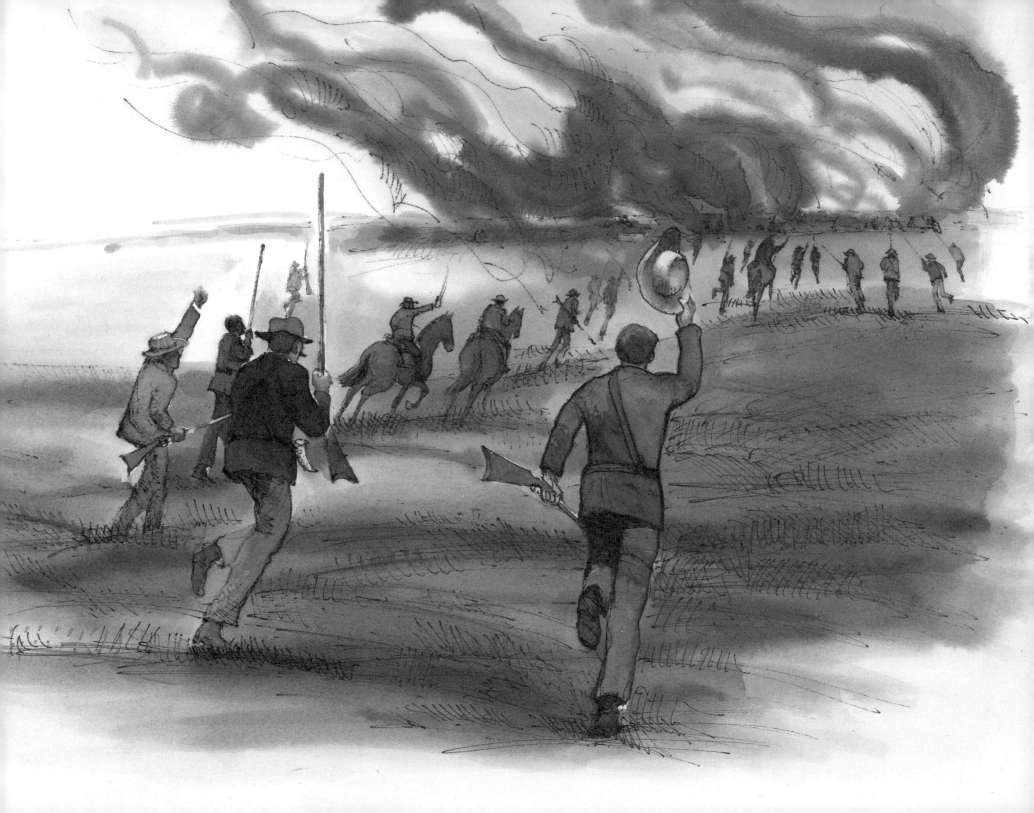

"Oh, it must have been glorious," said the man who told her the story. He continued:

"After old Sam Houston left Gonzales, he kept running ahead of Santa Anna, like a fox chased by a hound dog. But foxy Sam did it on purpose. He hoped he could pull Santa Anna away from the main part of his army. He got lucky. He did it.

"Just last week, it was. April 21. Right by Buffalo Bayou and the San Jacinto River.

"Around the middle of the afternoon, old Sam saw an eagle in the sky. He took it as a good sign and decided to attack right away. He said to our boys, 'Victory is certain. Trust in God and fear not.'

"Sam and his men caught Santa Anna napping. I mean, Santa Anna really was taking a nap under a big oak tree in his camp when Sam's two little cannon opened up and our boys charged."

Amazed and thrilled, Susanna listened intently to every word.

Although badly outnumbered, Houston pushed through meadow grass tall as a man, then up a hill to a barricade the Mexicans had built when they set up camp. Storming the hill, the Texans shouted a rallying cry. A bullet pierced Houston's right boot, but he kept fighting. The battle lasted only eighteen minutes.

"The poor Mexican soldiers thought they'd get the same cruel treatment our men got in San Antonio. They were scared and I don't blame 'em. They ran around, throwing guns away and hollering, 'Me no Alamo—me no Alamo.'"

Maybe Susanna should have smiled. But she couldn't. She had looked closely at the face of war. No person with any sense or feeling could do that and smile.

"Texas is really free now," the storyteller concluded. "Santa Anna got whipped for sure. Only trouble was, soon as the battle started, he jumped on a horse and left his men behind."

Susanna clenched her fist. "He got away?"

They all died for the new Republic.

But the Republic of Texas was already blowing to pieces, like leaves torn from a tree in the wind.

★

That very night, people in Gonzales packed up and fled eastward. Susanna and Angelina left with them. Before sunrise, Gonzales was burning—put to the torch on Houston's order.

Soon it seemed as if every settler in Texas was heading east. "The Runaway Scrape," people called it afterward.

Susanna didn't see Houston again. She lived with her memories.

Travis giving Angelina his cat's-eye ring.

Almeron saying goodbye in the chapel.

Santa Anna strutting.

The sad ride to Gonzales, then facing all the townsfolk. Telling of their loved ones' bravery— only to have Houston order everyone to *run!*

Awake or asleep, she was haunted by the memories. Often she said to herself, "I failed you, Almeron. I failed all of you."

Then, about a month and a half after the fall of the Alamo — late April — Susanna heard some news. Exciting news of what Sam Houston did at a place called San Jacinto.

Touching Susanna's hand, Houston said, "You're a brave woman. Now we must make plans. You said Santa Anna is marching this way. Every citizen must head east while we gather more men for the army. The supplies and food we can't take, we'll burn. I want nothing left for him or his troops. Not even Gonzales itself."

Destroy their own homes and retreat? Susanna couldn't believe it.

"You're going to forget those men at the Alamo, General?"

"Never."

Worn out, full of sorrow, she found it hard to believe him. She had told the story vividly—and he was ordering everyone to run.

What a sad end to the struggle. A very important struggle, she realized as Houston kept on talking, telling her some things she hadn't heard yet: While Santa Anna surrounded the Alamo, other men were meeting at Washington-on-the-Brazos and they declared independence from Mexico on March 2. Almeron and the rest had died for the new Republic of Texas and didn't even know it.

So had Colonel Fannin and his 400. On March 20, Mexican troops caught them near Goliad and forced them to surrender. They were held prisoner in town for a week, then taken to some woods on Palm Sunday morning and shot to death, every last one.

 General Sam Houston. Born 1793. A man with a hot temper. He could barely control it when Susanna gave him the letter from *El Presidente,* then told the story of the Alamo's last thirteen days. By the end, he was trembling with wrath.

"Did Santa Anna bury the men honorably, Mrs. Dickinson?"

"He burned them."

Houston's eyes were cold as a pond during a winter freeze. He called Santa Anna some names. Luckily Angelina wasn't old enough to understand.

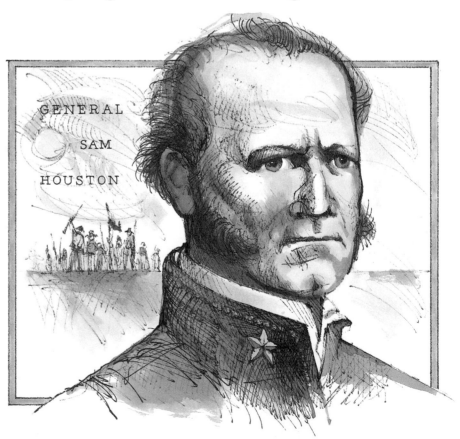

GENERAL
SAM
HOUSTON

heard them echo in her head. She would hear them as long as she lived.

Suddenly, a big man appeared and strode to her side. He tried to speak gently, but couldn't hide his rage.

"I know this is hard for you, Mrs. Dickinson. But I must hear the whole story. Every word. Are you strong enough—?"

She thought of Santa Anna. She remembered why she struggled so hard to make the long journey. She overcame her sadness and held Angelina close as she answered Sam Houston.

"Yes, sir. I am."

 Two of Houston's scouts, seeking news from San Antonio, found the travelers on the road. The scouts took Susanna and the others back to Gonzales, arriving after nightfall on March 13.

Yes, the scouts said, General Houston was in Gonzales. But Susanna wasn't able to speak with him right away. Friends and neighbors surrounded her, asking about loved ones.

Susanna gathered her courage. What she had to tell them almost broke her heart:

"Only women and children got out of the mission."

"You mean all of the men died?" a wife of one of the Alamo soldiers exclaimed.

"Yes, all but Joe and the ones Colonel Travis sent for help."

Sobbing began then. Outcries of grief. The townspeople pressed closer, calling out family names.

"I told you. There isn't a man left. My Almeron died too. Santa Anna butchered them. He's marching this way right now, probably with at least two thousand soldiers."

Cries of fright mingled with wails of sorrow. The voices grew louder. Clutching Angelina, Susanna

Citizens!
It became necessary to check and chastise
a parcel of audacious adventurers...
Bexarians!
Return to your homes and dedicate
yourselves to your domestic duties...
Inhabitants of Texas!
The good among you will have nothing to fear
~ Antonio López de Santa Anna ~

Susanna rode toward Gonzales. She hoped to find General Sam Houston and his men there. Ben led the way.

On the road they met Travis's slave, Joe. Susanna asked him about Colonel Travis. "Gone," Joe said sadly. After the battle, Santa Anna walked through the Alamo himself, to be sure the leaders had not escaped. Crockett. Bowie. Travis . . .

"And Almeron?"

"He fell beside his guns on the chapel wall," Joe told her.

Almeron. Almeron . . .

She loved him so much.

<div style="text-align:center">★</div>

The rain was cold and stinging, like defeat. Susanna carried Angelina and the letter Santa Anna wrote to the Texans. A letter full of false friendliness. She knew that her story was the real message he was sending:

Give up. It's hopeless. Listen to what happened. Keep fighting and the same will happen to you.

Ben heard her soft crying. "Miz Dickinson? You want to stop and rest?"

She did, but she remembered all the brave men. She was the only witness to the courage of those who died for both sides, all victims of Santa Anna's cruelty.

She was determined to find General Houston and deliver the message.

She owed it to Almeron. To all the fallen. She would deliver the message in a way that would make Santa Anna sorry he ever sent it.

"Miz Dickinson—?"

"No, Ben. We must go on."

The messengers continued through the storm.

When Susanna was able to meet Santa Anna, he repeated his boastful speech, then offered a blanket and money.

"Thank you, I don't want them," she said.

Santa Anna frowned. His well-known charm and exaggerated kindness were not working with this woman. What else could he try?

His eye fell on Angelina. He beamed.

"Señora Dickinson, please bring your daughter here to me."

Susanna didn't want the cruel man to touch Angelina. But with soldiers on guard around the room, she decided she had better obey.

"What a beautiful child," the general purred, holding Angelina.

Susanna said nothing.

"The rebellion will fail, you know. Your charming little girl should not stay in Texas. She's much too pretty to waste her life in a place as troubled as this. Let me send her to Mexico City. See to her education. The capital has fine schools. I will pay for everything personally."

"No, General. Texas is Angelina's home. And mine."

He didn't like that answer. His great show of humanity was failing.

"I will send you with her. You'll be far more comfortable—"

Her grief and anger were so great, she couldn't speak. She shook her head.

"Then I will send you somewhere else. A free woman."

"I said I don't want a blanket, or your—"

"Be still! You will go tell your Texan rebels what happened to those who dared to oppose me. You will describe it exactly. You will say it will happen to them if they continue their stupid little war."

He reached for pen and paper. "You will also carry a letter to all Texans willing to obey Mexican law once again."

He pointed to Colonel Almonte's orderly standing close by. "Ben will go with you to make sure you do as I command. You will go when your wound is better. You are a fool to refuse my generous offer, Señora. All of you Texans are fools, because it is impossible to fight me and win. Tell them Santa Anna is coming."

Susanna just stared at him.

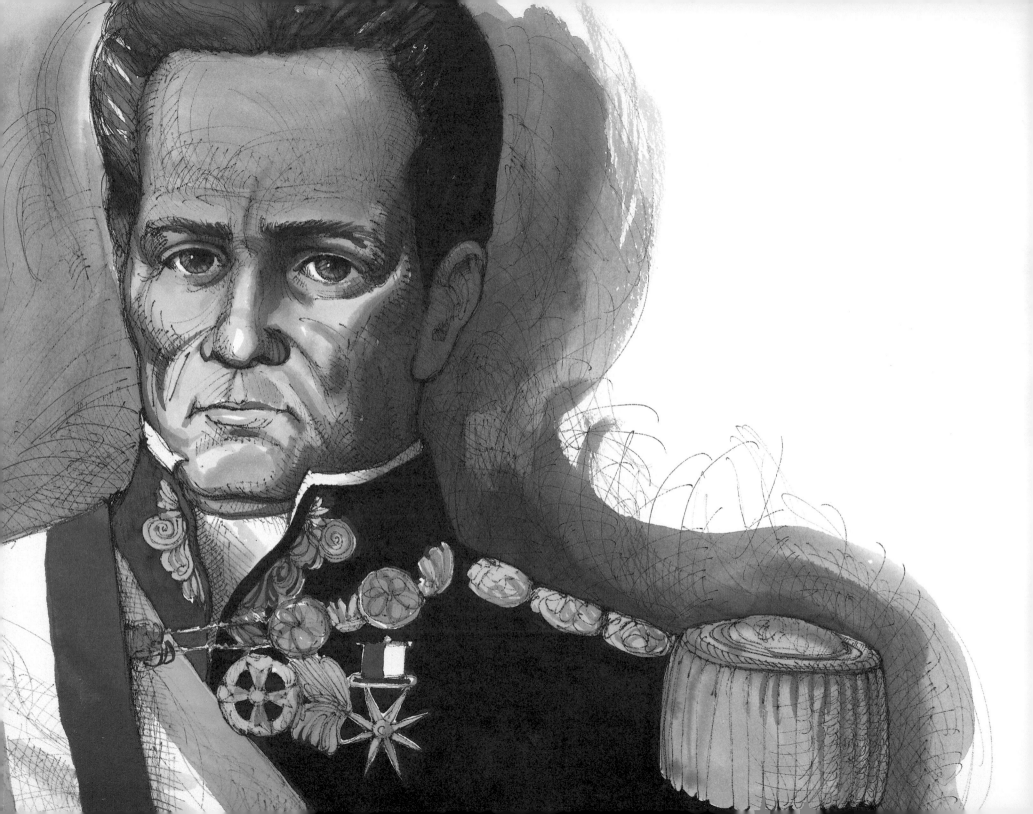

 General Antonio Lópes de Santa Anna. *El Presidente* of Mexico. His uniform glittered. His sword alone was worth $7,000.

Puffed up with victory, he summoned the survivors of the Alamo before him, all but Susanna, who was not yet well enough. To each—the wives and sweethearts of the Texans who fell, and Travis's black servant, Joe—he gave $2 and a blanket.

Like an actor, he strode around the room, waving his arms dramatically and boasting in a loud voice:

"I do not make war upon women and children! Neither do I make war on slaves. Humane rules govern my army!"

 That afternoon, Susanna lay wounded in San Antonio. A stray bullet had grazed her leg as she followed the officer out of the Alamo. She had hardly felt it, searching for Almeron with tear-filled eyes.

She had seen Crockett where he fell at the palisade guns, his coonskin cap beside him. She had seen many familiar faces. But not Almeron's.

About 200 Mexicans died in the Alamo, and 188 Texans. She recalled only the fury of it. The senseless brutality of some of the enemy soldiers after the battle was won. The memories would never leave.

The doctor finished bandaging her wound. "It is light. You should be able to walk tomorrow. General Santa Anna will want to see you then, I am sure." His face showed dislike of his great commander.

"My husband—?" she began.

The doctor looked away. "I am sorry. They are all gone."

"But I must find Almeron! I must give him a decent burial. . . ."

"You must rest." He glanced at Angelina, his voice low. "Burial is impossible."

"Why?"

No answer.

Susanna suspected something horrible then. *"Tell me!"*

Ashamed, the doctor pointed to the smoke blowing past the window. "On the orders of the General, they are . . . burning all the dead. Except for a few of Mexican ancestry. A man named Esparza—he will receive burial. The rest—"

The doctor could barely speak. "It is the greatest shame for a fallen soldier, you see. Not to be buried."

A strange kind of lump, harder and hotter than sorrow could ever bring, filled Susanna's throat for a moment.

"I want to meet this great general of yours."

"You will. But I advise you not to be so eager."

Susanna couldn't sleep that night. She couldn't stop crying either. She tried to cry softly so as not to wake Angelina.

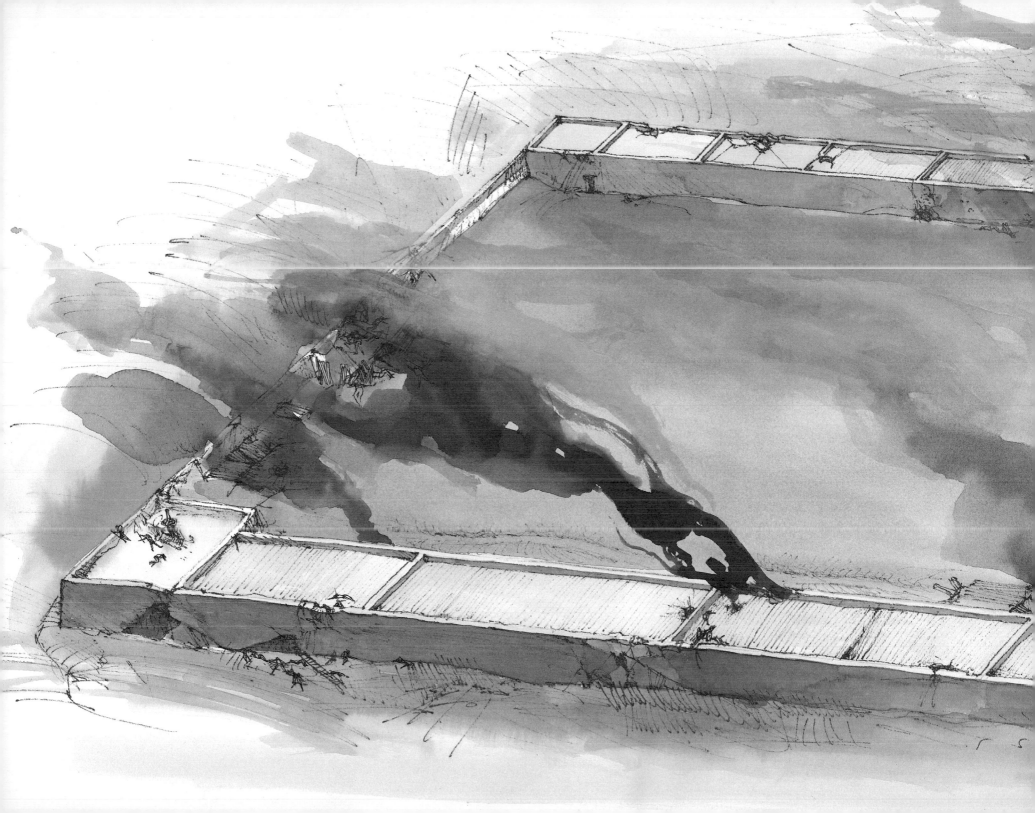

Such a short battle. Nearly over by six-fifteen in the morning.

The women and children still huddled together, at the mercy of the soldiers, and chance. Señora Esparza cried out when she glimpsed her husband fall in the chapel. Susanna remembered the bugles. *No mercy,* they said. *No quarter.*

More and more soldiers swarmed through the chapel. *Almeron's gone,* Susanna thought. She hugged Angelina tighter.

Grief fell on her like hammer-blows. She too wanted to cry out. Instead, she prayed.

At half past six, the last defender was gone. The Alamo had fallen. The women and children were ordered to move to a smaller room, the baptistry. Susanna felt the end was near.

She would do her best to meet it calmly. If there was time, she would beg the enemy to spare Angelina's life.

A soldier entered. He noticed Susanna's white face at once. His bayonet rose to strike—

"Stop!" An officer strode in. "Is there a Señora Dickinson here?"

For a minute she couldn't understand how he would know. But of course Santa Anna would have heard from people in town about the women and children in the Alamo.

She raised her hand. "Yes."

"Don't stand there," the officer growled. "Bring your child and come with me if you want to save your life."

He dragged her out, stepping over the smashed-down chapel doors.

"Blessed Lord forgive them," Susanna whispered when she saw the plaza.

Booming cannon.
Shouts of attackers and defenders.
Cries of wounded and dying.
Almeron calling orders to his cannoneers . . .
Angelina fretted, clutching her mother's apron.
Susanna knew the Texans were losing.
Suddenly, powder-stained, Almeron was there.
"Great God, Sue, the Mexicans . . ."

All of Santa Anna's bands were playing the *deguello* together, so everyone could hear it above the gunfire.
". . . they're inside the north wall. Hear them?"
"Viva Santa Anna! Viva Santa Anna!"
"If they spare you, save our child."
And he was gone.
Forever.

Ten days passed.
Eleven.
Twelve . . .

Gunfire from both sides remained steady. Santa Anna's military bands played during the night, so the Texans lost sleep. The Mexican army kept growing . . . to two thousand, then three.

Eating a supper of fried beans with Susanna, Almeron, exhausted, shook his head. "Sometimes I wonder why we're holding out, Sue. Killing isn't right, or good. Those soldiers out there don't want to die any more than we do."

"I know," she said softly. "But maybe we want to be free more than they do."

Gazing at her with love, he reached out and squeezed her hand. And nodded.

--------------------★--------------------

Before dawn on Sunday, March 6, Santa Anna's armies were stirring. Dozing in an old damp blanket with Angelina in her arms, Susanna woke suddenly.

"What is that music?" she whispered.

Guns were crackling outside the chapel. Artillery matches glowed near the cannon on the walls. Susanna stared into the horrified face of her friend Señora Esparza.

"You know what the bugle call means, Señora. Please tell me."

"Santa Anna is tormenting us. It is the *deguello*. It means the same thing as the big red flag. Show no mercy. Kill everyone."

Sharp as knives, the bugle notes flew through the air. Susanna clutched her baby. She heard shouting, ladders thumping against the Alamo walls.

She rushed into the plaza as the first enemy rocket lit the paling sky. She saw Travis running toward the north wall, carrying a sword and shotgun. Before Crockett and others pushed Susanna back inside to safety, she heard Travis cry, *"The Mexicans are upon us—!"*

Susanna's heart beat fast. With the other women and children, she huddled in the sacristy, a small room off the chapel. Hers was the only American face. But all the faces shared a common look. It seemed to say:

We are frightened. But we stayed here to show what we're made of.

Now it's time.

In the sacristy, Susanna never saw the final brief battle, only heard it:

 Even so, a few happy moments gleamed. Travis liked Susanna's pretty daughter. He gave little Angelina one of his treasures, a ring set with a shimmering cat's-eye stone. Travis's slave, Joe, smiled with approval.

Now and then Davy Crockett scraped out a tune on his fiddle. Davy's music was one of the few happy sounds left.

One of Travis's messengers, James Bonham, appeared suddenly after riding all the way back from Goliad, 95 miles. He brought bad news. Fannin was hesitating with his 400 men. Bonham returned rather than abandon his friends.

If Bonham can be so brave, Susanna thought, *I must too.*

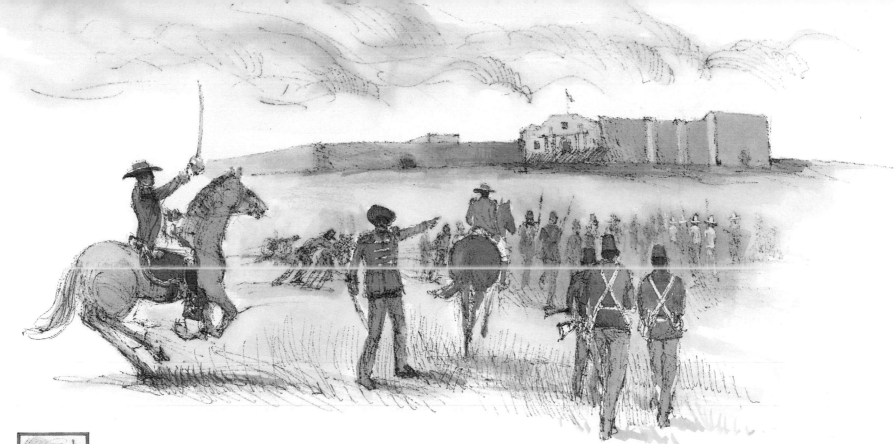

 Next day, Susanna's fear grew. Almeron told her that from the wall, he saw many more Mexican soldiers arriving. Then she heard cannon fire and rifle shots.

Before the day was over, Travis wrote a letter saying the defenders would never give up. *Victory or Death*, he wrote, just above his name.

On the fourth day, 32 men from Gonzales risked their lives to gallop into the mission. They all made it. Many were friends of the Dickinsons.

The weather was bitter cold now. Bowie was still sick with pneumonia, and Travis was writing more letters pleading for help. He sent them out at night with messengers who bravely dashed on horseback through showers of bullets. Most of all, Travis needed the 400 armed Texans waiting at Goliad under the command of Colonel James Fannin.

Outside, Santa Anna's men kept digging trenches, each new one nearer to the Alamo. Before long, soldiers and Texans were so close they could shout insults at each other.

The situation was desperate.

JIM BOWIE

COLONEL TRAVIS

of the Texans were Mexican, like Gregorio Esparza, who brought his wife and four children. He didn't like Santa Anna either. But the thought of fighting his own brother saddened him.

"Maybe your brother isn't with Santa Anna's army," said Susanna, trying to comfort Esparza.

"Yes, he is. He's afraid of *El Presidente*. But we must not be afraid to fight to be free of Santa Anna's unjust laws. Texans should be treated fairly—just like any citizen of Mexico."

"*El Presidente* started this war," Almeron said. "Too many Americans have settled in Texas. He thinks we're too strong now."

No one showed that strength more than Almeron, Susanna thought as they spoke. He was a kindly man, with the powerful arms and hands a blacksmith needed. As a smithy and former soldier, he knew artillery. He was in charge of the cannon brought into the Alamo. The sight of him, so brave and tall, made Susanna love him more than ever.

★

Later that day, one of Santa Anna's officers came to demand surrender. Travis ordered the Alamo's 18-pound cannon to fire one round—a thundering *No*.

But the defenders were surrounded. A siege began.

ALMERON DICKINSON

DAVY CROCKETT

The Texans defending the Alamo hoped to block the advance of Santa Anna's army and gain time for General Sam Houston, leader of the much smaller Texas army, to gather more men.

The stone and adobe buildings of the old mission were strong but partly in ruins. Once, Franciscan priests had lived there, and then some soldiers from Alamo de Parras in Mexico. Those soldiers were well liked by the local people, who nicknamed them *"los Alamos."* When the soldiers left, the name stuck to the place that had sheltered them.

Those in the Alamo with Susanna and Almeron also came from far places: Massachusetts. Pennsylvania. Tennessee. Europe. One had even served in Napoleon's army, years before.

There was former Congressman Davy Crockett of Tennessee, famous for tall stories and for killing ferocious bears that attacked him. He rode all the way from Tennessee to help. He brought 12 men, his fiddle, and a long rifle he called Betsy.

There was Jim Bowie, an adventurer who carried a big hunting knife later named after him. He was supposed to share command of the Alamo but he got sick, so the other commander took charge.

He was William B. Travis, a 26-year-old lawyer from Alabama. His past was mysterious. Some trouble over a woman. But he was a strong leader.

Not everyone in the Alamo was American. Some

San Antonio de Bexar, in the Mexican province of Texas. February 23, 1836.

"Look there, Sue!" cried a young blacksmith named Almeron Dickinson. "I know that signal. The red flag means the Mexican soldiers will show no mercy. Their general, Santa Anna, wants to scare us."

The young woman standing beside him, his wife, Susanna, was already afraid. She feared for Almeron and for their daughter, Elizabeth Angelina, almost fifteen months old.

Earlier that day, General Santa Anna's army rode into the town of San Antonio. Many people left after learning that more soldiers were on the way. But the Dickinsons and more than 150 other Texans didn't run. They moved inside an old mission called the Alamo and turned it into a fort.

Susanna felt a sudden chill as she and Almeron stood together on the Alamo wall. Was it caused by the winter weather, or their danger?

"Won't Santa Anna talk with us?" she said to him. "Mexico used to be friendly to Americans. We were asked to come to Texas to fill up the land. Mexico wanted settlers."

"But then Santa Anna became President. He took away our rights," replied Almeron. "No use talking to a man like that—a dictator. All we can do is stand up for what we believe."

Susanna was only 22. She couldn't read or write, but she was a caring mother—a loving wife. She and Almeron had come to San Antonio last fall, from the village of Gonzales. Gonzales was their home after they moved to Texas from Tennessee in 1831.

Life had been good in Gonzales. Susanna and Almeron were young, strong, hopeful.

But now, as she gazed at the red flag, Susanna worried about the future. Were they going to lose everything in a fight for freedom?

Dedicated to our wives.

WITH THANKS...

The author and artist here pay tribute to those who helped us tell Susanna's story so that it is faithful to the historical record. (Gaps do exist; and some "facts" live on in different versions.)

Leo Zuniga of HBJ opened doors for us in San Antonio. There, Mrs. Edith May Johnson, Alamo committee chairman and director of the Daughters of the Republic of Texas, the group that oversees the historical site with care and devotion, shared valuable time and knowledge. So did Henry Guerra, chairman of the Bexar County Historical Society, a man of good humor and vast information. Mrs. June Barth of the Daughters of the Republic guided us through what remains of the original Alamo compound. Bernice Strong of the D. R. T. Library at the Alamo clarified several important points.

Additional help with gathering research material and comparing versions of the story from different sources came from the author's wife, Rachel Jakes. And along the way, we have enjoyed the friendship and support of Willa Tupper, our editor at Gulliver Books, and Rubin Pfeffer, editor-in-chief of HBJ trade books, who gave the two of us the happy opportunity to work together.

As noted, questions still exist about parts of the Alamo story. Legends have sprung up to improve on what might have happened, as legends have a way of doing. We have avoided the legends, no matter how attractive, and invented nothing except some of the dialogue. This book contains no fictional characters or events. Where a fact is debated by historians, we chose the most widely accepted version.

Finally, while acknowledging the generous help of those people named, we must add that they are in no way responsible for possible mistakes of fact or interpretation. That responsibility belongs to us.

—J. J. and P. B.

Text copyright ©1986 by John Jakes

Illustrations copyright ©1986 by Paul Bacon

Library of Congress Cataloging-in-Publication Data

Jakes, John, 1932-

Susanna of the Alamo.

Summary: Relates the experiences of the Texas woman who, along with her baby, survived the 1836 massacre at the Alamo.

1. Alamo (San Antonio, Tex.)—Siege, 1836—Juvenile literature.
2. Dickenson, Susanna—Juvenile literature. 3. Pioneers—Texas—Biography—Juvenile literature. 4. Women pioneers—Texas—Biography—Juvenile literature. 5. Texas—Biography—Juvenile literature. [1. Alamo (San Antonio, Tex.)—Siege, 1836. 2. Dickenson, Susanna. 3. Pioneers. 4. Texas—Biography] I. Bacon, Paul, 1923— . II. Title.

F390.J2 1986 976.4'03 [92] 85-27143

ISBN 0-15-200592-7

Printed in the United States of America

First edition A B C D E

SUSANNA
OF THE ALAMO
A True Story

Written by
JOHN JAKES

Designed and illustrated by
PAUL BACON

Commandancy of the Alamo,
Bexar, Feby. 24th, 1836

To the People of Texas & all Americans in the world—

Fellow citizens & compatriots — I am besieged, by a thousand or more of the Mexicans under Santa Anna — I have sustained a continual Bombardment & cannonade for 24 hours & have not lost ... 'tis true that we are in great danger; a surrender at discretion. The greater therefore should our courage be. to the sword, if the fort is

SHAKESPEARE, *Henry V*

answered the demand with a cannon shot, & our flag still waves proudly from the walls — I shall never surrender or retreat. Then, I call on you in the name of Liberty, of patriotism & everything dear to the American character, to come to our aid, with all dispatch — The enemy is receiving reinforcements daily & will no doubt increase to three or four thousand in four or five days. If this call is neglected, I am determined to sustain myself as long as possible & die like a soldier who never forgets what is due to his own honor & that of his country — Victory or Death.

Lt. Col. William B. Travis

G U L L I V E R B O O K S

H A R C O U R T B R A C E J O V A N O V I C H

San Diego Austin Orlando

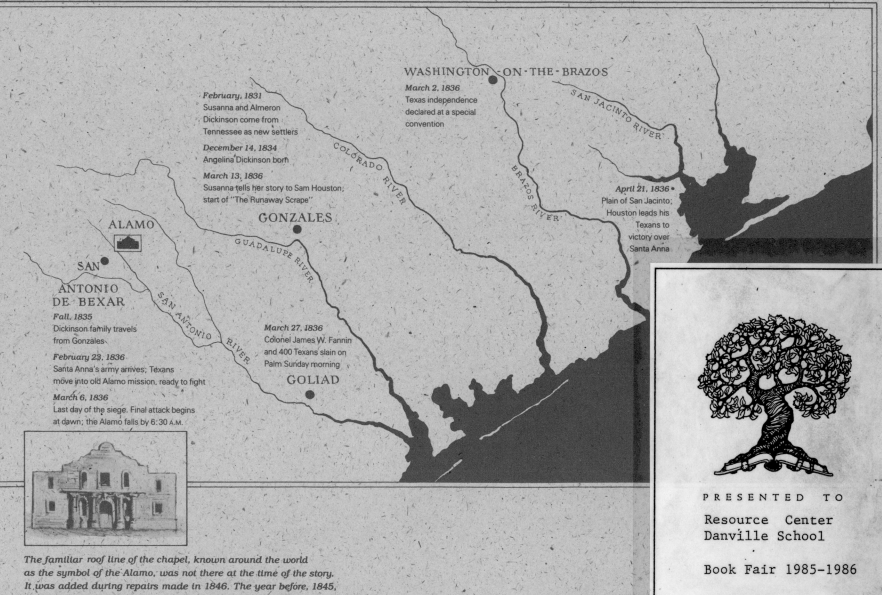

The familiar roof line of the chapel, known around the world as the symbol of the Alamo, was not there at the time of the story. It was added during repairs made in 1846. The year before, 1845, the Republic of Texas became America's twenty-eighth state.